THE GOLDEN EYE

Text by Mahonri Sharp Young
Introduction by John Train

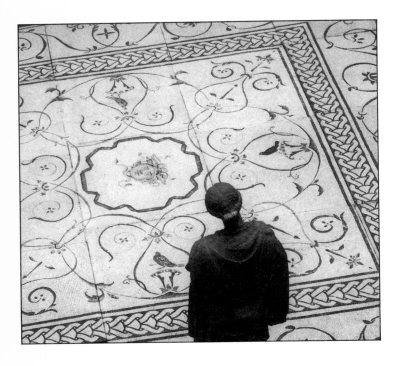

page 1:

Fenway Court; a statue overlooking the Roman mosaic at the courtyard's center.

Photographs by Albano Guatti and Nicolas Sapieha

Design by Lavinia Branca

Text Edited by Edwin Bayrd

Typographical Design Consultant: Tom Penn

Project Directed by Maria Teresa Train

First published in the United States of America
by Scala Books, New York.

ISBN 0-584-80001-0
Library of Congress Catalog Number 82-061015

First published in Great Britain in 1983
by Frederick Muller Limited
Dataday House, Alexandra Road, London SW19 7JZ

Typography by Fisher Composition, New York.
Studio Art: Julius Brito
Printed in Italy by Officine Grafiche, Firenze.

A Train/Branca Book

Magnificence . . . what a noble conception! Aristotle rightly puts it among the virtues of a superior man. Rarely do we find it in today's America, where great wealth creates an accountant's paradise but, like too much sun, a humanist's desert. How many Della Robbias or Hiroshiges do we find per cubic mile of Miami condominiums? Or, indeed, how many who love such things, or have even heard of them? No, rarer and rarer is the vision that can form and execute a Caramoor, a Morgan Library, a Fenway Court. Today's non-magnifico is content with ever more zeros in his bank balance, an endless interrogation of the computer: "Who is the richest one of all?" Life becomes a video game. Meanwhile, drowning in appliances, the soul perishes.

Museums come in two sorts: one is the organized collection that from the first is intended for public viewing and seeks to provide a balanced, representative sampling of styles, periods and places. The other is the magnificent indulgence of a rich and knowledgeable patron's private taste, intended for his own delight and often maintained in his own house or palace.

The typical private collection of a great patron represents the lifetime summation of his personal connoisseurship, and thus may have nothing to do with the tastes of the time. Quite the contrary: the best chance to establish an outstanding collection is when the objects bought are out of favor and thus affordable. One thinks, in this connection, of Cary Welch's inspired buying of Mogul miniatures, or the Garbisch collection of American naïve art.

I have known several of these great idiosyncratic collectors, and through local tradition in places in the East where I have personal ties have heard about others. A pattern emerges. Often the personality of a great collector, like that of the artist, is flawed: damaged in childhood, perhaps by ugliness or a low standing in society.

"Mad Ireland hurt you into poetry" was written of Yeats, but could it not have been said of Isabella Stewart Gardner?

Many an angry tycoon, like a hermit crab, acquires a brilliant borrowed carapace, his collection, obedient to Oscar Wilde's dictum, "If you can't be a work of art, wear a work of art."

The same determined singularity of viewpoint that enables the collector to buy what others overlook may also turn him into a figure of fable in his community. It would, in fact, be hard to exaggerate the arrogant originality of some of the subjects of this volume. Surely few men in the history of Philadelphia can have been more singular than Dr. Albert Barnes of the amazing Barnes collection of Impressionist paintings. One day, traveling in the trolley, Barnes was courteously saluted by Mr. Sturgis Ingersoll, a noted collector himself and president of the Philadelphia Museum—an institution for which Dr. Barnes's esteem fluctuated between zero and one on the percentile scale. Ingersoll, nattily turned out as always, his visage perfected by a finely waxed moustache, was discomfited when Dr. Barnes scarcely seemed to recognize him. But that was nothing compared to his feelings the next day, when a letter arrived from Dr. Barnes—not quite correctly headed, it began "Dear Sturgeon"—stating that he believed the addressee would want to know there was an imposter about, apparently a tramp, or at least dressed like a tramp, pretending to be Mr. Ingersoll.

Dr. Barnes had little use for proper Philadelphia, and Philadelphia had little for him. In fact, except for his beloved collection Barnes had little use for anybody or anything. Even a fellow magnifico failed to interest him; as at the clash of flint and steel, sparks flew when he was approached on behalf of Isabella S. Gardner. Could the mistress of Fenway Court view some of Dr. Barnes's paintings?

The last time he had let an unknown woman in to visit he had contracted an embarrassing affliction, replied Barnes and thus felt it prudent to decline this request. Even worse, pleased by his appalling rudeness, he circulated this exchange to his acquaintances. But then, what singularity did it require to buy hundreds of Renoirs and Cezannes when virtually nobody else could see the point of them? And who in the end is more remembered in Philadelphia: the intolerable Dr. Barnes or the im-

Carved motif from a grey marble fishpond at the main terrace of La Cuesta Encantada.

eccable Mr. Ingersoll?

In Boston they tell many tales about Isabella Gardner, a woman Back Bay society never really accepted but had to respect. A sample might be the story of her check on the acoustics of Fenway Court before its grand opening. She resolved that the effect of that grand occasion should not be diluted by any advance reports; nobody except trusted craftsmen could be allowed to view her achievement. She did have to test the acoustics of the music rooms, of course; but what if one of the musicians, like Marco Polo returning from Cathay, were to reveal the visions he had beheld? Descriptions might circulate, drawings from memory might even appear in the newspapers. Impossible! There was only one solution: a corps of blind music students was recruited from the Perkins Institution. They listened, they praised the acoustics; they were led forth and dismissed; they could describe nothing.

As Morris Carter relates in *Isabella Stewart Gardner and Fenway Court:* "One unfortunate incident seriously marred the afternoon, but established a precedent that continued for many years. As there was deep snow on the ground, the children had all worn rubbers; when they entered the house, their teachers carefully placed the rubbers of their respective charges where they could find them; when the music was over, it was discovered that a servant had gathered together all those wet rubbers which seemed to him unnecessarily disorderly in his beautiful new palace, and had dumped them on a piece of canvas which he had spread over his clean tile floor. To the teachers and the blind children that pile of rubbers was staggering. On days when Fenway Court was open to the public, Mrs. Gardner occasionally cut short a flow of compliment from a well-intentioned stranger with the abrupt question 'Have you got your rubbers?'"

On one particular occasion the socially ambitious Mrs. Gardner was almost defeated by the Boston matrons. A german prince, noted not only for his rank but his culture, was visiting the city. All the leading hostesses vied to lure him to their dinners, teas, lunches, suppers. Mrs. Gardner was successfully outbid, and she was, moreover, excluded from every occasion except one—the big ball to which *everyone* had to be invited.

Equal to the challenge, she made her entrance into the ballroom swathed, as usual, in row upon row of her magnificent pearls, draped in great ropes. She neared the prince. She stepped into one of the ropes. It broke. With a crash like Niagara, the pearls cascaded to the floor. All the men rushed to scoop them up, the prince in the lead. The prince was too kind! The prince was too kind! Thank you, thank you, dear prince. Would the prince, having rendered this signal service to Mrs. Gardner, care to be rewarded by a private glimpse of Fenway Court? He had heard of it all the way in Germany? He would be delighted? Wonderful! And off they sauntered. The coachman was waiting, the fires lit, the table set for two, the Steinberger Kabinet just the right vintage and temperature. The Back Bay matrons were apoplectic.

A feeling of intimate, almost uxorious possession, a passionate involvement with every facet of a collection, including the placement of each item in its setting, typifies the patron of a personal museum.

That is what I meant by "golden eye": the informed eye of a connoisseur with the wealth to indulge his desires, but also the yellow hawk-like orb of the rapacious acquisitor. Walter Rosen, the gifted creator of Caramoor in Katonah, New York, now a place of pilgrimage for the art and music lovers of the region, once told me that always, while accumulating his treasures, he had in his mind's eye a vision of the exact position that every object would occupy in the splendid house that he had not yet built to contain them.

A recent example of this obsession was Miss Helen Frick's loan of her collection, together with a splendid building to contain it, to the University of Pittsburgh. One condition: Nothing could ever leave the premises. When, like Bluebeard's bride defying his injunction not to peer behind the door, the trustees had the temerity to move some of the objects, Miss Frick did not hesitate. She took back the whole collection, lock, stock and barrel. And, of course, anyone who stayed with Bernard Berenson at I Tatti remembers his intense concern with every object. As he walked around he would smile at one picture, say a few words about another, pause to caress a sculpture or put it back *exactly* in place, pull a book from the shelf and lovingly turn the pages with his thin hands. There naturally flows from this feeling of

affectionate control a desire for exclusive possession, as of a woman.

Dr. Barnes, for instance, intensely resented ever opening his collection to the public. That is why it is not in this book: to this day photography has never been permitted there. Similarly, the Morgan collections were in his lifetime seen only at his invitation, by the nabobs of industry and finance, the bishops, and the scholars whom he considered worthy.

Although a special charm and fascination often surrounds the private museum, it has never before been contemplated as a separate category. This book discusses some of the most remarkable of these American museums, and by examining the lives and tastes of their extraordinary patrons, it gives one a delicious feeling of opening hidden doors, almost of prying away the hands of the creators, still trying to keep them shut.

And it does the soul good to contemplate the creators themselves, those magnificent egoists. Surely here are some of the "famous men" praised by Ecclesiasticus: honored in their generations, and the glory of their times, who have left a name after them.

J. T.

1

THE NORTHERN LIGHTS

The façade of the Venetian inner courtyard at Fenway Court, built by Isabella Stewart Gardner based upon designs by William T. Sears of Boston.

8

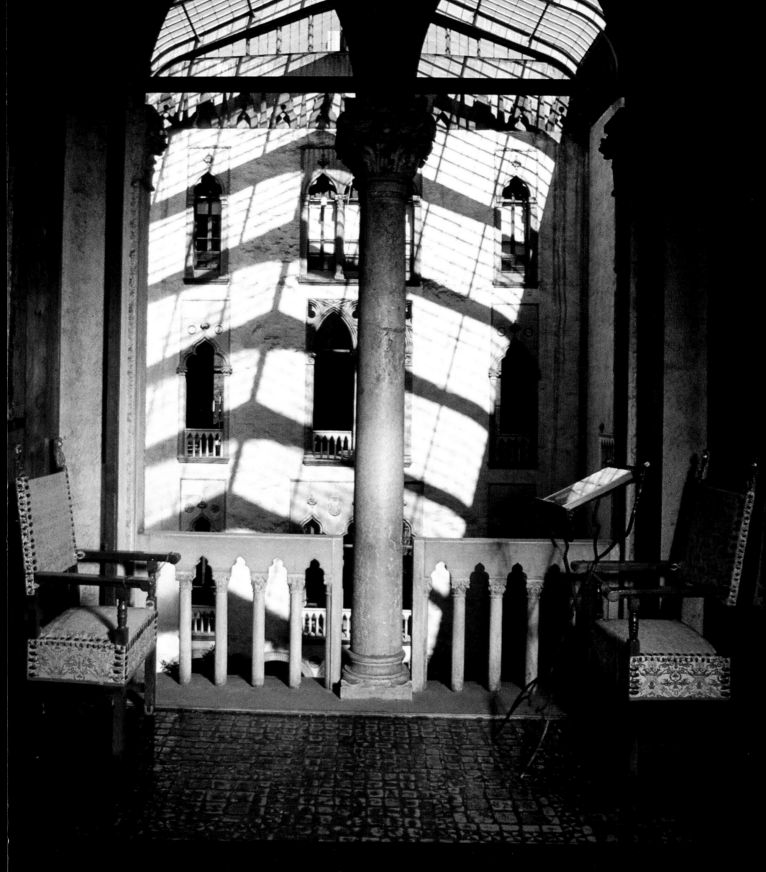

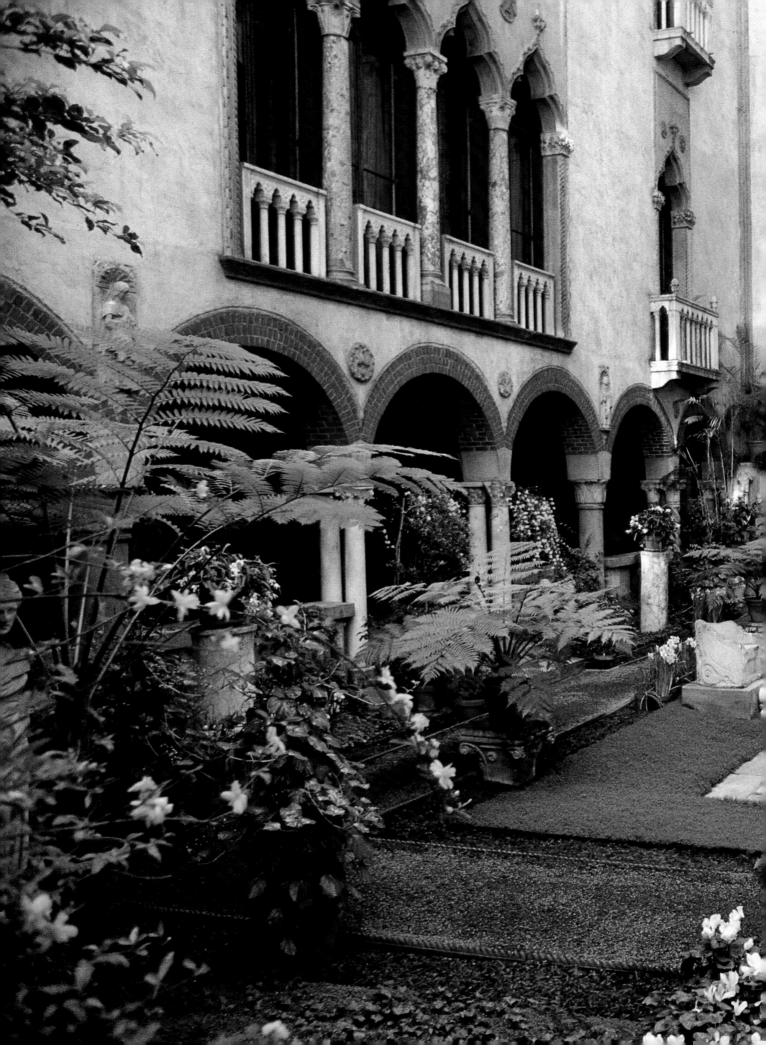

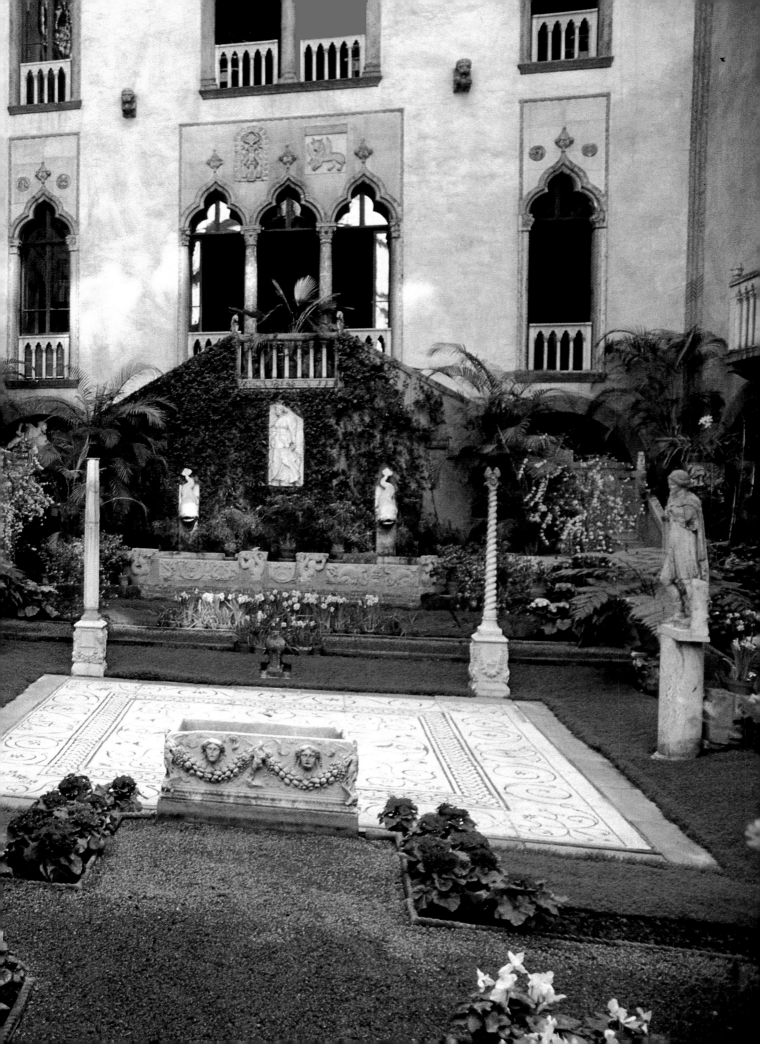

preceding page:

Marble statues and sarcophagi surround a Roman mosaic at the courtyard's center. Protected from the elements by a roof of glass panels like that of a greenhouse, the court is full of blossoms all year round.

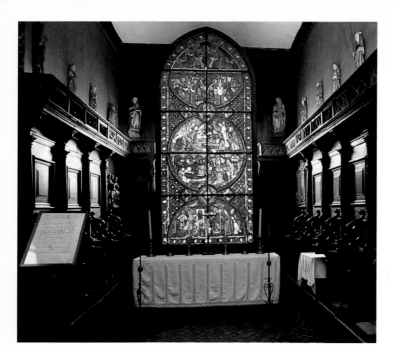

The chapel, where an Anglican midnight mass was celebrated on Christmas Eve, 1901.

The portrait of Isabella Stewart Gardner painted by John Singer Sargent.

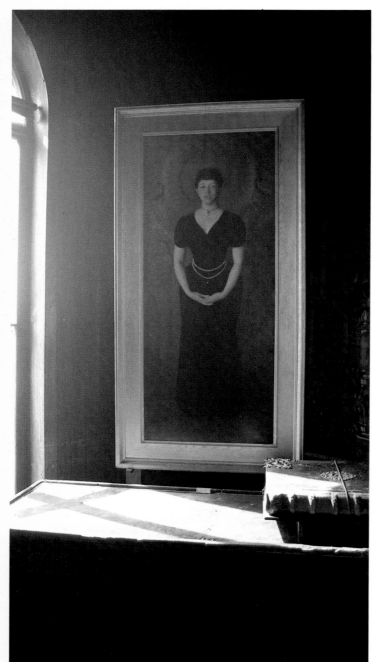

Oliver H. P. Belmont's extravagant bachelor digs, Belcourt Castle, built in 1893, is one of three vast marble "cottages" designed by the architect Richard Morris Hunt for Newport's "Millionaires' Walk".

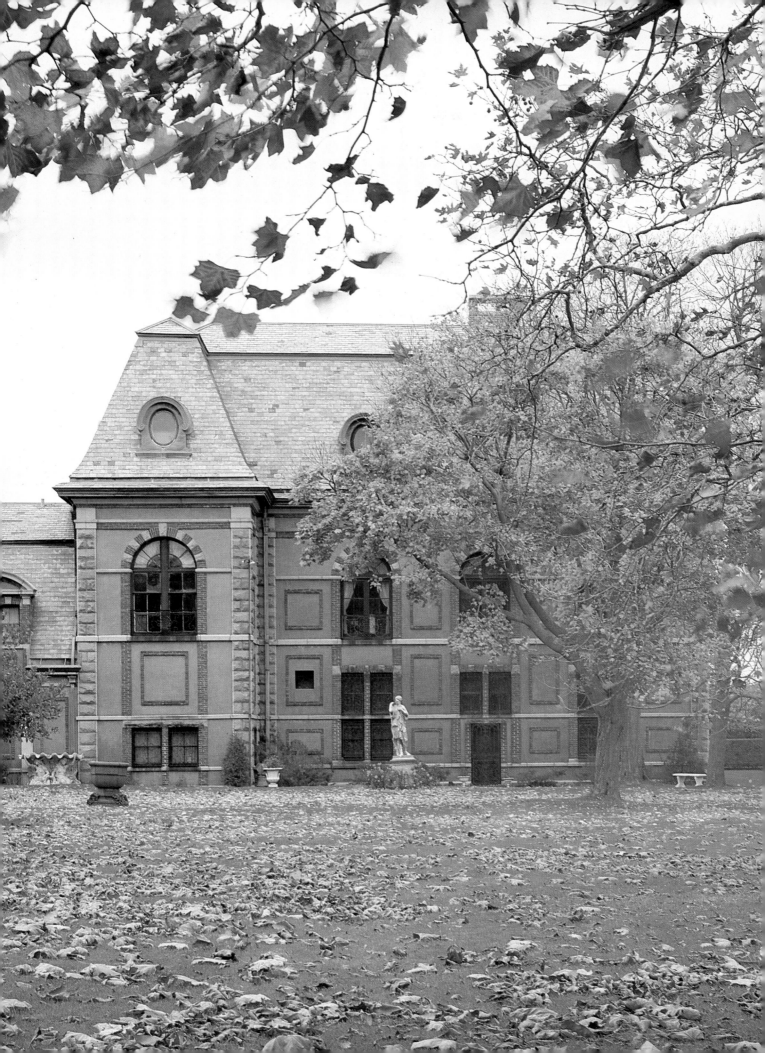

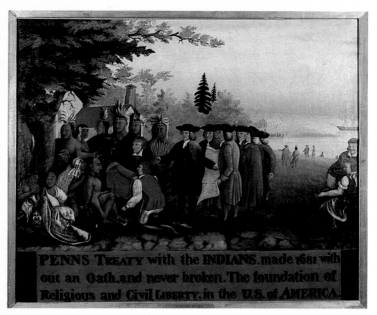

Oil painting by Edward Hicks (1780–1849) depicting William Penn negotiating a treaty with the Indians.

Dorset House, erected in 1840 in Dorset, Vermont, is one of the many eighteenth and nineteenth-century edifices reconstructed at the Shelburne Museum. It houses the collection of American wildfowl decoys and Audubon game bird prints.

following page:
Prow of the S.S. Ticonderoga, Shelburne Harbor, 1906. The last vertical-beam passenger and freight steamer in the United States has been converted into a marine museum. In the background, the Colchester Reef Lighthouse from Lake Champlain, 1871, contains figureheads, scrimshaw and early American maps.

Horseshoe barn, newly constructed in 1949, contains a collection of American farm wagons and stagecoaches.

Shelburne Park. At rear, the exterior of the Electra Havemeyer Webb Memorial Building, which incorporates rooms transported from the New York apartment of the co-founders, Mr. & Mrs. J. Watson Webb.

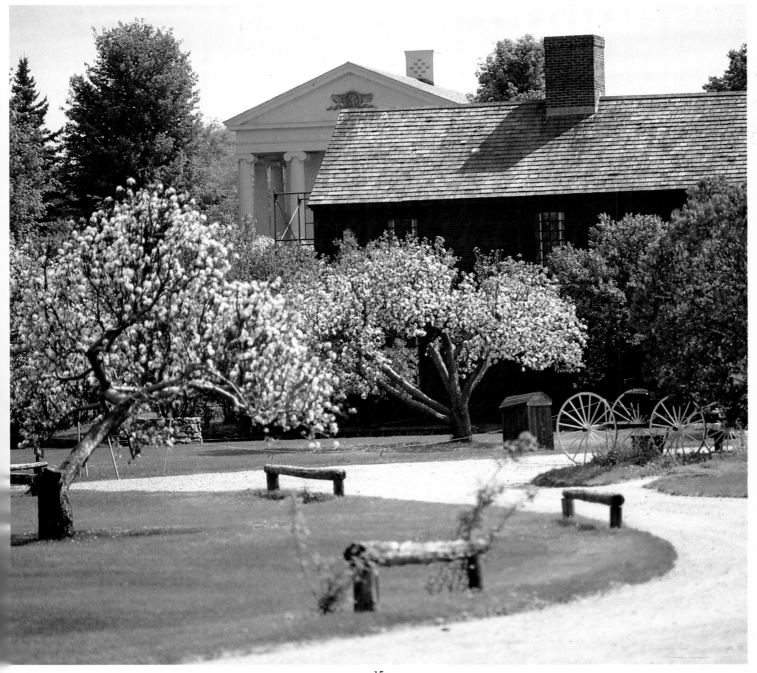

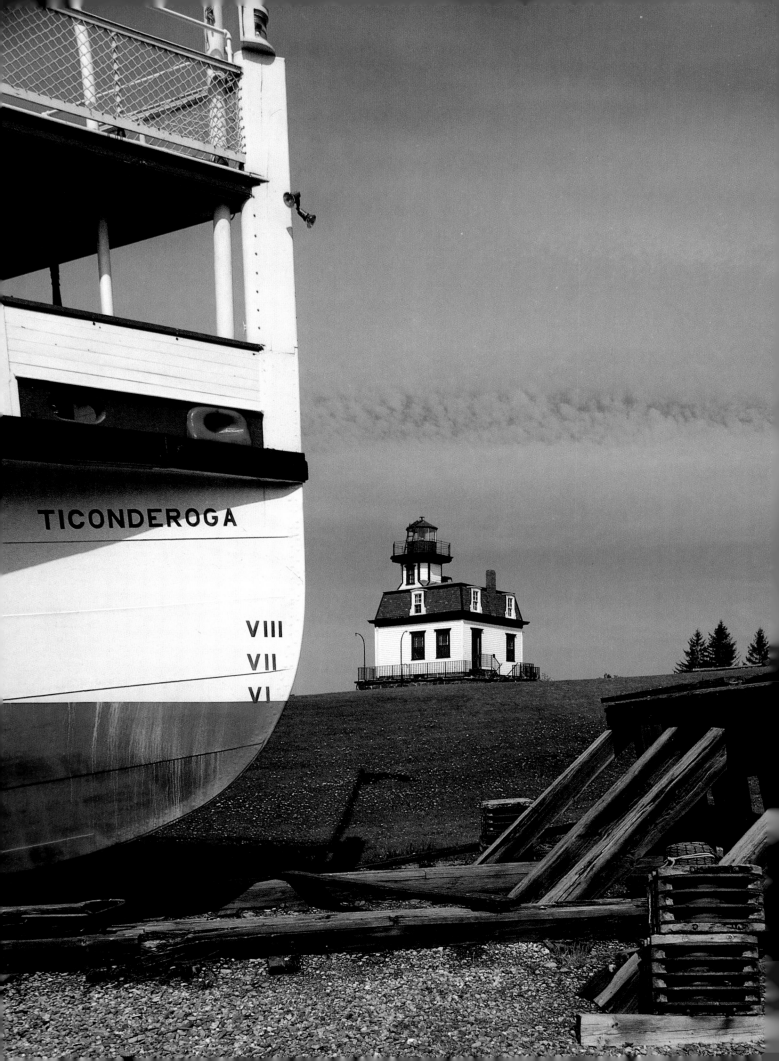

1

THE NORTHERN LIGHTS

The history of art collections in America is only two centuries old, and its story is that of extraordinary personalities and immense fortunes. In the post-Civil War years there were two kinds of museums in the United States. One was the "dime" museum, an emporium of curiosities operated for profit and dedicated to entertainment. Such was P.T. Barnum's New York Museum, which included jugglers, trained fleas, and the twenty-five-inch-tall Tom Thumb. The other was the impecunious but high-minded public gallery, usually dependent on an art academy or library. Nothing like the museums of Europe existed on these shores. America had no Napoleon to fill its national museums with plundered treasures; no Charles V, patronizing Titian and monopolizing the market for Bosch. The modern princes on this side of the Atlantic accumulated vast fortunes overnight and spent them demonstrating to the world that their wealth entitled them to prestige as well as power. Formed during the aggressive industrialization of this nation, these great fortunes gave birth to a new kind of collection—that of the private citizen who indulged in his sense of worth and took advantage of his country's lack of "items of high culture." Responding to this need and the call of other visionaries, the robber barons of the nineteenth century began to fill the void.

The surest way to success was to build a house, the grander and more European the better; fill it with pictures, sculpture and furniture; and surround it with gardens to disguise the cattle yards, steel mills, or railroads that paid for it all. All this was intended to suggest the gentility of the European—above all the English—aristocracy, by whose codes and standards these Americans aspired to live.

This mass importation of foreign taste was generally both selective and informed. American millionaires might, for example, be crazed Anglophiles—witness the market established by Duveen for large portraits by Reynolds, Gainsborough, Heppner, Romney, and their like, at prices that would have staggered both the painters and their very elegant sitters. Yet virtually no Americans were willing to fill their houses with the great works that

decorated so many English estates: canvases by the masters of seventeenth-century Catholic Europe showing martyrdoms or touching acts of devotion and piety. Instead, American houses were filled with drawingroom-sized paintings by the Dutch Masters, pictures painted originally to appeal to a Protestant mercantile community not at all unlike that of monied America of the nineteenth century.

In the century that followed, a small number of American men and women changed the cultural scope of the United States. On an unprecedented scale, they imported the masterpieces of Europe's past centuries. Brilliant collections of such pictures were formed by the likes of Benjamin Altman in New York City, who spent his vast wealth with unequaled and unvarying good taste, buying pictures, sculpture, and furniture. Alongside Benjamin Altman and his peers of sensible and proper taste grew another breed of collector, men and women of even greater individuality who defied convention and began a new tradition in American museums.

The most compelling of these great American characters was unquestionably Isabella Stewart Gardner—"Mrs. Jack" as she was called—and her museum, Fenway Court, is one of America's most beautiful.

FENWAY COURT

Isabella Stewart was born in New York City, where she spent her youth. She often traveled to Europe with her family. One February, at her schoolmate Julia Gardner's invitation, Isabella went to Boston, where she met Julia's brother, John. One year later they were wed and moved to Back Bay. During their thirty-eight years of married life, the Gardners were the envy of Boston society and the patrons of the city's literati.

When her husband died in 1898, Isabella was grief-stricken. Boston's most interesting widow, as she was called, turned all her energies to the cultivation of music and art, and with the architect Willard T. Sears she continued the planning of Fenway Court, the chief weapon in her frontal assault on Beacon Hill society. She was a good judge

17

men, and her choice of Sears was fortunate, for she required unusual agility and adaptability from her architect: Sears had the plans for Fenway Court ready in three months—even though his client had given him no idea of how much money she wanted to spend. Sears never had such a difficult client; she did not see, for example, why stone arches needed foundations. Mrs. Jack exasperated him with her demands and her changes, but she made him both a trustee of her museum and, eventually, a personal friend. Sears never designed another building as interesting as Fenway Court.

Mrs. Gardner did know what she wanted at Fenway Court: a tall inner garden court roofed with glass—which proved to be one of the most breathtaking rooms in America. Indeed, the whole house faces inward toward this court, whose sides are pierced by eight stone balconies bought by Jack Gardner on his last trip to Europe. These balconies came from Palazzo Franchetti-Cavalli, an old Venetian palace that was being restored at the time. While the foundations were being built, Mrs. Gardner went to Venice to buy marble columns, fountains, staircases, furniture, statues, and paintings. This mode of acquisition was standard procedure at the time: American "palaces" often obtained their patents of nobility through the scavenginig of famous European buildings. Altogether, Mrs. Gardner acquired some 2,000 art objects in this manner, which she eventually incorporated into different rooms—among them the Gothic, the Titian, and the Veronese rooms.

When she returned from her travels, Mrs. Gardner made daily visits to the construction site, where work was progressing. One of the Italian workers could play the trumpet and he became her piper, calling in the workers with one toot for a mason, two for a steam-fitter, three for a plumber, four for a carpenter, and so forth. "Mrs. Jack" also ate with the workmen during the building of Fenway Court, and she chipped in her dime for the oatmeal used to settle the water in the drinking pail.

The façade of the building was, as she required, bare and forbidding, while the inside had the brilliance of a Venetian palazzo. The court was surrounded by cloisters and carved windows. A Roman mosaic was placed in the center of this vast inner courtyard, and a seventeenth-century Venetian fountain in the south-most corner, making the courtyard, with its masses of blooming flowers, the most extraordinary conservatory in this country. Eclectic and rich, her collection included works by Holbein, Bonheur, Manet, Matisse, Van Dyck, and Vermeer as well as Chinese architectural fragments and Persian miniatures.

In the years that followed the completion of Fenway Court, Mrs. Gardner received the literati of the day. Among her famous visitors were the writers F. Marion Crawford and Henry James, the painter John Singer Sargent, and Bernard Berenson, who had long been her principal advisor in buying paintings. Berenson played an important role in shaping the taste of Isabella Stewart Gardner, although she always maintained a critical independence. Under his guidance she acquired Italian paintings of the fourteenth, fifteenth, and sixteenth centuries and holdings of French, German, Dutch, and Flemish works of the finest quality. Berenson was not involved with the building itself or the collection of architectural fragments and furniture that adorns Fenway Court. For the latter Mrs. Gardner relied on the enthusiastic aid of three other talented young Bostonians, who called themselves her "gnomes."

When she occasionally bought paintings through the gnomes, Berenson could not help showing how deeply offended he was. "Remember," he wrote on one such occasion, "that Raphael is not a great painter in the sense Titian or Veronese or Velasquez or Rubens are." Later he would sell her a Raphael portrait of Count Tommaso Inghirami and his *Pièta*. This was the arch flatterer's other side, wounded and wounding. A formidable ally, Berenson could also make a formidable enemy, as René Gimpel observed in his *Diary of an Art Dealer:* "The hatred he expends he gets back in full measure; but if he were in a cage with one of his detractors, he would not be the one devoured." Berenson had richer clients than Mrs. Gardner, and the fruits of those associations are evident, above all, in the collections of the Metropolitan Museum of Art in New York and the National Gallery of Art in Washington, D.C.; but no other collector had as great an impact on his life and his career.

Sir Philip Hendy, former director of the National Gal-

The steel architrave of the glass roof at Fenway Court is reflected in the still waters of a fountain.

ery in London and author of the catalog of Mrs. Gardner's paintings, called them "probably the finest collection of its compact size in the world." Several of the paintings are unique in this country: Piero della Francesca's *Hercules* is his only fresco in the United States; *The Rape of Europa* is our greatest Titian. Two paintings by Mrs. Jack's friend John Singer Sargent dominate Fenway Court. The first is *El Jaleo,* a huge, swirling canvas of passionate movement totally unlike anything else by Sargent. It occupies its own room. The second, his famous portrait of Mrs. Gardner with pearls around her pulled-in waist, is a touchingly vulnerable likeness.

Two years before her death she wrote her friend Count Hans Coudenhove: "This house is very nice, very comfortable and rather jolly . . . I have filled it with pictures, works of art, and if there are any clever people I see them. I really lead an interesting life." Mrs. Gardner died in 1924. In her will she donated the Isabella Stewart Gardner Museum "for the education and enjoyment of the public forever." A dazzling monument to Mrs. Gardner's intelligence, vision, and wit, the great house on Palace Road looks much as it did when she was its queen.

NEWPORT, R.I.

Before the Newport of the millionaires' "cottages" designed for the Vanderbilts and their friends, there had been another, less extravagant Newport, which people cherished for its own sake. This was the Newport where the painter John La Farge and the historian Henry Adams spent their youth, the Newport to which Henry James ascribed "a quiet mildwater sense, not that of the bold, bluff outer sea, but one in which shores and strands and small coast things played the greater part, with overhanging black verandas, with little wooden piers, with painted boat houses and boats laid up."

By the beginning of the twentieth century, all that had changed, and Louis Auchincloss, a most perceptive interpreter of Newport, dismisses James's vision as the novelist's loyalty to lost causes, to the Newport of three-o'clock dinners and high teas and Gothic cottages. By then, Newport had undergone a mild social revolution through which it had acquired that "monstrous, half sublime, half ridiculous architectural romp of Richard Morris Hunt . . . through the centuries of European grandeur." This was the Newport of the Vanderbilt era, which Aunchincloss called a "textbook, in bricks and mortar, of much of our history, or at least a certain side of our history." This Newport was made by great fortunes and maintained by competitiveness, caprice, and a consuming devotion to self-indulgence. In this Newport Auchincloss observed that life-style and architecture were matched in extravagance: "The plea to be accorded a nobler purpose, the almost pathetic need to stand for something new; these are implicit in the splendid Genoese façade of the Breakers, in the towering portico of Marble House, in the thrones that stand in the ballroom at Belcourt."

As it happens, all three of these mansions were built by Richard Morris Hunt, whose last and grandest house was Biltmore in Asheville, North Carolina. As the Vanderbilt architect, Hunt set a pace for Newport architecture that no one ever matched; his "cottages" are both the earliest and the grandest.

Marble Palace, which was built for William K. Vanderbilt at a cost of $2,000,000, allowed the owner to feel that he had surpassed both Louis XIV and Louis XV, for this house combines the best features of the Grand and Little Trianons at Versailles.

William Vanderbilt was one of the most important collectors of paintings of his day—the chief rival of William and Henry Walters of Baltimore and the man who gave Rosa Bonheur's *Horse Fair* to the Metropolitan Museum—but his collection is now dispersed, and his fame rests principally upon Marble House. Even more opulent inside than outside, Marble House cost $9,000,000 to decorate and furnish—and that in dollars worth perhaps twenty times what they are today. On the lawn of this most formal of all Newport palaces, Alva Vanderbilt, William's wife, built an exotic Chinese teahouse in excruciating disharmony with its prim and proper surroundings. Since the teahouse, with its upswept eaves, phoenixes on the roof, and stone guard-

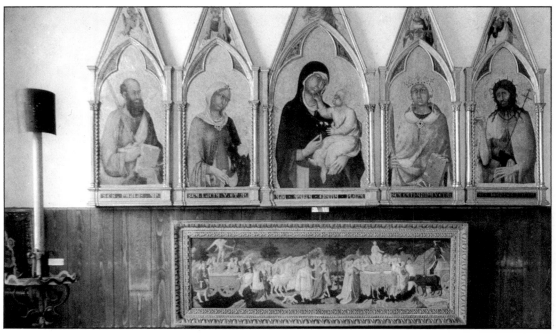

A fourteenth-century Sienese polyptych depicting The Madonna with Child and Four Figures. *Below, a Florentine painting of the fifteenth century,* the Triumph of Love, Chastity and Death *by Pesellino; from the Isabella Stewart Gardner Museum.*

ian lions, had no kitchen, tea was brought from the main house by narrow-gauge railroad—one more example of what the architectural historian Kidder Smith called "a concentrated array of extravagant domestic architecture unmatched in the Western world."

Because Cornelius Vanderbilt, William's brother, was both the favorite grandson of the Commodore and the titular head of the family, he felt an obligation to make The Breakers the grandest palace in Newport. As it happened, the chief obstacle to attaining this objective had been raised by his brother, for the rivalry that existed among the Vanderbilts traditionally found expression in the size of their residences. To satisfy Cornelius's ambitions, Richard Morris Hunt designed The Breakers in a formidable and extravagant Italian style. (Hunt personally preferred French architecture, but he was fluent in any style—and eager to please his client.)

The Breakers has seventy rooms, which were used only during the two-month season. Although it sits on eleven acres of grounds, the house occupies the exact site of the house that was torn down to make room for it. This meant that Hunt had to reach upwards to find the sort of space his client wanted; and while The Breakers is indeed tall, it is also massive and constricted, and by no means as graceful and serene as Marble House. The four façades of The Breakers are different, and the shape is noticeably out of kilter because of the enormous living room and porte-cochère that project on one side.

The great hall of The Breakers, with its grand staircase and intricate balustrade, rises forty-five feet to the roof; and the Flemish tapestry on the balcony, although dwarfed by its surroundings, measures eighteen by twenty-four feet. The library, one of the few intimately scaled rooms in this colossus, was designed by Hunt himself without assistance from members of his firm, which almost certainly accounts for its French flavor, emphasized by the twenty-five-foot fireplace from the château of Arnay-le-Duc. Elsewhere, the interior design of The Breakers is an amalgam of styles and periods, but the effect is nevertheless dazzling—on occasion, stu-

pefying. Up to Vanderbilt standards, this is most emphatically a house to show off, not to live in, one belonging to the Newport described by the French novelist Paul Bourget, where "there was too much of everything, too many tapestries and old masters on the walls, too many splendid equipages on the avenues, too much yachts on the bright sea."

August Belmont, who, like Commodore Vanderbilt, was the founder of a great family fortune, was the father of Oliver Hazard Perry Belmont, the bachelor who built Belcourt Castle. August Belmont's children were by and large a disappointment to him—especially Oliver, whom the elder Belmont considered incapable of handling his own affairs. His sentiments are reflected in a biography of Oliver, written by Donald Black, which describes the still-young man as "long ago lost to frivolity."

Oliver Belmont had little financial ambition, and he felt no compunction whatsoever about putting off all decisions about his life in order to take a year-long Mediterranean cruise with William K. Vanderbilt on his yacht, the Alva. That ship, named for Vanderbilt's wife, was, at 285 feet long and 32 feet wide, the largest steam yacht in America. It had a dining room with a piano, a library with a skylight and a fireplace, a ten-room suite for Vanderbilt's family, and seven guest rooms, each with a canopy bed and private bathroom. There were also quarters for the ship's fifty-three-man crew, which included a doctor, three cooks and a man to work the ice-making machine.

Oliver Belmont and Alva Vanderbilt fell in love with each other during this extended cruise, and when they returned home Alva obtained a divorce from Vanderbilt and married Belmont. In the property settlement she received Marble House, but Belmont found his former friend's "cottage" too cold and formal, and the couple moved into Belcourt, which was far more to his taste. Hunt had designed Belcourt in the French country style with an intentionally random and nonchalant atmosphere. At Belmont's request, the house had been planned so that he could drive a carriage directly into the living room, and soon he was doing the same thing with his automobiles.

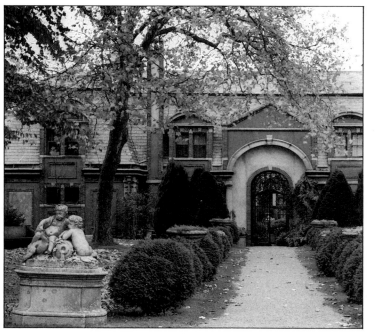

At Newport, R.I. in the early days of the twentieth century, lavish festivals were given at Belcourt Castle to focus international attention on the "bubbles," as automobiles were then called. A longtime bachelor, Oliver Hazard Perry Belmont had built his mansion so horses and carriages could enter Belcourt Castle and allow guests to step directly into the living room. The bubbles would soon do the same.

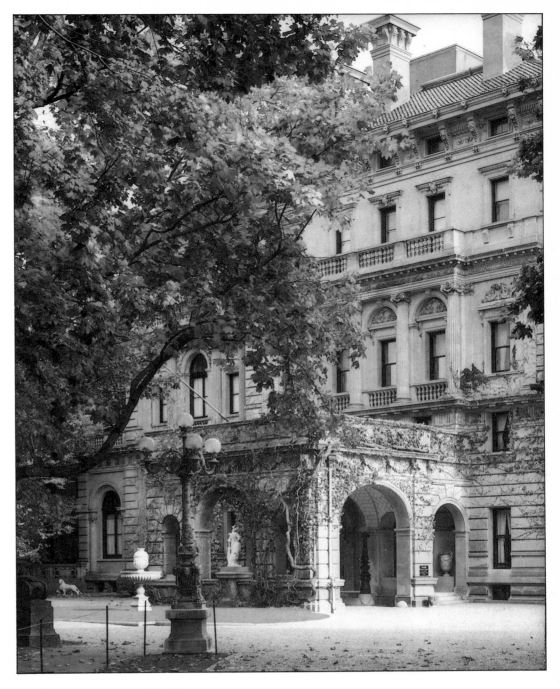

The Breakers was completed in 1895 for Cornelius Vanderbilt, from designs by Richard Morris Hunt. Beneath the entrance's porte-cochère are two massive carved oak doors engineered to open at the touch of a finger.

From the outside Belcourt looks like a travesty of a French château, and this playfulness extends inside. The ballroom is Gothic, and over its mantelpiece is an enormous sculptured dream castle that runs all the way up to the groined ceiling. The house was built with a single bedroom, which was deemed sufficient for a bachelor, but Alva, who loved building, added several more. The plan of Belcourt was inadequate in other ways as well. Belmont had originally asked Hunt to create a domicile for himself and his thirty horses. Hunt had dutifully incorporated features from early French hunting lodges and stables into his design, and the result, according to Merrill Folsom, the architectural historian, was stables that were tiled, upholstered, and paneled in the luxurious style of a ballroom: "The horses had white linen initialed sheets, embroidered blankets with gold coats of arms, and harness fittings of sterling silver."

The new mistress of Belcourt was less interested in horses than in parties, however, and the emphasis shifted from the stables to the ballroom. This required a number of structural changes in the house, all carried out with Alva's active participation. And this, in turn, spurred her interest in architecture. Significantly, it is because of her work at Belcourt that Alva Vanderbilt was made the first woman member of the American Institute of Architects.

THE SHELBURNE MUSEUM

If one were asked to give a very general definition of a museum, one might answer that it is a building containing many objects displayed for their beauty. Then how does one fit a full-size lake steamer, a lighthouse, thirty-five buildings, and a replica of six rooms in a New York apartment into this description of a museum? They don't fit . . . but on second thought, they do.

Set on forty-five acres of western Vermont's meadowed Lake Champlain shoreline is the Shelburne Museum. The Lake Steamer is the 220-foot steam-driven side-wheeler S.S. *Ticonderoga*, the lighthouse used to be on an island, the thirty-five buildings are New England structures ranging from a 1733 saltbox to a Vermont jail built in 1890, and the replica of the New

York apartment represents the New York home of the museum's founder, Electra Havemeyer Webb.

The Shelburne Museum is not a reconstructed New England village, despite the fact that its contents could easily become one, it is instead an outdoor museum that adorns its grounds with lilac and rose bushes, stands of apple trees, and lawns. It has a variety of New England farmhouses, an 1840 Methodist church, an old general store, an up-and-down saw mill, and a blacksmith shop. They are not placed together in such a way as to be visually linked one with another, so that each structure stands on its own and can be appreciated for itself. While there are many paintings and objects of great beauty, there is none of the cuteness that could easily accompany such a display. The buildings, their hearths, the barn, the blacksmith shop all make plain the fact that eighteenth- and nineteenth-century New England life was tough. The implements that were used for a variety of different chores are at once beautiful in their simplicity and visibly practical as well.

In 1913, at the age of eight, Electra Havemeyer Webb bought a wooden cigar store Indian—the first piece of the future museum. At that time no one collected "Americana." No one bought naïve American painting or folk handicrafts or even practical old-fashioned objects. Electra Havemeyer was the first to do it. Although she and her mother had very different ideas of what constituted art—Electra Havemeyer never laid any claim to being an expert on it—they did share a profound enthusiasm for collecting. Her mother, Louisine Havemeyer, was the wife of the owner of the American Sugar Refining Company, which at one time controlled most of the sugar production in the United States. For advice her mother turned to Mary Cassatt, the Philadelphia-born painter and friend of Edgar Degas. With Mary Cassatt's help, Mrs. Havemeyer and her husband acquired a vast collection of art, the bulk of which they later donated to the Metropolitan Museum of Art. When Mrs. Havemeyer died in 1929, however, certain paintings went to her children. Some of the best of these can now be seen in the Memorial Building at Shelburne.

In 1947, J. Watson and Electra Havemeyer Webb founded the Shelburne Museum to exhibit Mrs. Webb's "collection of collections," gathered over forty years. The museum also received her husband's family collec-

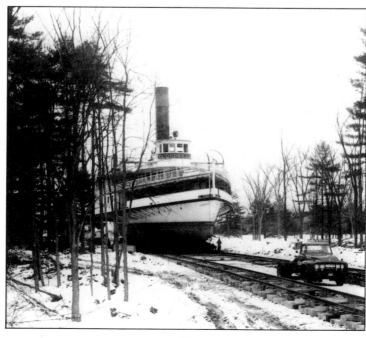

The S. S. Ticonderoga was pulled through the snowy Vermont forest on its last journey— a 65-day overland crossing. It ended on April 6, 1955, when the last stretch of railroad tracks reached the Shelburne Museum.

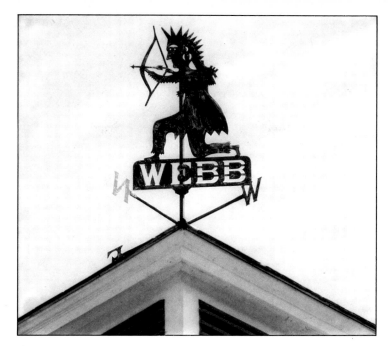

A weathervane atop the horse-shoe barn, at the Shelburne Museum, celebrates the name of the museum's founder: Electra Havemeyer Webb.

on of carriages and sleighs, which had been stored in he coach barn of Shelburne farms.

For the next thirteen years Electra Webb directed the onstruction of the museum. Under her supervision, uilding after building from places as distant as East orset, Vermont, and East Canterbury, New Hampshire, as transported along New England roads to Shelburne nd placed into the landscape as though they had always been there. A back porch with its step lying a fraction of an inch off the ground, its floor timbers aslope, eems as though a generation of kids had crossed it, unning from barn to barn. An apple tree stands opposite the back of the house, the color of its pink lossoms in contrast with the rust-red of the house.

The most incongruous and striking of the Shelburne isplays is the side-wheeler *Ticonderoga*, which the 'ebbs removed from the lake instead of sending it to he scrap pile. Launched in 1906, the *Ticonderoga* was he last Lake Champlain steamer in service. Landocked today, it is the sole surviving example of the vercal-beam vessels that were once such a common sight n the lake. With time, Shelburne came to acquire the own's railroad station, a steam locomotive, and one of he last covered bridges in Vermont, which now stands t the entrance to the museum.

A connoisseur of American arts and crafts, Electra 'ebb became one of the principal collecting forces in he country. Her example had considerable influence n such fellow collectors as Abby Aldrich Rockefeller nd Henry du Pont. Over the decades Electra Webb massed some 180,000 items, prompting a New Enlander to comment that at Shelburne Americana is as nick on the ground as geese in a corn field after the arvest.

Electra Webb didn't much care about taste. She cared bout a quality deeper than that: a love of beauty. While eople may have horrendous taste, the love of beauty well-nigh universal. That is why Vermont farmers anted graceful weathervanes, why merchants put up andsome looking trade signs, why sea captains anted carved figures on the prows of their ships, and hy farm girls decorated their quilts with beautiful patrns. This was why Electra Webb collected the weather anes, the signs, the figureheads, and the quilts. She ved workaday things that made life more beautiful for hose whose lives were often circumscribed and

laborious.

Mrs. Webb kept on collecting. As she recalled two years before her death in 1960, "I filled a house with collections and my attic, of course, was a wonderful place." Her son-in-law recalled the hazards of chasing a deep lob at the tennis court building where Mrs. Webb once kept her "junk," as her family called it. "You were in danger of breaking your leg over a sidelined carousel horse," he said.

Among her acquisitions was a painting collection that spans three centuries of American life. It ranges from anonymous primitive work to academic painting by nineteenth- and twentieth-century American artists. It also has a collection of textiles, including a quilt collection ranked best in the United States. There are also hand-woven rugs, lace, and white-on-white embroidery, a part of ladies' dresses in the 1820s.

The Stage Coach Inn, from Charlotte, Vermont, houses a collection of wood sculpture that includes many examples of the American eagle, ships' figureheads, cigar store indians, and shop-front characters. The Prentice House, from Hadley, Massachusetts, is furnished with eighteenth-century cookware. Similarly, the Vermont house is filled with examples of America's best furniture; Hepplewhites, Chippendales, and Queen Anne pieces are included.

At the founding of the museum there was considerable local ambivalence about the project. That vanished when the museum was opened in 1952. It was obvious that Mrs. Webb had paid a warm and eloquent tribute not only to the resolute forebears of Vermont but also to the vigor and craftsmanship of all of early America.

Shelburne Museum is an all-American project that delights in the unexpected. On these grounds, one becomes a time-traveler and stands inside the past.

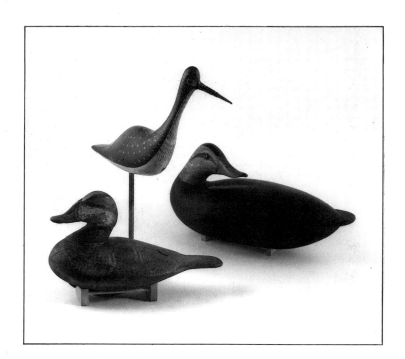

Wild duck decoys from the extensive collection at the Shelburne Museum. Left to right: Puddy duck by Lee Dudley, Knotts Island, Virginia, circa 1890. Witlet, by an unknown maker, circa 1900. Black duck by Albert Laing, Stratford, Connecticut, circa 1870.

2

THE STONES
OF METROPOLIS

In the Italian garden of the Phipps Estate at Old Westbury, Long Island, a pergola arch frames a winter landscape.

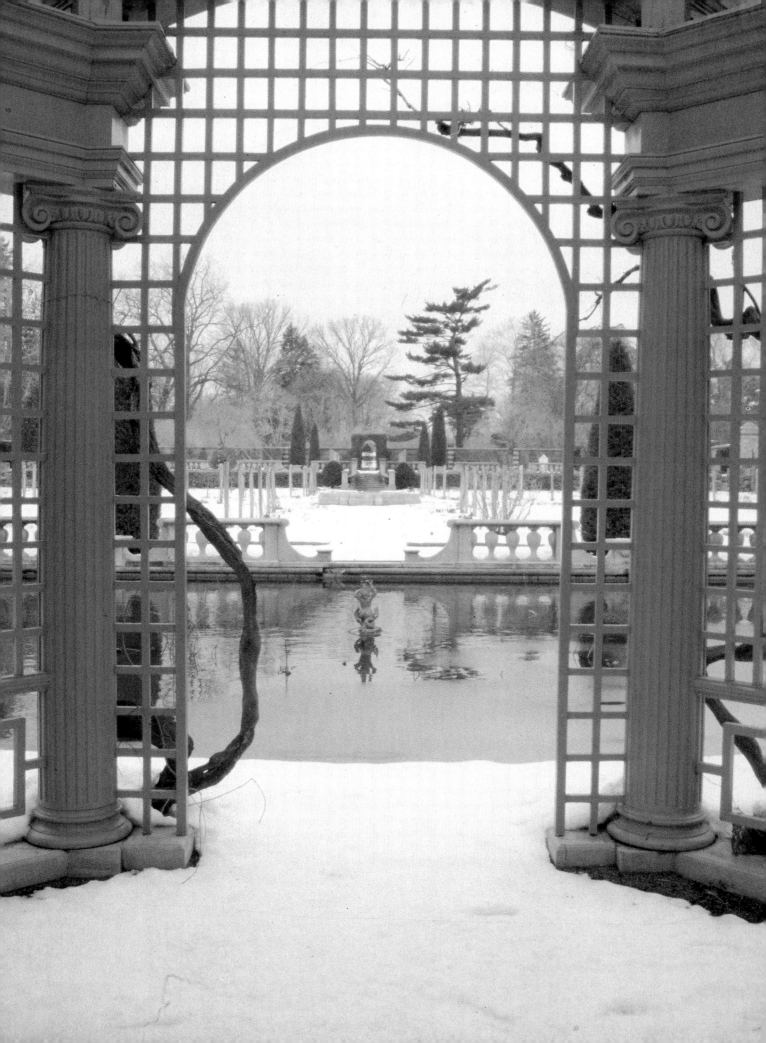

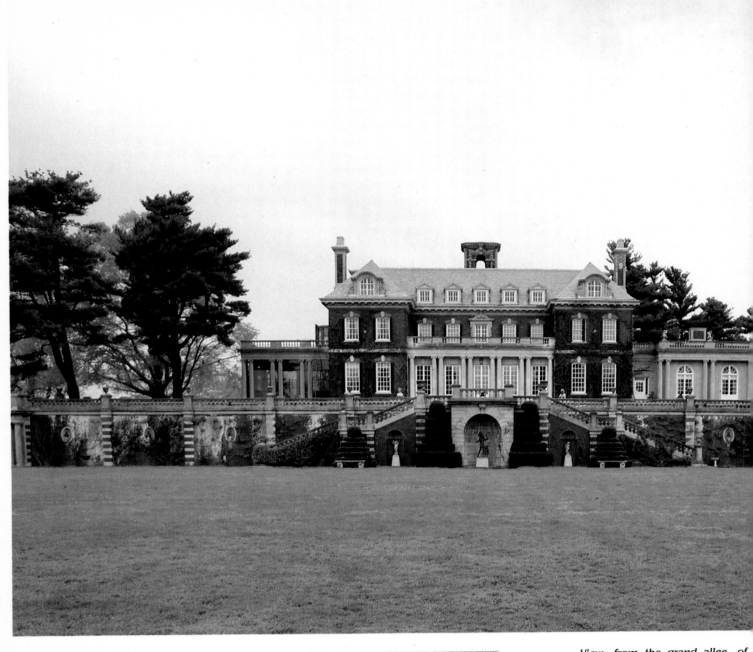

View, from the grand allee, of Westbury Manor, built in 1905 by John Phipps and designed by the English architect George Crawley.

A primrose path under the trellis leading to the rose garden.

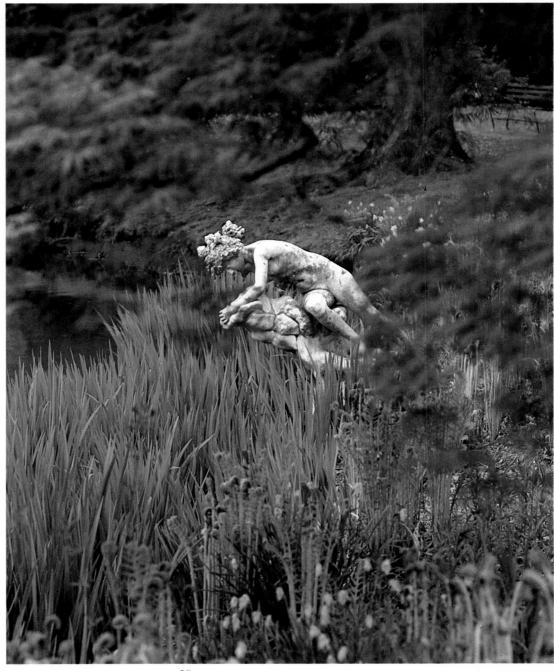

A nymph statue by the West pond.

Shell mosaic, reflected in the winter waters of the pool at Old Westbury Gardens.

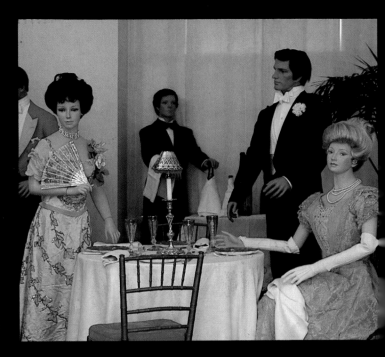

Costumed mannequins recreate the Midnight Hunt Supper of 1912. Such tableaux are a seasonal event at Westbury Manor.

Two tulip blossoms in the Italian garden.

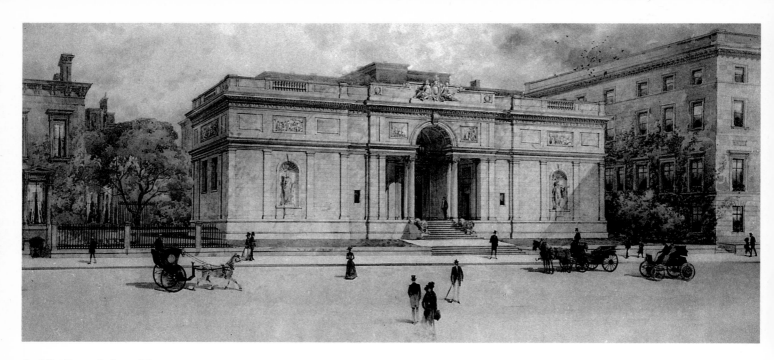

Architect's rendering of the street façade, made in 1902 by McKim, Mead and White. Originally built as a private library, it became public in 1924.

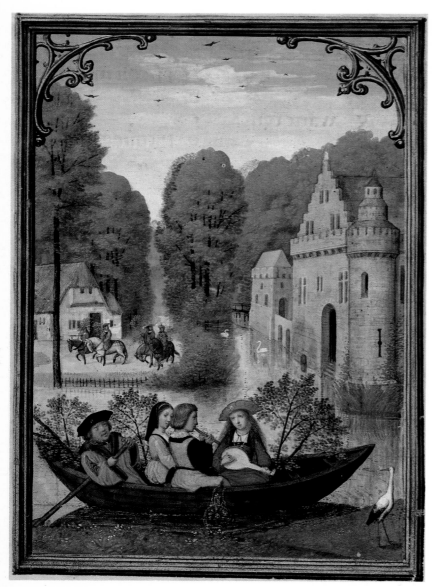

Among the many rare manuscripts in the Pierpont Morgan Library is this illuminated calendar-page for the month of May from the da Costa Book of Hours, Bruges, 1515.

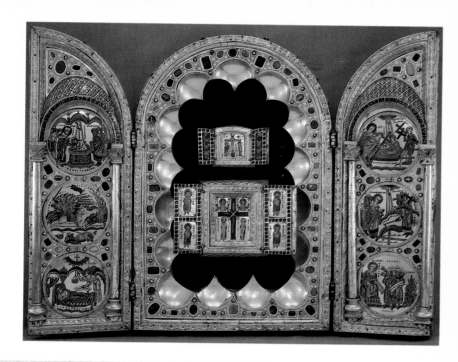

The Stavelot triptych, made for the abbot Wibald of Stavelot (1155—1156) is an important piece from the collection of the Pierpont Morgan Library.

Complete double-page zodiac with a small Atlantic hemisphere in the center, from a manuscript atlas written and illuminated by Baptista Agnese, circa 1550.

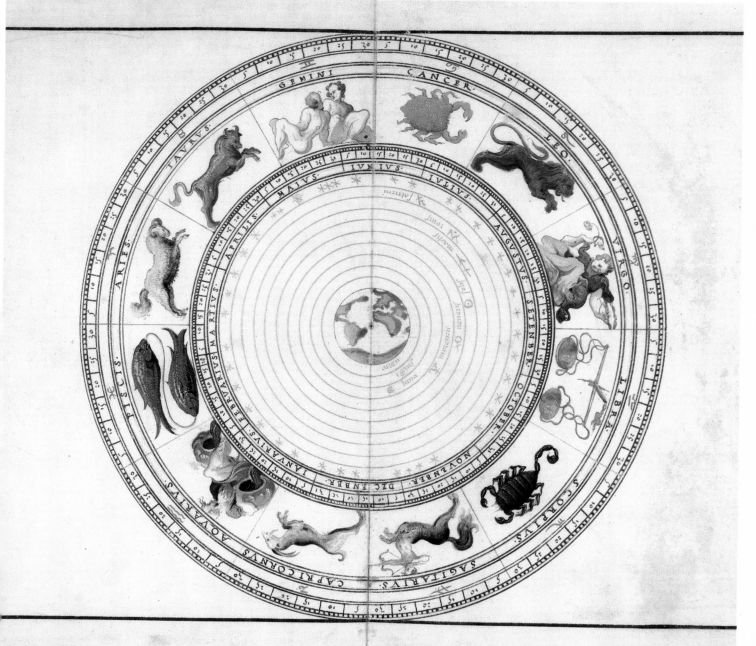

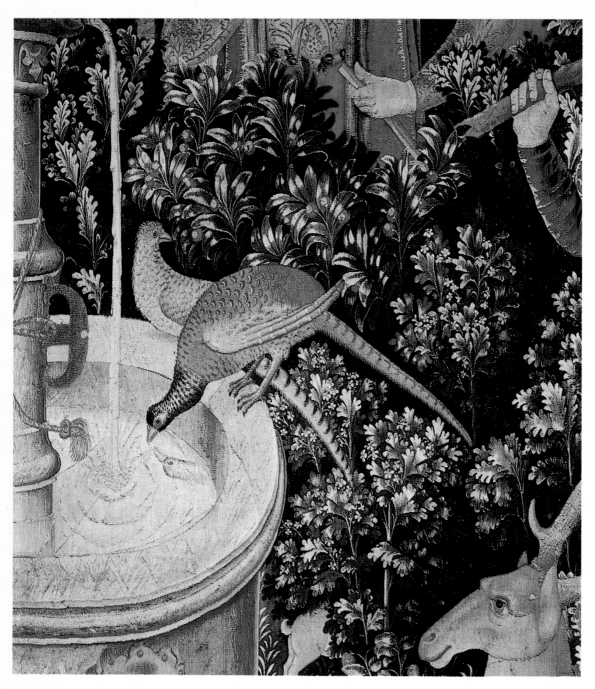

Detail of the Unicorn Tapestry, from the extensive collection of medieval tapestries held at the Cloisters.

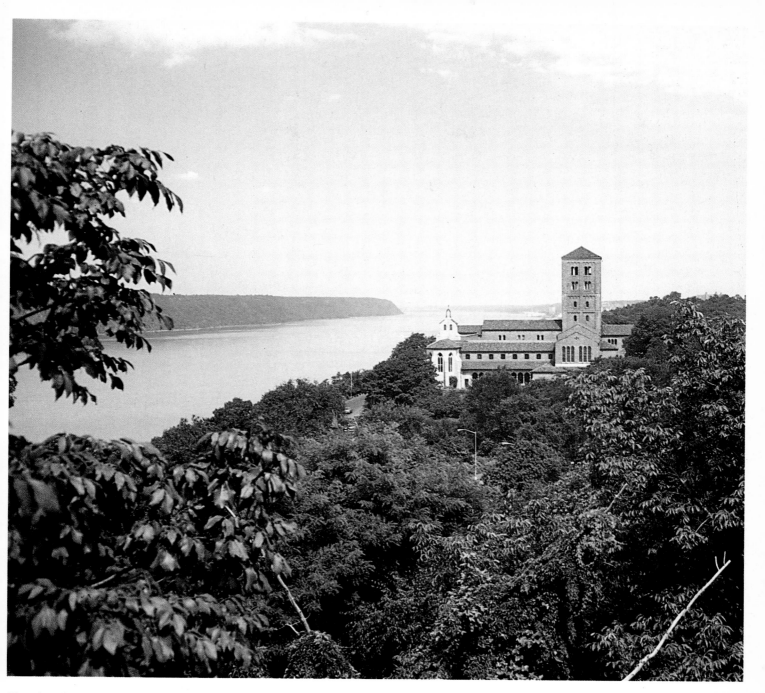

The site of the Cloisters, atop a hill overlooking the Hudson, was donated to the Metropolitan Museum by John D. Rockefeller, Jr. He also donated the funds for the purchase of the Barnard Collection, to which he added some forty medieval sculptures from his own collection.

The George Washington Bridge is visible from the North arcade of the Bonnefont Cloister. These columns and capitals were part of the vast collection of medieval architectural material of the American sculptor George Grey Barnard.

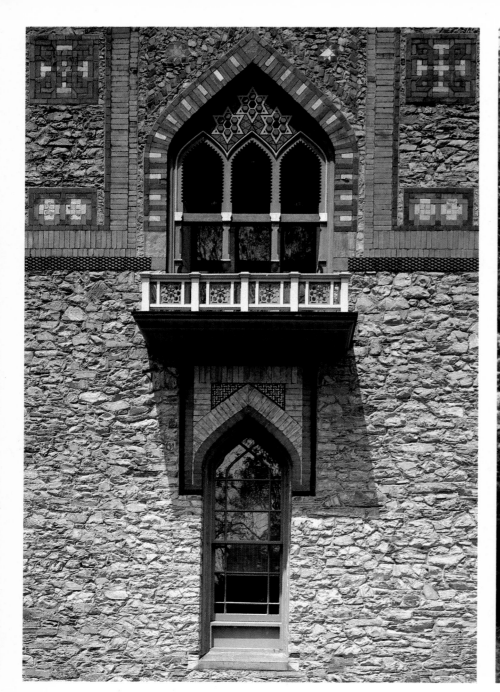

Detail of Oriental design from the façade of Olana, designed and built by Frederic Edwin Church, a leading member of the Hudson River School.

The Hudson River Valley and Catskills as seen from Olana.

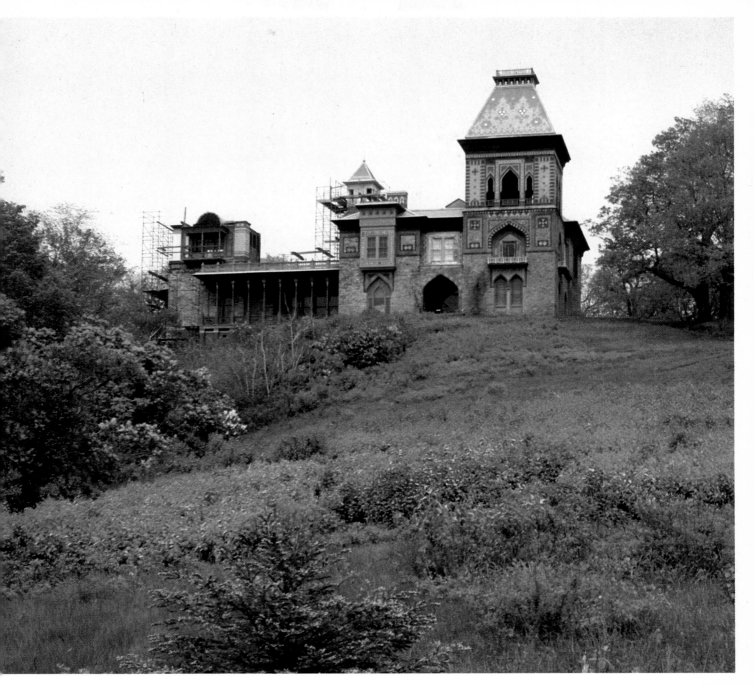

View of the house, built in 1872 atop a hill overlooking the river.

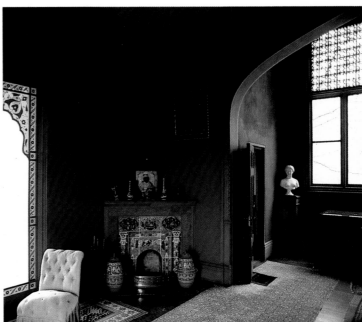

The living room and study of Frederic E. Church still contain many of his canvases.

The library at Caramoor comes from a château in Aveyron. The vaulted ceiling depicts scenes from the lives of Old Testament heroes and the furniture is mostly European from the seventeenth and eighteenth centuries.

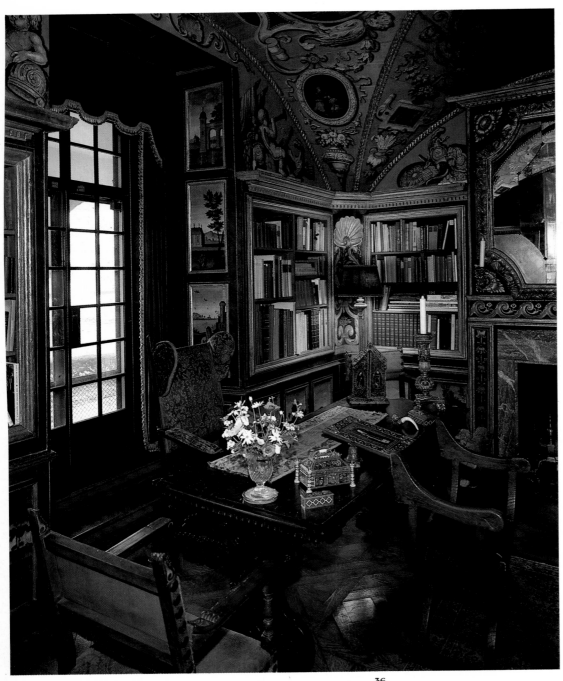

Walter and Lucie Rosen have devoted the major part of the 150-acre estate to orchestral concerts, operas, ballets and lectures.

Caramoor's wrought iron gates from Verona, Italy, are flanked by two horse heads by Malvina Hoffman.

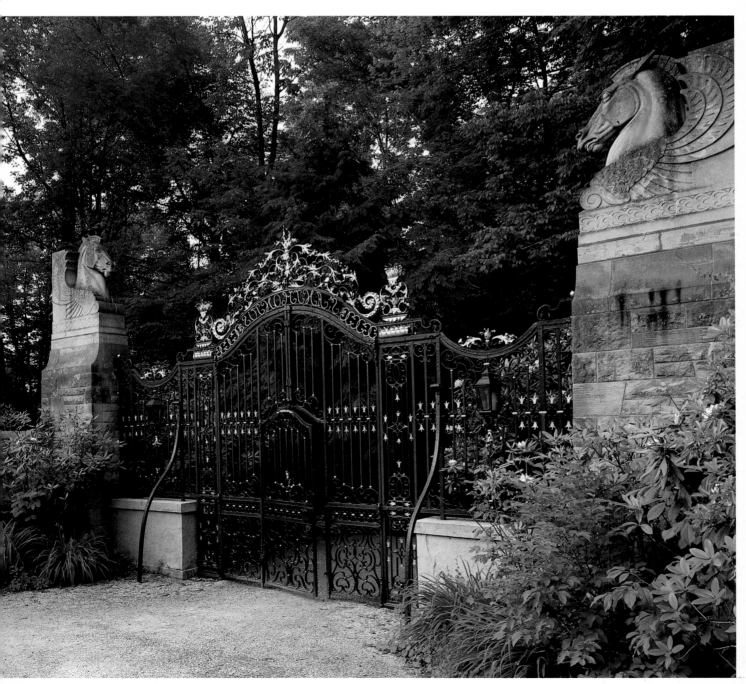

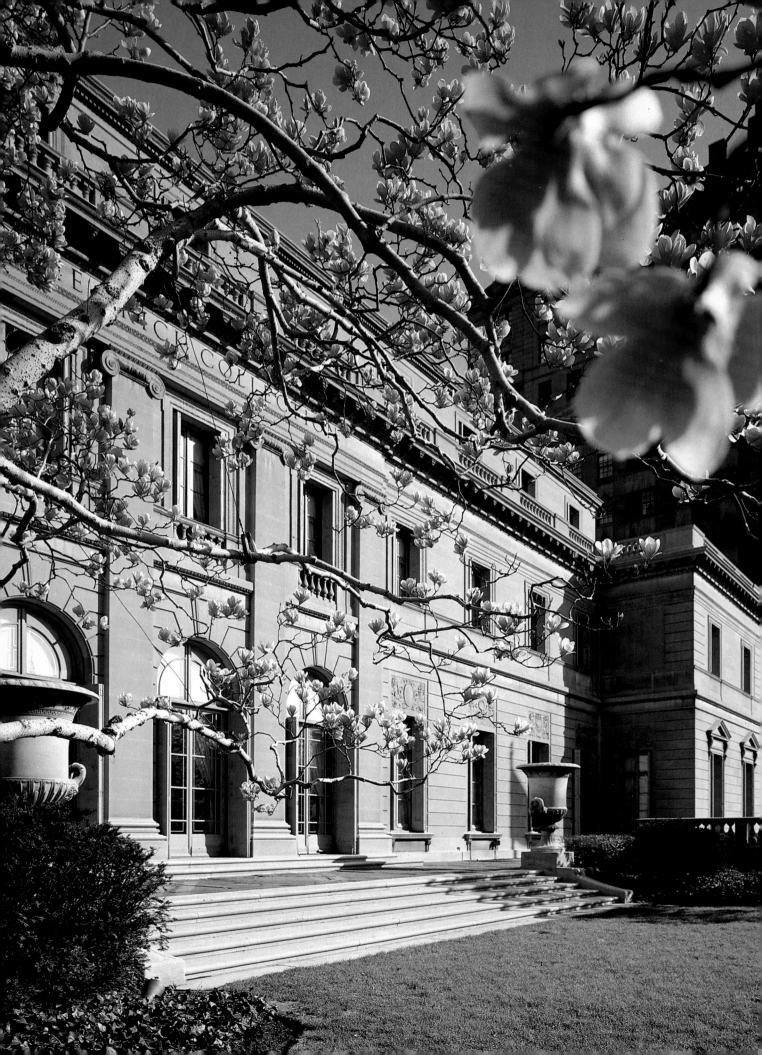

The mansion that houses the Frick Collection was built in 1913–1914 by Henry Clay Frick as his residence. The original architect of the mansion was Thomas Hastings. When later structural changes, including the addition of a new wing, were made to convert the house into a museum, the services of other architects were required.

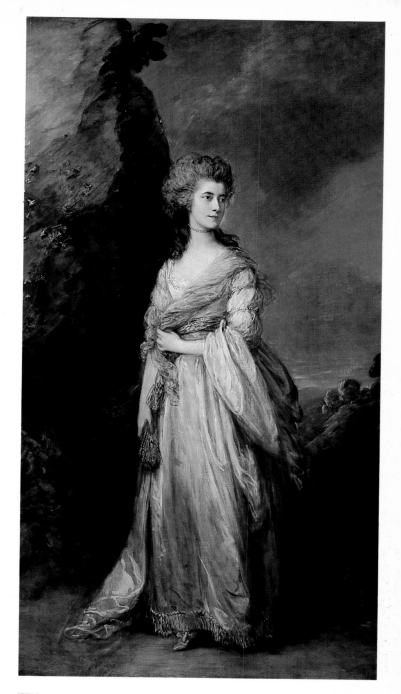

Thomas Gainsborough's portrait of Mrs. Peter William Baker was painted in 1791.

The Boucher Room has eight panels by François Boucher depicting "Arts and Sciences" as personified by children. Executed in 1750–1753 possibly for Madame de Pompadour's château of Crecy.

following page:
In 1928, the architect Horace Trumbauer designed Shadow Lawn for Hubert T. Parsons, the President of the F.W. Woolworth Company. The mansion in West Long Branch, New Jersey, is now part of the Monmouth College campus.

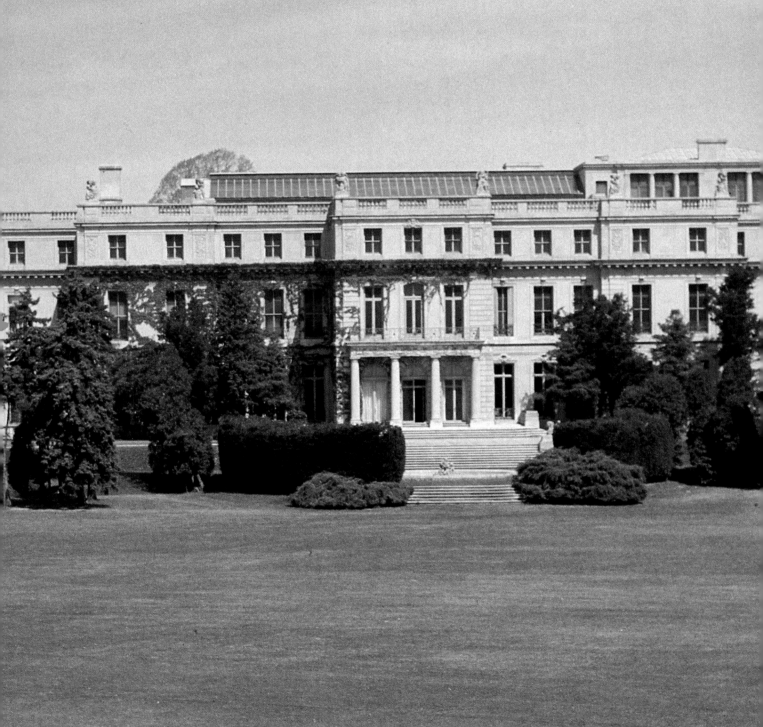

2

THE STONES
OF METROPOLIS

OLD WESTBURY GARDENS

John Phipps created a thoroughly English country manor and estate on Long Island to make his British wife feel at home in the United States. Marguerita Grace was born in Battle Abbey in England, and Old Westbury Gardens was designed to make her feel as though she had never left her homeland.

Today, Old Westbury Gardens is a restoration of a recreation. Built in 1906 and opened to the public in 1959, Westbury is an exceptionally fine example of the sort of houses and grounds that graced Long Island's renowned Gold Coast in its heyday. The estate encompasses a hundred acres of artfully landscaped woods and fields. Masses of rhododendrons lead up to a lily pond surrounded by a boxwood hedge that was a hundred years old when it was brought from Virginia in the early 1900's. In the old days the only way to reach the island in the middle of this pond was by swan boat. A shell grotto, created in 1969, is one of the few recent additions to the grounds. The walled gardens, planted with two acres of perennials, are the finest examples in this country of the English herbaceous border. These acres of stillness are an oasis of beauty among the jammed freeways, subdivisions, and shopping malls of Long Island. One of the greatest display gardens in the United States, Old Westbury is only twenty-five miles from New York City. The planting of the garden is scheduled to show it always in its prime, and the woods are cut through with grand allées, like those in a well-kept European forest. In autumn, Westbury has a great advantage over its English models, for our flaming foliage is unknown across the Atlantic. The estate is now owned and operated by the Old Westbury Gardens Foundation, of which Mrs. Etienne Boegner, the Phippses' daughter, is president. The house is maintained very much as it was when Mr. and Mrs. Phipps lived there. Each year one room recreates, with astonishing costumed mannequins, a tableau representing a social event in Westbury's past. Two of these were "The 1912 Hunt Ball" and "Clothes worn on Long Island in the 1900s for Croquet, Tennis, and Polo."

Very few of the ostensibly "English" houses in this country were actually designed by English architects, and Westbury House, which was created by the well-known English architect George Crawley, is a noteworthy exception. The mansion, with its unobtrusive columns and its profusion of white window-frames, is rectangular and roughly symmetrical in plan, with a regular facade and slightly projecting wings. Set on a high terrace, its broad lawns spotted with huge solitary trees, Westbury has a comfortable air, as though it had been there for centuries.

The interiors of Westbury House were also done by George Crawley, and the furnishings came from Joseph Duveen. The latter remained much as they were when the Phipps family was in residence; where substitutions have been made, they are scarcely noticeable. The portraits by Reynolds, Gainsborough, and Sir Henry Raeburn may have come from Duveen, but they are subordinate to the decor. In the English manner, the emphasis is upon ease and comfort rather than formal beauty. Everything dates from the nineteenth century with the exception of such family portraits as *Mrs. Henry Phipps with Her Grandchild* by John Singer Sargent. The abundance of flowers makes the house seem inhabited even today.

Westbury House is exceptionally warm and welcoming: the terracotta bricks on the walls and along the paths glow red in the sunlight and the roof-slates, imported from England, have a golden tone. A shaded loggia leads to the bright rose garden and the children's playhouse. The Ghost Walk is a reminder of a walk at Battle Abbey, where each tree stands for a dead monk.

John Phipps was an enthusiastic sportsman. He built an estate without fences in Long Island's finest polo and fox-hunting country: an area which, with its grand oaks and perennials, is as "English" as any America has to offer.

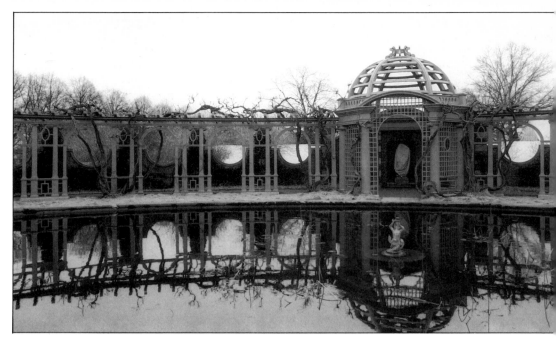

An autumn scene at Old West-bury Gardens, the gazebo re-flected in the pond of the Italian garden.

THE PIERPONT MORGAN LIBRARY

New York offers the greatest concentration of fine collections to be found anywhere in this country, and the Morgan Library is outstand-ing even in this company. It represents the only surviving section of the Morgan Collection, once the greatest in the world. Still in its original building and still associated with the family of its founder, the Morgan is this nation's preeminent treasurehouse of rare books, medieval and Renais-sance manuscripts, and Old Master drawings. In the trade, referring to something as being of "Morgan quality" means that it is absolutely first-rate.

Even today, more than a century after it became a public institution, the library retains the special character given it by Pierpont Morgan, whose pas-sion for collecting began early in life. In 1851, when he was fourteen years old, Pierpont Morgan asked President Millard Fillmore to send him his auto-graph—now found in the library among the finest collection of autographs in the world. And when, several years later, young Morgan studied in Switzerland and Germany, he acquired the frag-ments of medieval stained-glass that are now built into the library's West Room.

Pierpont Morgan was very much a man of the world—our Edward VII, whose tastes he shared. In his early years he was too occupied with business to be able to devote much time or energy to collecting, for from the time of his father's death in 1890 he was sole manager of the family business, J.S. Mor-gan and Company. So powerful was the House of Morgan at the end of the nineteenth century that it served as an important monetary backer of the French government in the Franco-Prussian War; at home, Pierpont Morgan was the lynchpin of this country's economy—a role no other single individ-ual has ever played, and one Morgan played to the hilt.

After Morgan turned fifty, he began to spend money with the same passion he had previously used to acquire it. On top of the nation's largest fi-nancial empire he built the world's largest art collec-tion. It included an unrivaled holding of medieval and Renaissance decorative arts, the rarest old

books, and superlative Old Master drawings. Mor-gan rarely bought single pieces, however fine they might be; he bought whole collections, the best in their field. Nobody could compete with him, for he simply outbid his rivals, dominating the art market as completely as he did financial markets. He was, in fact, our only imperial collector, spending 51 per cent of the profits of one of the world's most profit able banks to build his stupendous collections. A his death in 1913, Morgan's art holdings were ap praised at $60 million—perhaps $6 billion in to day's market—while all his other holdings wer valued at a mere $8 million more.

Books were Morgan's greatest passion. One of the first purchases he made after his father's death wa a Gutenberg Bible, and soon thereafter he acquired an equally important volume in the history of print ing, a Psalter printed in Mainz in 1459—for which Morgan paid what was then a record price for a printed book. He bought four Shakespeare folios and the manuscript of Dickens' *A Christmas Carol* which he read to his children every Christmas. He late acquired all the manuscripts Byron had given to hi mistress Countess Guiccioli, and he bought a grea number of the manuscripts and letters of Ruskin. He also assembled the country's most important collec tions of fine bindings, of early Italian presses, and o French medieval manuscripts. He bought hundreds o Rembrandt's etchings, most of the medieval manu scripts that had belonged to the designer William Mor ris, and everything he could find printed by William Caxton, the first English printer. He eventually owned the manuscripts of nine of Sir Walter Scott's novels and all the letters of the kings and queens of France tha came on the market.

As the result of these and other purchases, one of the rooms in Morgan's house on 36th Street in Manhattan became so jammed with books and art that one could barely get into it—and in 1900 Morgan asked the archi tectural firm of McKim, Mead and White to build a li brary next to his house. This light and airy Renaissance palazzo was designed by Charles F. McKim himself, and it is his masterpiece. In 1906, when the building was almost finished, McKim wrote lightheartedly to his part ner Stanford White that Morgan was delighted with it Achieving that had not been simple, for both Morgan

nd McKim were accustomed to having their own way. fter all the architectural drawings had been made, for nstance, Morgan suggested that the height of the uildings be lowered one foot, a change that rankled lcKim. Later, when a fireplace cracked from the heat of ne of the first fires laid in it, Morgan was furious. What oth men wanted was perfection—and that, in the end, ; what they got.

Two years later Morgan took up temporary residence n London, and his house soon became the center of ne expatriate American community there. Among the rominent Americans invited to dine with Morgan in 910 was Nelson W. Aldrich, chairman of the U.S. Montary Commission. As Aldrich's biographer, Nathaniel tephenson, reveals, Morgan used the occasion of a inner attended by Aldrich to get his guests "deeply inerested in his famous collection of pictures. He told nem he wanted to give it to the Metropolitan Museum, ut under the Tariff Law as it then stood, getting the ictures into the United States would cost one million nd a half dollars in the way of duties." The very next ear Aldrich altered the Tariff Bill to permit the importaon of art duty-free. Among other things, this cleared ne way for Morgan to purchase the Old Master drawngs belonging to the English collector Fairfax Murray; /ith this important addition, the Morgan Library immeliately assumed first place in this field of American ollecting.

Elected president of the Metropolitan Museum, Morjan treated it as part of his expanding collection. This /as not altogether unreasonable, as he intended to eave his entire collection to the museum at his death. Roger Fry, an English art critic who was also, for a time, urator of paintings at the Metropolitan, found Morgan nfuriating, for Morgan expected Fry to work just as ard for him as he did for the museum. When Morgan ook for himself a painting by Fra Angelico that Fry had ought for the museum, the latter wrote a stern letter f protest—on which Morgan scribbled "This is the nost remarkable letter I have ever received. I do not ropose to answer it."

Fry eventually left the Metropolitan—at Morgan's beuest—yet even Fry had to admit that a great boom now existed in the art market in the United States, and t existed largely because of the stimulus provided by Morgan. As Henry James wrote at the time, "There was noney in the air, ever so much money . . . and the noney was to be all for the most exquisite things."

In 1904 Morgan began a campaign to fill the Metroolitan Museum's board of directors with members of is own choosing, among them Henry Walters, Henry Clay Frick, John G. Johnson, George F. Baker, and Edvard Harkness—making this not only the most exclusive club in New York but also the richest. For all the ower Morgan wielded, both personally and through his andpicked board, the museum declined to accept his collection without the promise of funds to build a new ving to house it. This matter was not resolved in Morjan's lifetime, and at his death the greatest of all American collections was therefore dispersed. His son sold ome of the 4,000 medieval and Renaissance works of rt Morgan had amassed, with others going to the Vadsworth Atheneum in Morgan's native Hartford, Conecticut. The library was the only part of the collection hat remained intact.

In 1928, fifteen years after Morgan's death, his son added an annex onto the library. Designed by Benjamin Vistar Morris, this addition fits beautifully with McKim's original structure. One of its ceilings was painted by H.

Siddons Mowbray, who had painted the frescoes on the ceiling of the original library. All the frescoes are obedient to Pierpont Morgan's dictum that the decorations of a library should whisper, not shout. The annex contains a reading room and a gallery that is used today for scholarly exhibitions. The Morgan is a working library for scholars as well as a museum, however, and the curators of the institution continue to add "Morgan quality" purchases to the collection in all areas related to the museum's interests.

Pierpont Morgan's study was located in the so-called West Room of the main house. Francis Henry Taylor, a former director of the Metropolitan, once called this study one of the seven wonders of the Edwardian world. The room has been left exactly as it was in Morgan's day. Here many a great trust was formed, and here the financial panic of 1907 was stopped dead in its tracks. The study's mantelpiece was carved in Renaissance Florence, and the sixteenth-century frescoes on the ceiling also come from northern Italy. Three of the rarest paintings in the room are by the Flemish master Hans Memling, and the portraits of Martin Luther and his wife are by Luther's friend Lucas Cranach the Elder. A great deal of gold and enamel is on display—and, all in all, this remains a room fit for America's greatest merchant prince.

THE CLOISTERS

The Cloisters is the most magnificently sited museum in America. On a woody hill near the tip of Manhattan, facing the Palisades across the Hudson, this modern monastery, a branch of the Metropolitan Museum of Art, is a monument to George Grey Barnard, the artist who gathered the greatest American collection of medieval sculpture and architectural fragments. This last enchantment of the Middle Ages dominates the northern end of the island as the twin towers of the World Trade Center dominate the southern extremity.

James J. Rorimer, director of the Metropolitan, arranged the Cloisters in the 1930s, working with Barnard, the architect Charles Collens, and John D. Rockefeller Jr., who funded the project. The museum is as special in character as it is valuable for its holdings. It was designed not only as a place to display the hundreds of pieces in the Barnard Collection but also as a modern "monastery-citadel" incorporating several French cloisters as well as medieval columns and capitals, vaulted chapels, carved staircases and tapestries. The overall effect is one of architectural harmony and authenticity, and the visitor is hard-pressed to believe that this thoroughly medieval enclave is a creation of the 1930s.

Many of the museum's holdings came from the Gothic Museum that Barnard had founded and that was situated not far from where the Cloisters now stands. When commissions for Barnard's own large-scale sculptures had not come in fast enough, he turned to collecting French medieval sculpture on an enormous scale. In time, Barnard became by far the most important medieval dealer in the world. What is at the Cloisters today is the cream of his collection and the largest sale he ever made.

Barnard's earliest patron, who bought or commissioned all his early enormous works, was Alfred Corning Clark, an heir to the Singer Sewing Machine

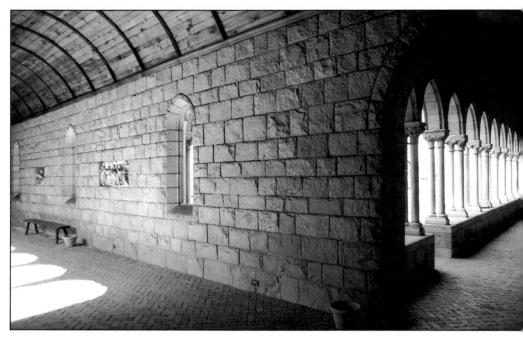

The west arcade of the Cuxa Cloister meets the vaulted gallery of the Bonnefont Cloister at the Cloisters, New York.

fortune. Unfortunately, Clark died at an early age in 1896. Seventeen years later Barnard took Clark's two sons on a tour of Europe. Both of them were to become important collectors: Robert Sterling Clark now has a museum named after him in Williamstown, Massachusetts, and Stephen C. Clark has divided his collection among the National Gallery, Yale University Art Gallery, and Cooperstown, New York, which he turned into a virtual museum in itself.

In time the Clark family's patronage of Barnard was replaced by that of another, far wealthier family. John D. Rockefeller, the founder of his family's fortune, was not known as a collector, but in an unprecedented gesture he bought Barnard's crouching statue, *The Hewer*, which was six feet tall. To go with it, he took an equally large nude, *Primitive Woman*. Apparently, John D. admired Barnard's sculpture as much as his son, John, Jr., admired Barnard's collection. Although he was one of the successful sculptors of his day, Barnard was more famous as a dealer in medieval sculpture.

Roger Fry, who continued to advise the Metropolitan Museum on acquisitions even after he left the museum, wrote of Barnard in 1906: "I must say I am profoundly impressed by his understanding of French Gothic sculpture. He has shown me things in the Louvre which, according to him, he offered to the [Metropolitan] Museum in times past for a mere fraction of the sums the Louvre subsequently gave and, if his account is correct, and I see no reason to doubt it, the Museum might have had the very finest works of French Gothic sculpture now in the Louvre . . .". Fry noted that Barnard was "at the head of quite an elaborate organization of chercheurs" who ransacked small country villages and peasants' houses for medieval treasures."

In 1906, when Fry wrote the passage above, the museum was negotiating to buy the cloister of Saint-Michel-de-Cuxa from a site in the Pyrenees. A year later Fry wrote to Sir Purdon Clarke, the director of the Metropolitan, "Mr. Barnard's cloister is quite complete, I believe, and is said to be a superb example of Romanesque art. Also, I believe the French government tried to make it a *monument historique,* but were just too late"—and so the Metropolitan acquired Saint-Michel-de-Cuxa.

A few years later Barnard's Gothic Museum opened The medieval historian Kingsley Porter called it "th most beautiful museum I have ever seen." In 192 John D. Rockefeller, Jr., bought the museum's who collection. He also provided land and money for a ne museum that would incorporate the Metropolitan cloister of St. Michel, Rockefeller's collection of med eval sculptures, and Barnard's treasures. St.-Michel-de Cuxa became an important component of The Cloi ters, along with the reconstructed cloisters of Sain Gulhem-le-Desert, Trie, and Bonnefont.

The art collection at The Cloisters covers the entir range of Medieval treasures. Its religious art objects in clude precious chalices and reliquaries, magnificen stained-glass windows, rare illuminated manuscript and a large number of statues. The best-known piece in the collection are the so-called Unicorn Tapestrie The Cloisters was probably Rockefeller's favorite pro ject. He even bought a long stretch of the Palisades, th bank of the Hudson River across from the Museum, t keep it free of buildings and preserve the Cloister: view.

OLAN

Frederick Edwin Church painted the mos spectacular paintings of the nineteenth cen tury in America and lived in the most spec tacular house of any American artist. Churc came from Hartford, Connecticut, Pierpont Morgan' home town, and his first admirer was Danie Wadsworth, the founder of the Wadsworth Athe neum, the oldest art museum in the United States Church was a widely-travelled artist, but his whol career was bound up with the Hudson River, and h built his Moorish castle on its shores, where h spent his last twenty years.

With Wadsworth's assistance, Church became th only pupil of Thomas Cole, the founder of the Hud son River School, our first national style of land scape painting. Of this School of the Sublime Church was the peak, to use his favorite moun taineering terminology. Cole and the artists of th Hudson River School painted the glories of th United States, for they believed, as Cole said, tha "the most distinctive, and perhaps the most impres

sive, characteristic of the American scenery is its wildness. It is the most distinctive, because in civilized Europe the primitive features of the scenery have long since been destroyed or modified".

But Church extended the range of American painting far beyond the Hudson. His spectacular and vastly successful *Niagara* caught the public fancy, and at Mount Desert in Maine he painted sunsets of impossible brilliance. Because of his admiration for the German traveller and scientist Alexander von Humbolt he went to South America, where he lived in Humboldt's house in Ecuador and climbed the peak of Chimborazo in the Andes, which Humboldt had been the first to climb. Hunboldt was a tremendous inspiration to Church and his whole generation, for he created the romantic image of Latin America just as James Fenimore Cooper and the French writer Chateaubriand had created the image of the Noble Red Man.

Church's paintings of the South American landscape like *Cotopaxi* and *The Heart of the Andes* were unbelievably popular. Church also travelled extensively in the Arctic, where he saw the City of God in the icebergs. Later he travelled extensively in Europe and the Middle East, painting the marvels of man after the marvels of nature.

Fortunately, Church also earned a great deal of money, and he spent his remaining years in the glorious Oriental dream-house which he had built just outside Hudson, New York. Olana, as he called it, is one of the most fantastic structures in the United States, far more exotic and colorful than anything in Morocco. He had planned the house in consultation with his friend the architect Calvert Vaus. Church himself designed the grounds, with a lake to lighten the large areas of shadow created by the woods. Interested in the effect produced by sunlight and its potential to enhance a landscape, Church also created views of the river that are framed by trees and brought to life by the play of light.

Olana was finished in 1874. Church had every reason to look forward to a continuation of his heroic career for the rest of his natural life, but instead Olana was the witness—and, we hope—solace of his long decline. It is brilliant as a rainbow, inside and out, with bright tiles in bold patterns and swooping roofs like a flight of swallows.

As Marshall Davidson says, "Church's 'Persianized' mansion near Hudson, New York, still stands, a reminder of his extensive travels, his creative imagination, and the considerable fortune amassed from his painting. It carried exotic eclecticism about as far as it was possible to do, borrowing heavily from Near Eastern designs." "I can say," Church himself remarked, "as the good woman did about her mock turtle soup, 'I made it out of my own head.'"

As Kidder Smith has observed, "Olana, the opulent home of Frederick Edwin Church, presents a dramatic composite of Western and Near Eastern architecture. . . . Acting to a large extent as his own architect and decorator, and taking advantage of his ample resources, he wove into the exotic design of Olana, inside and out, ornamental forms and themes from far places and distant ages. Oriental, Islamic and European cultures were enthusiastically combined in a grandiose Victorian manner. The exterior walls of its towers, porches and gazebos are highly ornamented with colored tiles and glazed brick. To Church, Olana was the center of the world. 'And,' he added, 'I own it'".

The ornate gates of Caramoor in Katonah, New York, with their filigree work and their flecks of gilding, have been open to the public since the end of World War II—so that superior performances of superior music may be enjoyed in superior surroundings. Lucie Bigelow Rosen, the inspiration for and the patroness of these alfresco concerts, liked to say that it all began when she fell ill in Europe in 1927 and wistfully asked her husband if she might have a small house with a garden in her own country, where she could feel at home. Caramoor is what she got, and it proved to be rather more than what she asked for. The property at Katonah, in one of the most beautiful parts of Westchester County, was acquired in 1927, but the house itself was not ready until 1939.

Walter Tower Rosen, Lucy's devoted husband, was born in Germany in 1875 and brought to New York by his family when he was ten. He went to Harvard, became a lawyer, and joined the investment firm of Ladenburg, Thalman and Company, of which he became a senior partner. The consuming passions of Walter Rosen's life were music and art. From the time he was a small boy until he was admitted to Harvard College, he practiced the piano every morning before breakfast. In Boston, he was introduced to Mrs. Jack Gardner of Fenway Court, and one of the blessings of knowing "Mrs. Jack" was the privilege of being able to practice the piano at her house. Rosen's frequent visits to Fenway Court confirmed his interest in Italian Renaissance works of art. When he finally established himself in business, he turned to collecting with great passion.

In 1914 he married Lucie Bigelow and together they began a tradition of musical evenings. The musicales that ensued at their house on 54th Street in Manhattan were to feature the greatest performing artists of the day. When the Rosens moved to Caramoor, they brought the tradition of the weekly musicale with them.

The main house at Caramoor was built to contain Walter Rosen's collection of paintings and decorative arts. Like so many of the great houses of that generation, its inspiration is North Italian, enriched with a fanciful eclecticism. Included in his collection are Tiepolo doors from the Palazzo Rezzonico in Venice, Louis XVI furniture, Italian bronzes, and Chinese ceramics. A piece Rosen particularly treasured is a statue of Justice attributed to the school of Andrea Riccio and made in Padua about 1490. According to Michael Sweeley, president of Caramoor, Mr. Rosen made a point, before he went off to work in the city, of visiting his favorite objects. In 1970, two years after Lucy Rosen died, the house itself was opened to the public. In 1974 a new wing was added to house the works of art that had been in the Rosens' house in New York City. These included Lucas Cranach's painting of *Mary Magdalen* and della Robbia's *Adoration of the Infant Christ*. A feature of that house were period rooms, precise in virtually every detail, and these also were transported to Katonah and reassembled at Caramoor, where one can find the superbly carved Jacobean bedroom that once graced the Rosens' Manhattan residence. The other period rooms range in style from medieval to neoclassical and in provenance from northern Italy to southern England. Notable among them is a black and gold lacquer room

from the Palazzo Ricasoli in Italy.

The exterior of Caramoor is a picturesque jumble of Italian rustic architecture, with gardens that seem to be straight out of a tale by the Dominican monk Bandello. But the tall chimneys with their classical temples on top look more Portuguese as do the rugged tile roofs.

Today the Caramoor Music Festival is a significant part of the New York musical season. Chamber music concerts are given in the estate's Venetian Theatre and, during the summer, symphonic performances are heard in the Spanish courtyard. In 1977 a celebration held to mark the Silver Jubilee of Queen Elizabeth II featured several works by Benjamin Britten, with *The Rape of Lucretia* performed under the artistic direction of Albert Fuller.

The success of Rosen's legacy is explained by Robert Sherman, program director for one of New York's leading classical music stations: "Again and again through the years, I have marveled at the stunning artworks in the house, the spectacular gardens, even the sprawling lawns. The memories tumble over themselves, but they leave me feeling exceptionally lucky to have partaken of so much beauty." He concluded, "that is at the heart of it all—beauty. Beauty, not only in the music itself, but of music in totally harmonious surroundings, music in an ambiance of dignity and grace that brings to mind earlier times, other places. How wonderful to preface a Bach Cantata by standing before the gorgeous stained glass doors of the House Museum, to listen to a Haydn Divertimento in much the same sort of courtly environment Franz Josef knew himself. To hear the Strauss Sonata punctuated by the swoops and cries of birds at twilight."

THE FRICK COLLECTION

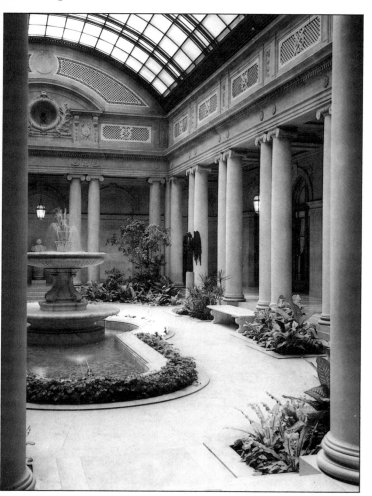

The Garden court of the Frick Collection, formerly an open carriage way of the Frick residence, was designed by John Russell Pope. It houses Jean Barbet's bronze Angel, *dated 1475.*

Were you to ask any well-travelled tourist to name his favorite museum in the United States, the chances are that he would answer "The Frick," one of the few residences in New York that remain as evidence of an era when millionaires did not have to share their wealth with the government.

Unlike Morgan, Frick was not born to great wealth. His family owned a small interest in Old Overholt, then as now a leading brand of rye whiskey, but Frick made his own fortune in the Pittsburgh of Andrew Carnegie and the Mellons. Henry Clay Frick began working at the age of seventeen in his uncle's store and later became a bookkeeper for Old Overholt at one thousand dollars a year. In the financial debacle of 1873 he bought coke ovens and coal mines at panic prices.

Frick's interest in art dated from a very early age. At twenty-one he borrowed money from the Mellon bank in Pittsburgh to expand his coke-manufacturing company. The credit report, which was drawn up by Andrew Mellon's father, read in full: "Lands good, ovens well built; manager on job all day, keeps books evenings, maybe a little too enthusiastic about pictures but not enough to hurt; knows his business down to the ground; recommend making a loan." Within a few years Frick became "The King of Coke," a millionaire known for his dislike of labor unions as well as for his culture and generosity.

Frick made his first trip to Europe—in the company of Andrew Mellon—in 1880. Stimulated by what they saw on this trip, both men began forming private collections around Old Master paintings,

which they later bequeathed to the cities of New York and Washington, D.C., respectively. From 1895 to 1900, Frick bought more than one painting a month. He bought the works of such successful painters of the day as Bouguereau, and he bought works by Pittsburgh artists of the 1870s. He also bought contemporary European paintings, among them a few pieces from the Barbizon School and, more remarkably, works from the School of The Hague, Van Gogh's precursors. He later acquired several paintings of the French Impressionists, which he mingled, in his typical fashion, with works by Millet and Corot.

After Morgan formed the U.S. Steel Corporation—into which Frick's company was amalgamated along with many others—Frick retired from active business and devoted himself to his enormous investments and his growing collection. In 1901, the year U.S. Steel was formed, Frick bought a Turner, a Monet, and a Vermeer. His El Greco was one of the first in an American collection. Frick occasionally bought through Roger Fry, then a curator at the Metropolitan Museum; among these purchases were an early fifteenth-century French Pièta, two important Veroneses, and the *Polish Rider*, Rembrandt's enigmatic portrait of an unknown young man in a Polish costume whose meaning is still not ascertained despite the many treatises written on it. Today its historical significance may be lost but its haunting power remains, a clue to human destiny and frailty. Fry was also responsible for the sale of one of Holbein's greatest portraits, *Sir Thomas More*. More than a work of art, it is an icon of British history. For all Fry's involvement in Frick's activities, the retired industrialist continued to buy most of his paintings from Knoedler. After Pierpont Morgan's death in 1913, Frick became America's leading collector—in part because, when the Morgan collection was sold, Frick had first choice of those treasures. That year he began plans for a mansion that could house his growing collection. The building was designed by Carrère and Hastings, architects of the New York Public Library—which includes the Lenox Library, which formerly stood on the site of the Frick collection. Frick had gotten the idea for the whole ensemble—building, paintings, and French furniture—from the Wallace Collection in London.

Duveen sold Frick many of the furnishings for his splendid residence on Fifth Avenue. Duveen was one of those characters, like W.C. Fields or Mark Twain, around whom stories gather, and his role in the formation of the Mellon Collection has been similarly exaggerated. According to Harry Grier, the former director of the Frick, the role of the legendary dealer Joseph Duveen was not all that important, "for Mr. Frick's first purchase from Duveen was not made until 1910, by which time he had set his course as a collector and made many of his brilliant acquisitions."

Frick's adviser in selecting his magnificent Renaissance bronzes, Limoges enamels, and Chinese porcelains—most from the Morgan Collection—was Belle de Costa Greene, director for many years of the Morgan Library. According to Elsie de Wolfe's autobiography, the decorating of the Frick family's living quarters was entrusted to her. She wrote that Frick paid her 10 percent on everything she bought—far below her usual commission—but Frick nonetheless proved to be her best client. While she was working on the Frick mansion, the incredible collection of Lady Sackville came on the market. She had been left a Paris house and all its contents by her protector, Sir John Murray Scott. He had inherited this greatest of all collections of French furniture from Sir Richard Wallace, founder of the Wallace Collection in London. Scott's pieces included a number of items said to have been made for Marie Antoinette.

Legend has it that Frick, a fanatical golfer, refused to cancel a scheduled game to look over the Sackville furniture with Miss de Wolfe. She finally persuaded him to give her just half an hour, and in those thirty minutes he bought, for three million dollars, what would become the greatest collection of French furniture on the American continent.

The building that houses the Frick Collection looks like one of the graceful and dignified palaces of Europe. The interiors, on the other hand, are eclectic in style. Everything is the best; even the clock at the foot of the grand staircase is the finest Louis XVI clock in the world, probably made for the king himself; the Boucher Room is said to have been painted for Madame Pompadour. The most remarkable room in the building—and perhaps the most remarkable roomful of paintings in America—is the Fragonard Room. It contains fourteen panels of the finest Fragonards; the four principal panels were ordered by Louis XV for Madame du Barry. Duveen had bought this room in toto from Morgan's estate for $600,000—and then sold it to Frick at cost. After Mr. Frick's death in 1919, he left the Fifth Avenue residence to his wife, Adelaide Childs Frick, for her lifetime. Following her death in 1931, John Russell Pope was retained as architect to alter the residence for public use. At that time the Garden Court, with its pool and ordered rows of columns, was added.

In accordance to Henry Clay Frick's will, the display of the art works in the museum is intimate. The only part of the building that feels like a museum are the main galleries—and even there every effort has been made by the Frick's board of trustees to create a homelike atmosphere. Today the Frick Collection is maintained by a large endowment from the founder himself. Visitors to the museum tend to agree with the eminent French composer François Poulenc, who divided his praise evenly between "those beautiful paintings and the extraordinary building which houses them." He once said: "Of museums, the one I love best in the world—and I have visited many—is the Frick Collection in New York . . . Since I have a visual memory, it is this museum which has most often comforted me."

SHADOW LAWN

Hubert T. Parson's mammoth mansion in West Long Branch, New Jersey, is often described as the American Versailles. Parson's 128-room extravaganza, Shadow Lawn, set on 108 acres in the center of this country's oldest seaside resort, is clearly French in inspiration, and its hulking scale and rigid symmetry owe more to the Sun King's palace at Seine-et-Oise than to the graeful châteaux of the Loire Valley that inspired George Vanderbilt's Biltmore. But while this mansion's nickname is not inaccurate, it is inadequate—for Parson's Shadow Lawn is not merely a grand-scale residence, it is also a *folie* of colossal proportions. It is, in fact, an American Shangri-La—and it could easily have served as F. Scott Fitzgerald's inspiration for his classic short story, "The Diamond as Big as the Ritz."

Parson made his vast fortune a nickel at a time—

quite literally, for he began his career in retailing as Frank W. Woolworth's assistant, at twelve dollars a week. Over four decades he rose from office boy in Woolworth's "five-and-ten-cent" notions shop to president of a worldwide chain of 2,400 stores. In 1919, the same year that he was made chief executive officer of F.W. Woolworth, Parson paid an even one million dollars for Shadow Lawn, a manor house built at the turn of the century by the president of the New York Life Insurance Company and used by President Woodrow Wilson as a summer White House. When fire gutted this mansion in 1927, Parson and his wife replaced it with a three-story limestone pleasure dome embellished with forty-six varieties of petrified wood and marble, 1,500 mirrors, wrought-copper balconies, and gold-plated plumbing fixtures. Construction took two and a half years, and the final cost to Parson was nearly $9.5 million in Depression-era dollars.

The amenities at Shadow Lawn included a 300-seat theatre, an indoor swimming pool of Pompeiian inspiration, a rooftop solarium of ersatz "Aztec" design, two bowling alleys, and a nine-hole golf course. The servants' wing alone contained thirty-five bedrooms and twelve baths. Each of the seventeen principal bedroom suites drew its decor from a different design source—Chinese, Japanese, French, Italian, and Spanish—and the adjoining bathrooms and dressing rooms carried out these national themes.

The central feature of Shadow Lawn is its great hall, one hundred feet long, three stories high, and capped by a leaded-glass skylight illuminated at night by thousands of inset electric bulbs. So cavernous that heating it required ninety tons of coal a month, Shadow Lawn proved a burden to the Parsons as the Depression deepened, and when taxes on the property rose to $24,000 annually in the 1930s, the couple simply closed up the great house and moved back to New York. When the bill for back taxes reached $132,000, the borough of West Long Branch foreclosed, and Shadow Lawn, the very definition of the white elephant, passed from owner to owner before becoming the home of Monmouth College in 1956.

What Monmouth acquired was not only one of the largest but one of the most fanciful private residences ever built in the United States, for Shadow Lawn is as whimsical as it is ornate. Its built-in bathroom scales are so sensitive that they will register a human heart beat, its closets so large that one must use a built-in staircase to reach the second level. An electronic communications system includes hidden buttons, set into the walls at convenient spots around the house, that once permitted Mrs. Parson to play Shadow Lawn's enormous organ from whatever room she happened to be in at the time. A more practical design feature is found in the kitchen, where two walk-in safes were provided for the table silver and silver and gold serving pieces.

Silver and gold, marble and petrified wood, Pompeiian and Aztec motifs—a fantasy worthy of Fitzgerald's fictive potentate, and an astonishing reminder of what money can do, when amassed, one nickel at a time.

3

THE PATH OF
AN AMERICAN DYNASTY

Façade of the Wilson-Warner House in Odessa, built by David Wilson in 1769 and donated to the Henry F. du Pont Winterthur Museum by a later owner, Mary Corbit Warner, in 1969.

Pergola and vines in spring at the gardens of the Eleutherian Mills, Winterthur, Delaware.

Garden façade of the Corbit-Sharp house in Odessa, Delaware, built by William Corbit in 1774 and endowed and donated to the Winterthur Museum in 1958 by H. Rodney Sharp. Many of the original furnishings and objects made by local craftsmen are on display.

The kitchen wing of the Wilson-Warner house.

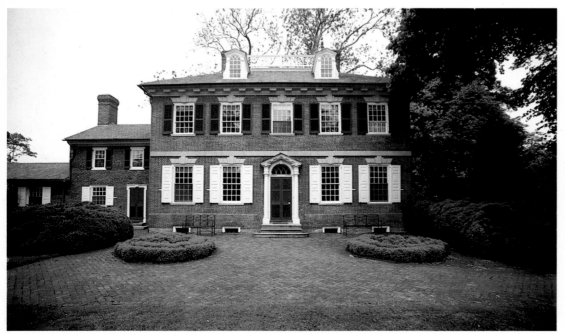

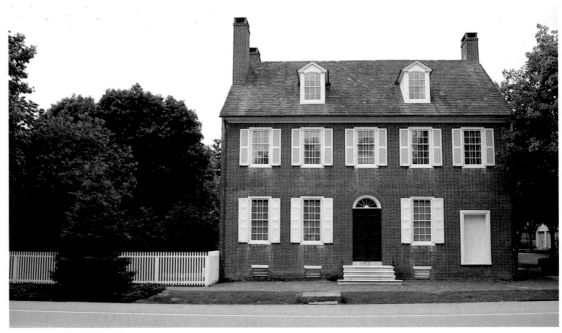

Street façade of the Brick Hotel in Odessa, which houses the Sewell C. Biggs Collection of American painting and silver and Delaware furniture. Built in 1882, it was donated in 1966 to the Winterthur Foundation and opened in 1981.

One of the entrances to Winterthur, which Henry Francis du Pont inherited in 1927 and immediately designated to house his growing collection of American art and crafts.

Winterthur has some 963 acres, which H.F. du Pont, a brilliant landscape gardener, supervised himself.

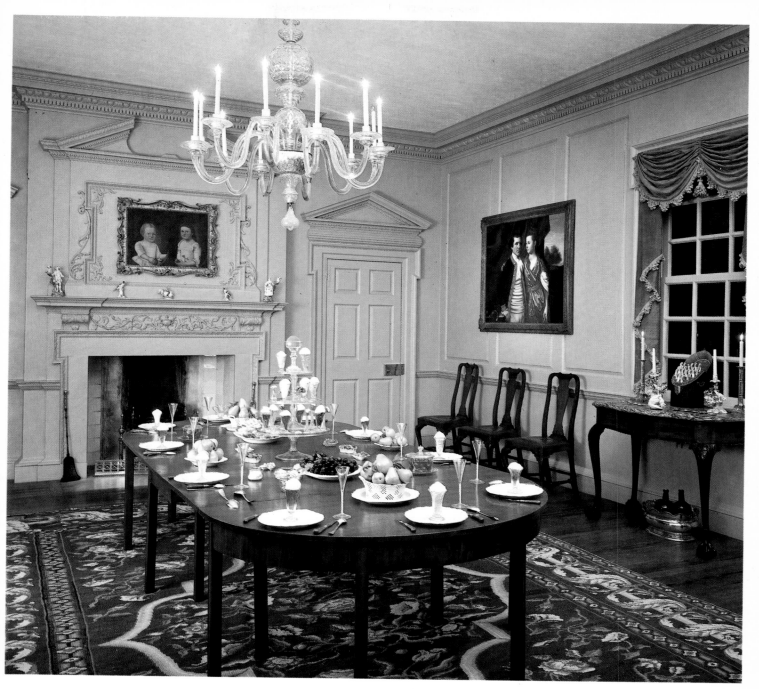

The Charleston Dining Room is among the 196 rooms on display at Winterthur.

The structure of the Winterthur Museum was altered several times to accomodate the du Pont Collection of American interiors. This is a view of the mansion in winter.

The bust of Talleyrand in the French-style garden on the 300-acre Nemours estate in Wilmington, Delaware.

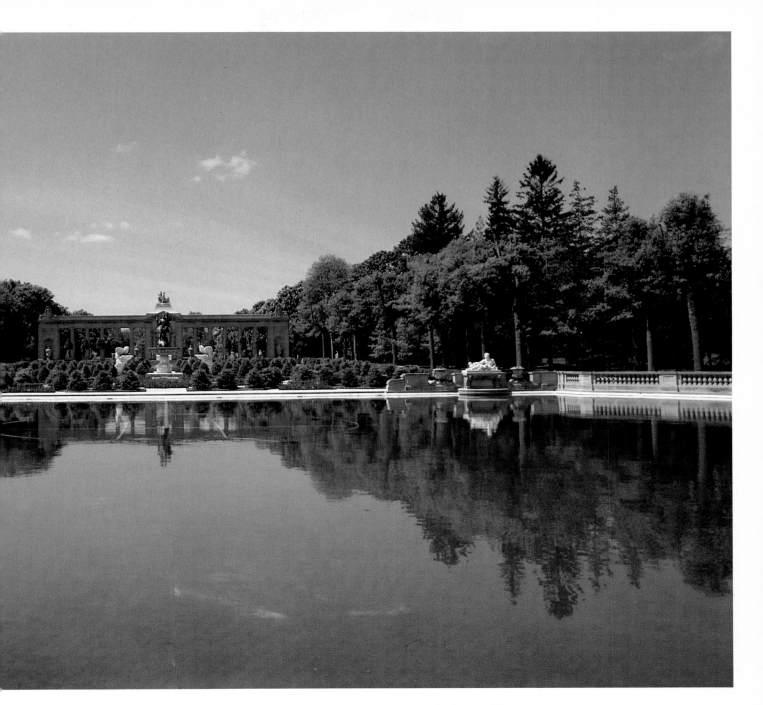

Alfred I. du Pont named Nemours after the town of his ancestral home in France. The gardens, extending one third of a mile from the mansion, are landscaped with pools, statuary and fountains. Nemours is also the site of an important hospital, the Alfred I. du Pont Institute.

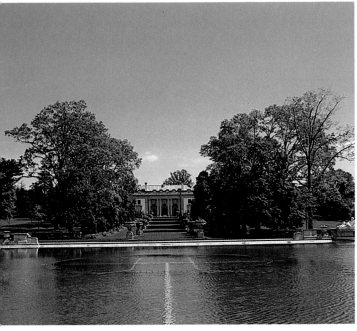

The mansion was designed by Carrère and Hastings, New York, and built between 1909 and 1910. It contains 77 rooms furnished with European art and furniture.

A trellis on the wall of the mansion.

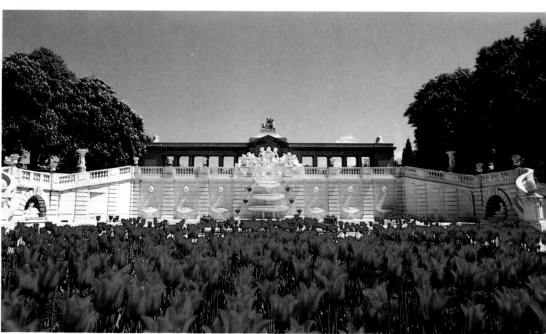

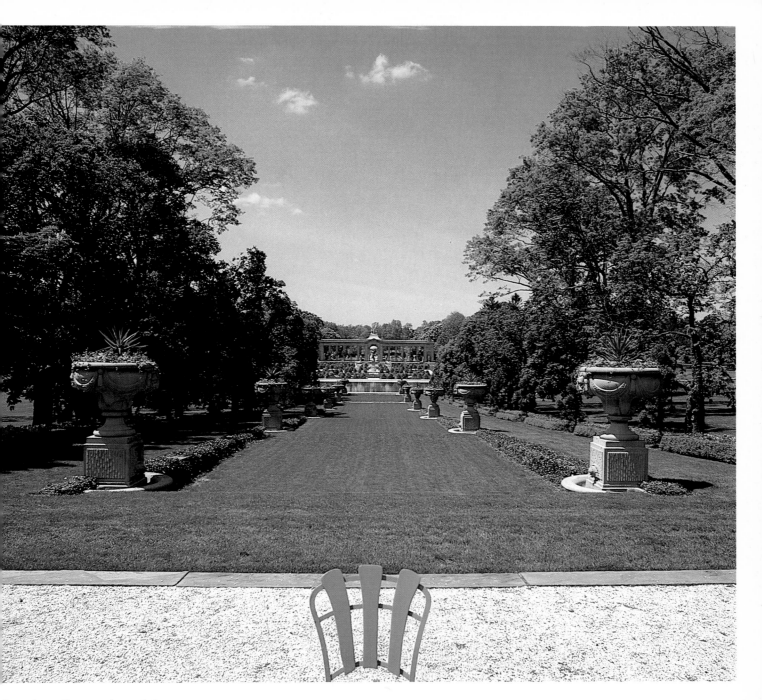

View, from the mansion, of the gardens at Nemours.

following page:
Longwood Gardens, in the Brandywine Valley in Pennsylvania, has been under development since it was purchased in 1906 by Mr. Pierre S. du Pont. He transformed the surrounding farmland into a 1000-acre country estate and garden. Among the conservatories is the Azalea House.

page: 60

Tulips in bloom in the sunken garden at Nemours.

A lake on the grounds of Nemours.

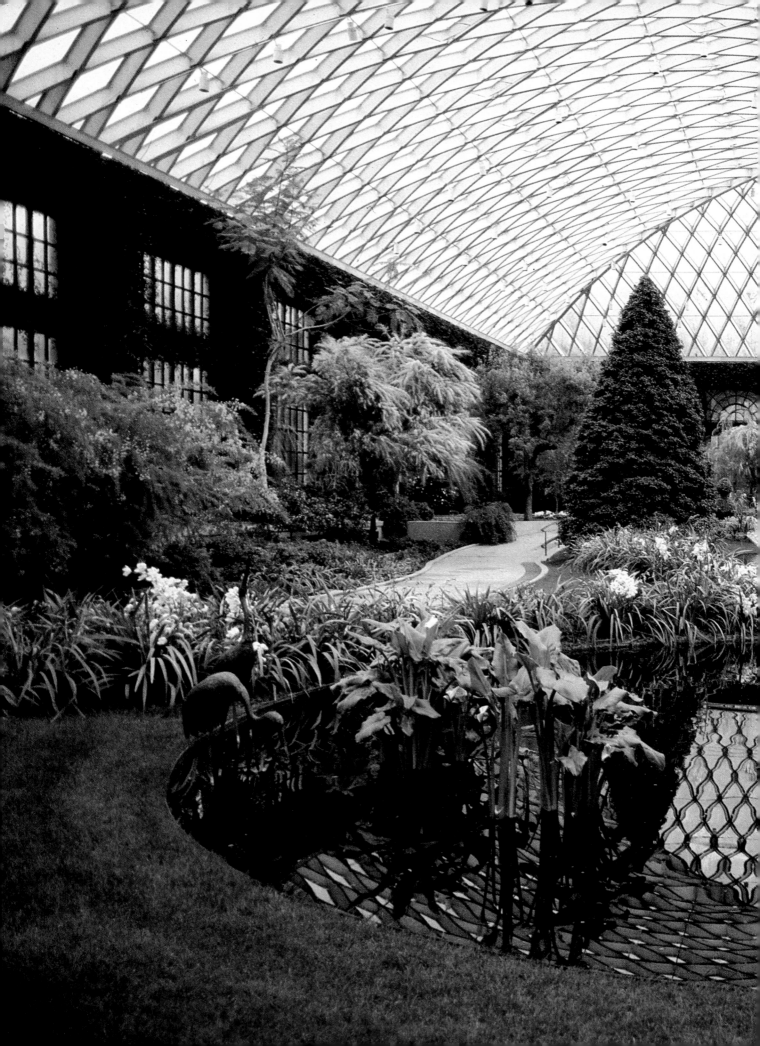

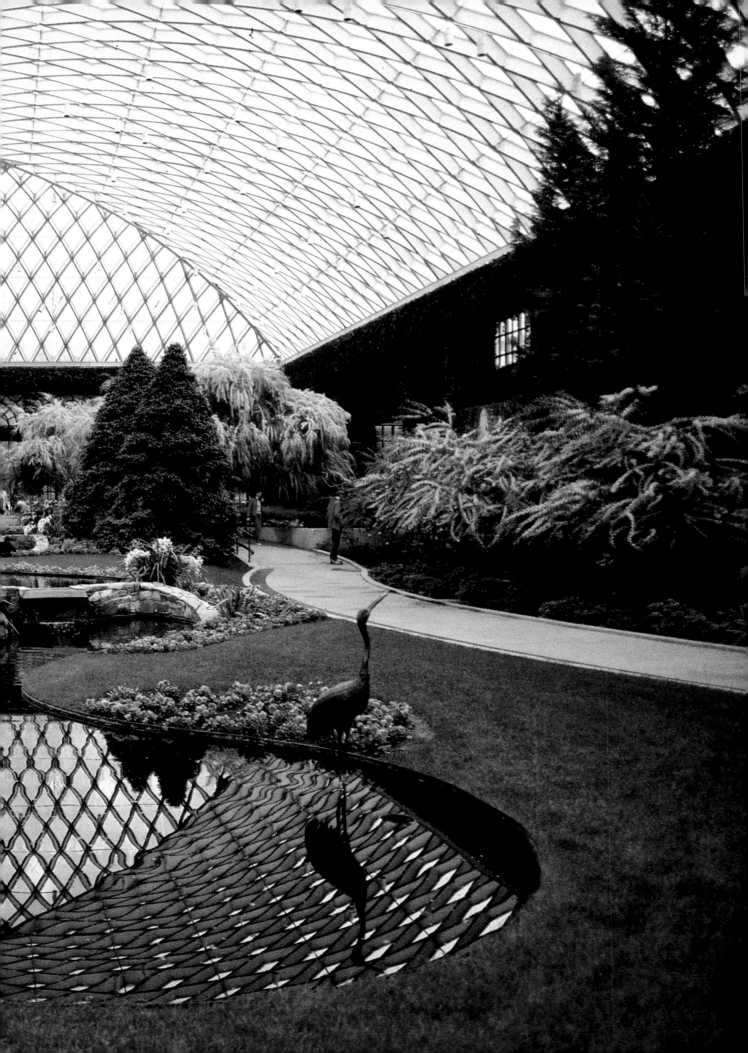

3

THE PATH OF
AN AMERICAN DYNASTY

Delaware, one of the original thirteen states, is technically a state and culturally a principality. The dynasty that controls it is the du Pont family, all descendants of Eleuthère Irenée du Pont. Settling in the Brandywine valley of Delaware in the first decade of the nineteenth century, when Thomas Jefferson was president, the scions of the du Pont family were true merchant princes, inheriting the largest fortune ever amassed in the United States. For six generations they have continued to be patrons of the arts, acquiring with that rarest of combinations, scholarship and zeal.

Although the du Ponts arrived in America as botanists, their importance began when Eleuthère du Pont established a powder mill on the Brandywine Creek. He was the son of Pierre Samuel du Pont de Nemours. At the age of seventeen he entered the royal powder works near Paris, where Antoine Lavoisier, considered to be the father of modern chemistry and an important powder-man, taught du Pont the art of explosives. Lavoisier was arrested during the Reign of Terror that took place after the beginning of the revolution in France, and du Pont went to work managing his father's printing plant. When the du Ponts started printing counterrevolutionary pamphlets the Jacobins closed down the printing house. The du Ponts left for America where, plagued by financial worry, they worked to improve the explosive quality of their gunpowder. Although Eleuthère du Pont's fortunes improved during the War of 1812, they were not sufficient enough to cover his debts. Hardly the kind of man one would imagine a maker of gunpowder to be, Eleuthère du Pont was a romantic whose primary interest was in plants. Before leaving Paris he took a course in botany that meant classes in the Jardin des Plantes at six o'clock. He wrote to his wife, Sophie, living some sixty miles away and taking care of their three children, that, "apart from the interest I have in botany, the thought that I can share it with you, makes it infinitely more delightful to me."

The weave of American cultural history is composed of all manner of collectors. They ran the gamut from thoughtful scholarly men like Henry Huntington, archtypal zealots like William Hearst, to renaissance figures like du Pont. Those who acquired their collections with care and taste were in the minority. And of those, few passed on such standards to their children. The du Pont family has been an exception; theirs has been a tradition of intelligent passion in everything they acquired.

Like the Medici, whose acquisitions came from their own fief and time, the du Ponts have collected nineteenth-century Delaware. Not Renaissance Florence, to be sure, but Delaware did make exceptionally fine furniture and silver, not to mention its elegant eighteenth- and nineteenth-century architecture. These are the cornerstones of the du Pont collection—the best Americana to be found anywhere in the United States.

THE ELEUTHERIAN MILLS

When Eleuthère Irénée du Pont arrived in the United States in 1799, he listed his occupation as "botanist." This was a gross exaggeration if not an outright fabrication. True, he had attended lectures given from six to nine each morning in the Paris Botanical Gardens. He did so also because he, his father, and his brother were planning to emigrate to the United States, which Eleuthère called "the bright new side of the cheese", and it was easier to get a passport as a botanist than as a gunpowder manufacturer or publisher—young du Pont's profession. He heard only eight of these lectures, spending the rest of his time helping his father print the Duke de la Rochefoucauld-Liancourt's *Voyage dans les Etats-Unis*, an influential work that was highly favorable in its assessment of the new nation.

When the du Ponts reached the United States, they planned to establish a settlement of their own, called Pontiana and modeled on Marietta, a colony founded on the far side of the Ohio River in 1788 and named for the late queen of France, Marie Antoinette. But land on the frontier was too expensive, so the three du Ponts settled instead in Delaware, where Eleuthère soon put in a garden at the Eleutherian Mills, site of the family's gunpowder plant. He seemed equally interested in both projects, and he passed these dual enthusiasms on to his children.

Odessa sits on the banks of the Appoquinimink River twenty miles south of Wilmington.

The village is rich in old barns, stables, and other outbuildings, among them a "skinning shack" where muskrat pelts were once dried. What was originally the New County National Bank building, erected in 1853, is now a branch of the Bank of Delaware, and the Odessa Women's Club now occupies the Old Methodist Church, begun in 1791. Several houses and four entire blocks in the center of the village are listed in the National Register of Historic Places. Some of the finest buildings belong to the du Pont family's museums at Winterthur, and all of them have been attentively restored and lovingly maintained. Three of these were donated to Winterthur by H. Rodney Sharp, who devoted much of his long life to the conservation of Odessa.

Sharp was born in Sussex County, Delaware, and attended the state university at the turn of the century. He was one of the fourteen members of the class of 1902. After graduation, Sharp took a job as principal of Odessa's three-room school, having been assured by his predecessor that living in Odessa would be quite pleasant and that he would like the people. Odessa made a powerful impression on Sharp even though he lived in the village for only three years. He moved on to Wilmington to work for the du Pont Company and eventually married Isabella Mathieu du Pont, a sister of the man who created Longwood Gardens.

THE CORBIT-SHARP HOUSE

Rodney Sharp became interested in architecture as a student, and his lifelong friendship with Henry du Pont furthered his interest. Sharp once wrote to du Pont "just to say how much I appreciate all the many things you have done and continue to do to make Winterthur the treasure house of the very best." Shortly after Sharp retired from the company, he heard that the old red brick Corbit house in Odessa was up for sale. He bought it and started to restore the place. Over the next thirty years he was to restore a dozen buildings in Odessa. In 1958, a decade before his death at the age of eighty-eight, he gave the Corbit house to Winterthur. The Corbit-Sharp House, as it is now known, was built between 1772 and 1774. Designed by an architect from Philadelphia in an English style, it has brick chimneys at either end, white shutters on the ground-floor windows, and dark shutters on those above. A "Chinese Lattis" stands between the chimneys as it did when the town was young and known as Cantwell's Bridge.

Today the Corbit-Sharp House is used by the University of Delaware for the study of local history. William Corbit, the builder, left behind a detailed inventory, through which many of the house's original furnishings have been tracked down. Corbit descendants have donated many of these pieces to the house, giving it an authenticity far beyond that of most restorations. In the same spirit, the bathrooms Rodney Sharp installed in 1938 were removed in 1970 and the interior walls of the house were painted dark colors that approximate the original color scheme and give the rooms a Quaker look.

The Hardenberg Bedroom at the Winterthur Museum. The glazed earthenware, made in Delft in the early eighteenth century, stands on the handpainted Ka made in New York during the same period. The canopied bed, made in the United States late that century, is covered with a European linen-and-wool drapery embroidered with a flower motif in silk-and-cotton thread.

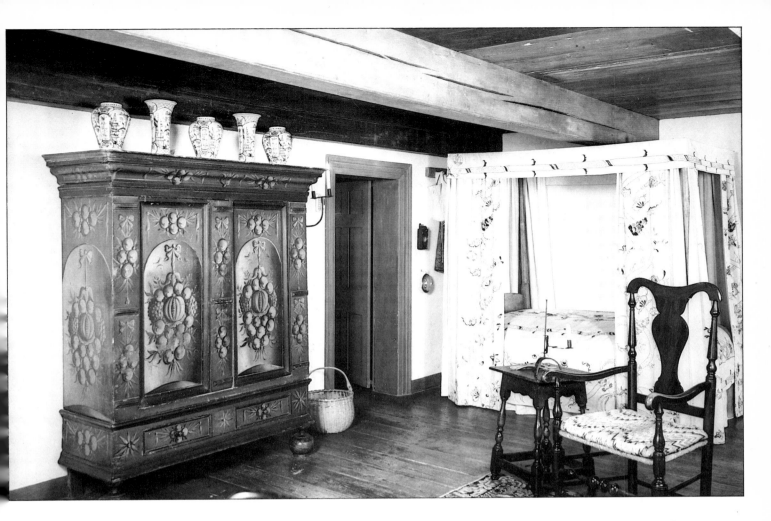

Sharp, with his taste for authenticity, would surely have applauded these changes.

THE BRICK HOTEL

Not far from the Corbit-Sharp House is the Brick Hotel, where Rodney Sharp stayed on his first visit to Odessa. The hotel dates from 1822. Sharp bought it and donated it to Winterthur in 1966, but it was not until 1979 that funds were raised to restore the structure. It now houses the Sewell C. Biggs Collection of American paintings, furniture, and silver. Some sixty canvases are in the Sewell collection, among them Thomas Cole's *Summer Sunset* and Albert Bierstadt's *Niagara Falls*. The collection features landscapes by artists of the Hudson River School and painters from the mid-Atlantic states, especially Pennsylvania and Delaware.

Sewell Biggs was a lifelong Delaware resident. Grandson of a state senator and descendant of a Delaware governor, he took special pleasure in purchasing familiar scenes such as George Bonfield's *Summer on the Delaware*. Biggs collecting was more focused than that of his contemporary Henry du Pont, but it was in the same enthusiastically American spirit.

THE WILSON-WARNER HOUSE

Built in 1769 as a major addition to a structure dating from 1740, the Wilson-Warner House is the oldest house museum in Delaware. Like its grander neighbor, the Corbit-Sharp House, it is a finely detailed adaptation of the dominant English architecture of the day. The Wilson-Warner House was built by David Wilson. Mary Corbit Warner, a granddaughter of William Corbit and great-granddaughter of Wilson, bought the house in 1901, after it had been out of her family's hands for some seventy years, and installed her own sizable collection of Americana in the house. After her death in 1962, a second wave of restoration was undertaken and now the house is closer to its original state. The façade, with its large, handsome windows and its dentil cornice, is far more finished than any other face of the house. The interior features plain paneling set in simple geometric patterns. The furnishings, mostly Delaware pieces, include a number of Wilson family heirlooms. A bow-front mahogany chest in one of the bedrooms bears a note written by Mary Elizabeth Janvier, a granddaughter of the cabinetmaker who created the piece: "This bureau made by Thomas Janvier of New Castle, never to be sold, kept always in the Janvier family."

Thomas Jefferson once described Delaware—or what he knew as "the three Lower Counties on the Delaware of William Penn's Quaker Colony"—as a diamond, for the region was small but had great value. Odessa is one of the sparkling facets of that diamond.

WINTERTHUR

Set in the wooded hills of the Christiana Hundred, near Wilmington, Winterthur is the foremost bastion of the du Pont family. It is a 110-room private house that has been converted into a museum of American decorative arts. It is also one of the country's more recent mu-

seums. Once a farmhouse, it has developed into a mansion. The museum's founder, Henry du Pont, by nature somewhat taciturn, was considered to outrank his rivals in his knowledge of American decorative art. When the museum opened in 1951, its director Edgar P. Richardson, said of its collection, "Winterthur's collections are known wherever American decorative arts are known and acquired, but its nature and purpose are far from being understood." Henry du Pont's knowledge of Americana gives the exhibition's installation a special character.

Winterthur's first owner, James Antoine Bidermann, came from a town of the same name in the Zurich Canton, known for its locomotives and its Hapsburgs. Bidermann's family, which had moved to Paris many years before, held stock in the Du Pont de Nemours Company, which had established a gunpowder factory on the banks of the Brandywine River in Delaware. The company was the joint venture of two European capitalists, du Pont and Bidermann, both of whom were active powder-men in France. There have been many such ventures since, but none so successful as this one.

Success, despite the war of 1812, was slow in coming. When in 1814 the fledgling American company got into financial trouble, Antoine Bidermann was sent to America by the French stockholders to look into its tangled finances. He carried with him letters of introduction from Lafayette to Jefferson, who, before becoming President of the United States, was its ambassador to France, like Benjamin Franklin before and Gouverneur Morris after. Jefferson was a great admirer of French taste, if not French politics.

Bidermann bought into the Du Pont Company and thereafter managed it, reassuring the worried French stockholders. He sealed his pact with the family by marrying one of its daughters, Evelina Gabrielle du Pont. He entered a remarkable clan. His wife's grandfather had been a close friend of Diderot, editor of one of France's most remarkable eighteenth-century documents, the *Encyclopédie*. He was also an acquaintance of Talleyrand, who, exiled from France by its post-revolutionary government, had spent some months in Philadelphia. The latter's comments about arts in America denigrated the very period

of cabinet-making that is so wonderfully celebrated at Winterthur. Whatever his feelings were, Talleyrand did nothing to deter the elder du Pont from following his son Eleuthère to Delaware. He arrived in 1815, the year Antoine Bidermann married his granddaughter.

Eighteen years later, Antoine Bidermann and his wife bought land farther from the mill, in the Christiana Hundred near Wilmington. The house they built would be occupied by members of the Bidermann and du Pont families for the next century. Today, the original house is no longer recognizable. Miriad changes have been wrought since its construction, wings, chimneys, shutters, columns, and more. It might be considered architecture with French influence under its concrete skin, but its architectural heritage is actually blurred. Antoine's son James inherited the house in 1865 and two years later he sold it to his mother's brother, Henry du Pont. Henry doubled the size of the land on which the mansion stands by buying two adjacent farm properties. In 1889 it was acquired by Colonel Henry A. du Pont, a Delaware senator who had won a Congressional Medal of Honor for his role in the Civil War. On the colonel's death in 1926, Winterthur went to his son Henry du Pont, who founded the museum.

Judged on the basis of other mansions of its day, Winterthur was modest in size—this despite the fact that at its prime it covered 2,400 acres, the largest single landholding in Delaware. Its head of Holsteins was regarded with something just short of awe. Indeed the dairy barns were said to be as grand as the house itself.

By comparison with the Vanderbilts, the du Ponts lived on a simpler scale. On inheriting the house, Henry du Pont commissioned renovations that increased the mansion's interior space two hundred percent. In an attempt to unify the exterior, a Georgian façade was applied as well. On the house's conversion to a museum, further additions took place: fifty-six period rooms were installed under the aegis of Joseph Downs, curator of the Metropolitan Museum. By the time these changes were made, Winterthur contained 196 rooms. Although modest in size, they are appropriate to the furniture they contain. The years represented by these rooms span two centuries, from 1640 to 1840. The woodwork, the ceilings, the walls, the windows, and the floors of entire rooms from New Hampshire to North Carolina have been brought to Winterthur and re-established in

Set of six silver tankards made by Paul Revere in 1772 in Boston, Massachusetts, from the collection of the Henry Francis du Pont Winterthur Museum.

the mansion. It was reported that when a room from Wernersville, Pennsylvania, failed to fit into the space designed for it, the walls of the mansion were pushed out twelve inches.

The antique furnishings have been so painstakingly collected and sorted that all objects and decorations in each room harmonize. Collectors and architects generally agree that it is perhaps the largest and most complete assemblage of fine old chests, chairs, tables and rugs in the United States. A visiting Italian expert in antiques said that the shape of a chair leg seemed to matter almost as much as the course of the American Republic.

"Individuals and nations take their greatest inspiration through remembrance of a glorious past," said Henry du Pont, who gave as the objective purpose of Winterthur, "to show Americans the way early Americans lived and to preserve our country's rich tradition of craftsmanship in architecture and household arts."

He began the collection of old rooms and furnishings in 1927 and deeded the Winterthur corporation to the State, in 1951, when he moved into a house next door.

Many of the rooms at Winterthur are not literal recreations of period rooms, but are composites that best illustrate the period from which they came.

Typical of the exhibitions on display is the Port Royal Entrance Hall. It was taken from a house built in 1762 on Frankford Creek, north of Philadelphia. Its owner was Edward Stiles, a planter and merchant from Bermuda. Visitors are greeted by an ornate mirror with ormolu filigree. The wallpaper is Chinese, the three faïence jars are imitations of Chinese porcelain, and the chair seats are English chintz. The hallway is noted for its Doric entablature, which follows the severe pattern of classical architecture. The arched fanlights above its entrance doors suggest the pierced shell ornamentation found in Chippendale furniture.

The Latimeria Room was originally part of a house built in 1815 by William Warner in Wilmington from plans drawn by his friend Eleuthère Irénée du Pont. The Stamper-Blackwell Porch and Parlor were formerly in a Philadelphia house built in 1764 for John Stamper, an English-born merchant and mayor of Philadelphia. The house later came into the possession of a clergyman, Dr. Robert Blackwell.

The du Pont dining room has paneling from Read-

bourne, an historic house in neighboring Maryland. The mantelpiece and overmantel are from Willow Brook, built in 1800 near Kernstown, Virginia. Over the mantel is a Stuart portrait of Washington. The Candlestick Room has cupboards and shelves taken from a store in Chelsea, Pennsylvania, in 1880, which have been adapted to display the wide variety of candlesticks used in American houses from 1750 to 1850. The porcelain on the table is English and the Aubusson on the floor is French. The unique set of six matching silver tankards is the work of America's foremost silversmith, Paul Revere; and the principle painting is the work of Benjamin West, who was born in Pennsylvania but made his name in England. Decorative purity, the Winterthur proponents point out, is a retroactive invention, not a decorating convention. They prefer an appropriate eclectic elegance.

The Baltimore Rooms, from eighteenth-century houses, have decorations reminiscent of the Roman Republic, inspired by objects found at Pompeii and Herculaneum. Classical ornamentation was very much in vogue in America's Federal period of architecture.

The Marlboro Room was taken from a plantation house known as Patuxent Manor, built in 1744 for Charles Grahame in Calvert County, Maryland. A collection of furniture by the New York cabinetmaker Duncan Phyfe graces the Phyfe Room, illustrating the elegant simplicity of the Federal period and the American adaptations of the styles of Thomas Sheraton, French Directoire, and English Regency.

Some of Winterthur's rooms are of simple origin. The Dominy Woodworking Shop is one. Until 1946 it was a functioning shop in East Hampton, Long Island. Reassembled at Winterthur, it contains some 800 tools, lathes, workbenches, and templates for shaping chair legs made by the Dominy family in the practice of their trade, which began in 1765.

Winterthur is noted for its exceptional gardens as well as its Americana. It is an arboretum and horticultural showplace and considered to be one of the world's great gardens. Henry du Pont, like his forebears, was well known in horticultural circles, where he was regarded as a gardening expert and a connoisseur. He was listed among company stockholders as an "agriculturist."

The floral displays of Longwood Gardens are restricted to several magnificent greenhouses during the winter months. In spring, the outdoor fountains are reopened and extraordinary son et lumière shows fill the gardens.

Du Pont is a common name in France, and so to distinguish itself the Americanized family chose to call itself du Pont de Nemours, after the town in France where they had once had a country estate. The place they left behind at Nemours is something of a garden spot even today, suggesting that the family's interest in botany and horticulture was strong even before they left France. Certainly the du Ponts are the most estate-minded of the great American families, and Nemours in Delaware, the home of the late Alfred I. du Pont, is one of the most beautiful American country houses.

Set at the end of a long allée of chestnut trees, Nemours looks remarkably like the châteaux one glimpses while driving through the Loire Valley. The grounds are formal, their design strongly influenced by Versailles, but without the openness. An air of reserve, of remoteness from the ordinary hurlyburly, hangs about the place, even though it is now open to the public. Nemours was not, like Winterthur, designed as a showplace, but as a private residence for an extremely private man and his wife. It has seventy-seven rooms but looks smaller, and it is set in a small park entirely surrounded by a high stone wall topped with shards of broken glass. Alfred du Pont, the builder, was a zealous guardian of his privacy, and with good reason. He built Nemours for and with his second wife, Alicia Bradford du Pont.. They had met and fallen in love while they were both married, and their subsequent divorces and secret marriage created a scandal that prompted the other members of the huge du Pont clan to cut them off. "That wall," Alfred du Pont liked to say, "is to keep out intruders—mainly by the name of du Pont."

Nemours kept out the curious too, so that Derek Fall, writing in *Architectural Digest*, would later observe that "probably no other mansion and garden of such distinction in the United States has been seen by so few." When Alfred was a boy, his father walked this piece of property with him numerous times, once observing, "if I could do what I wanted, I'd build a house under those trees, sit down, read books, and eat ice cream for the rest of my life." The son, who felt that a du Pont *could* do what he wanted, built the house and spent much of his long life sitting in it.

LONGWOOD GARDENS

Created in the first decade of this century, Longwood Gardens lies but a few miles from Winterthur in Chester County, Pennsylvania, an area which has played a significant role in American history. William Penn, the Quaker founder of Pennsylvania, granted land to an English settler in 1700 and his descendants encouraged an interest in trees, both native and foreign.

A well-known arboretum, Pierce's Park, stood on the Longwood site when Pierre S. du Pont acquired the land in 1906. He chose the name of the original charter and called his gardens Longwood. In establishing these gardens, Pierre du Pont was carrying on his family interest in botany. Curiously, at the time the du Ponts were establishing their powder mill in Delaware and carrying on their horticultural interests, Joshua and Samuel Pierce were planting their arboretum nearby.

According to Pierre du Pont, when he bought the land he had "no intention whatever of using the place as a residence as it was entirely inaccessible for parts of the year on account of the condition of the earth roads during spring and in stormy weather." Less than a year had passed when he began spending weekends at the Pierce farmhouse clearing and pruning the old arboretum and laying out a formal flower garden south of the house.

From the beginining Longwood was open to the public, just as Pierce's park had been before du Pont bought it. There was little to see other than a flower garden to the south of the house, and the lakes with their surrounding woodlands. In 1913 the first unusual feature, an outdoor theatre, was added southwest of the house. Rebuilt in 1927, it includes a water curtain across the front of the stage. Water was one of Pierre du Pont's particular delights. Longwood's free-running water and numerous fountains are reminiscent of the gardens at Versailles and Tivoli, which du Pont was perhaps intentionally imitating.

In 1916 du Pont completed a new wing to the north of the original Pierce house. Adjoining it was the first of the Longwood conservatories, a graceful glass structure which shelters a small selection of tender and out of season plant materials. Five years later, the first of the great conservatories was opened. The "Orangery," as it was called, was designed to house citrus fruit, flowering trees, and shrubs. It is the focal point for Longwood's seasonal displays—spring bulbs, acacias, Easter lilies, begonias and chrysanthemums, as well as flowering pot plants at appropriate times of the year.

An important facet of the gardens is the vast fountain system, which covers an area of about five acres. The first fountains were modest, single jets, placed in pools along the flower garden walks. On a trip to Florence, du Pont was so taken by the garden at Villa Gambaraia that he obtained its dimensions and evolved a plan for a water garden to be placed east of the Pierce arboretum, near the largest of the two lakes. The Italian Water Garden was completed a year later.

In 1928 construction of the main Fountain Garden was begun. Set south of the conservatories, its retaining wall is composed almost entirely of Italian limestone, sculpted in Italy and transporoted in sections to the United States. One set of its jets produces a fan-shaped spray thirty feet across, while another, at full pressure, throws a column of water 130 feet high.

In 1936 Pierre du Pont commented to a friend that, there being no family member to carry the work on, it was most likely Longwood would pass into oblivion after his death. However, in 1946 the Internal Revenue Service approved the absorption of the gardens into a trust.

The structures that support many of Longwood's educational and research projects are the gardens and conservatories. There are now approximately four acres under glass, including several new display conservatories. The Palm House is tall enough to accommodate forest-size plants of many species. In 1959 the All-American Rose Garden was created to display the best available rose varieties in the United States.

Flowers in Longwood's huge conservatory are changed constantly, with the gardens' staff making

their selections from a store of some 45,000 bulbs. The displays of orchids—there are 8,000 varieties—and of bonzai are permanent features of the greenhouses. Of Longwood's one thousand acres, three hundred are cultivated to produce the ever-changing displays housed in the conservatories.

As with all projects undertaken by the du Pont family, Longwood Gardens have not only been created on a grand scale, but with taste as well. They are also the site of long-term research into horticulture and horticultural education. Longwood has been developed throughout with the magnanimous style characteristic of all du Pont creations.

Pierre S. du Pont's mansion, Longwood Gardens, holds one of the largest organs in the world: it has over 10,000 pipes. Following its installation in 1930, it was played by Mr. Firmin Swinnen, for many years Mr. du Pont's private organist. The Ballroom is 101 feet long and has a ceiling made of pink glass. The walnut parquet floor was made from surplus World War I gunstock wood.

4
THE VISION OF A NATION

Entrance to the Phillips Collection, Washington, D.C., which was founded by Duncan and Marjorie Phillips, both of whom were painters, and is dedicated to modern art and its sources.

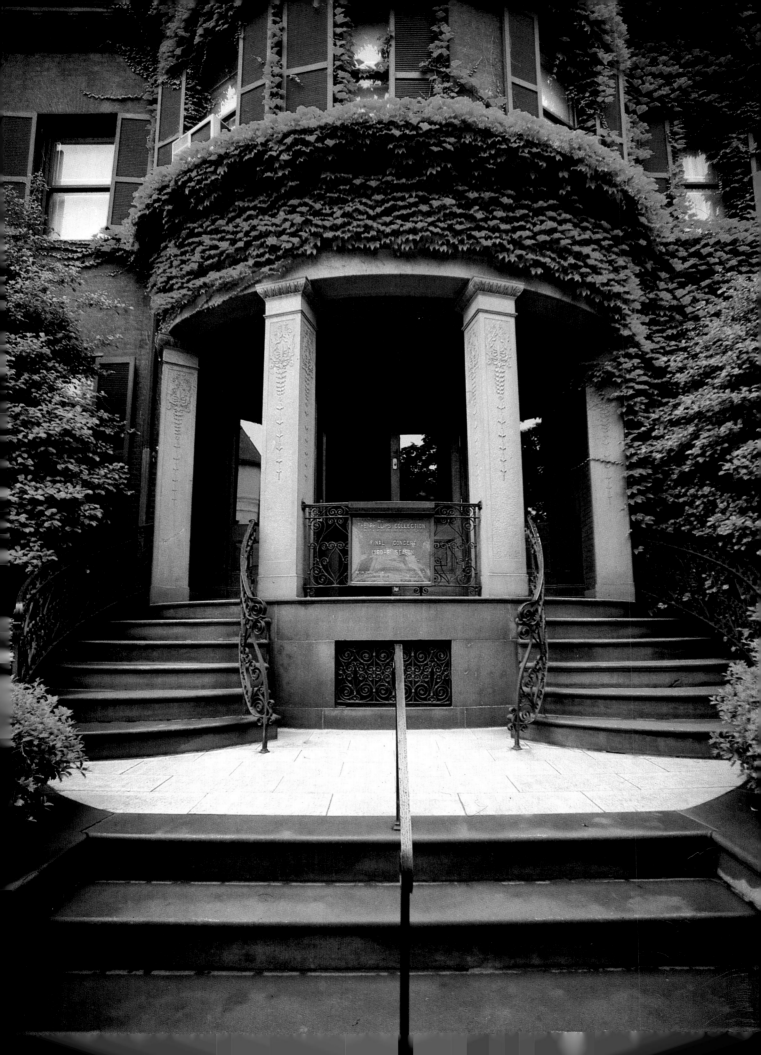

The Luncheon of the Boating Party, *by Pierre Auguste Renoir, was painted in 1881.*

Night Baseball, *painted in 195_ by Marjorie Phillips, co-found_ of the museum.*

Honoré Daumier's The Uprising, *executed around 1860.*

Le Grand Gueridon, "The Round Table," by Georges Braque, 1929.

The original Federal-style house at Dumbarton Oaks was built in 1800 for William Hammond Dorsey. The structure existing today has been modified several times since Mr. and Mrs. Robert Woods Bliss bought the property in 1920.

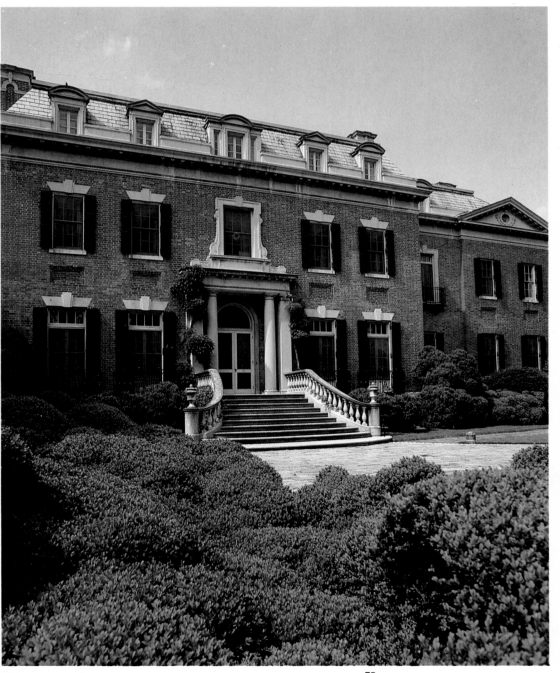

Entrance to Dumbarton Oaks; the house and collection were donated in 1940 to Harvard University.

Open courtyard and mosaic pool in the ten-acre formal garden laid out by Mrs. Bliss and the landscape gardener Mrs. Beatrix Farrand.

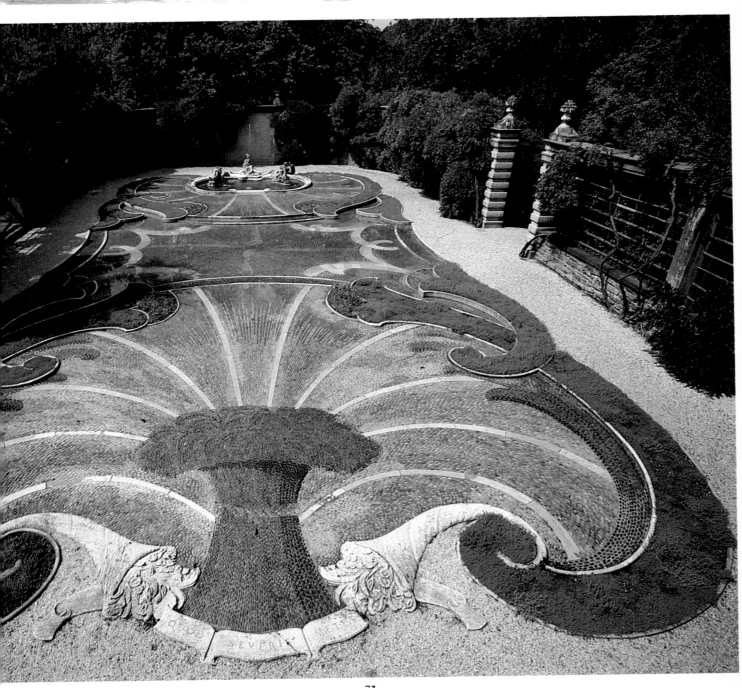

Exterior of the Pre-Columbian Museum at Dumbarton Oaks, which was designed by Philip Johnson in 1963.

Interior of the Pre-Columbian Museum, whose collection was begun by Mr. Bliss in 1914.

A geometrically inlaid mirror from the coastal Tiahuanaco culture, which flourished on the Peruvian Coast around the eleventh century. It is inlaid with turquoise, pyrites and shell.

More than half the pieces of the Byzantine Art Collection at Dumbarton Oaks date from the early period. Among them is this gold marriage belt, made in Constantinople in the late sixth or early seventh century. The detail shown is of the two large central medallions representing Christian motifs.

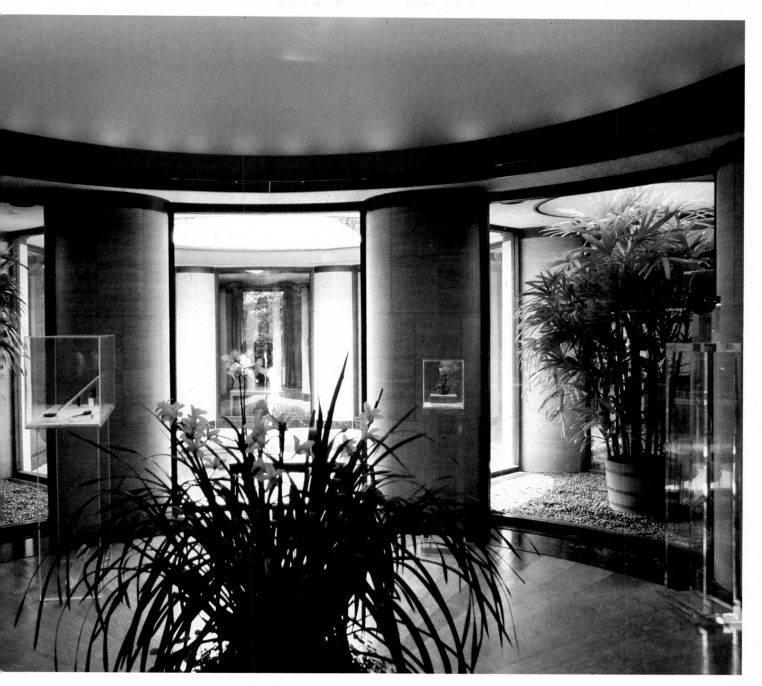

following page:
The central core of the round structure that houses the Hirshhorn Museum is an open exhibition space. In the foreground is a sculpture by George Rickey.

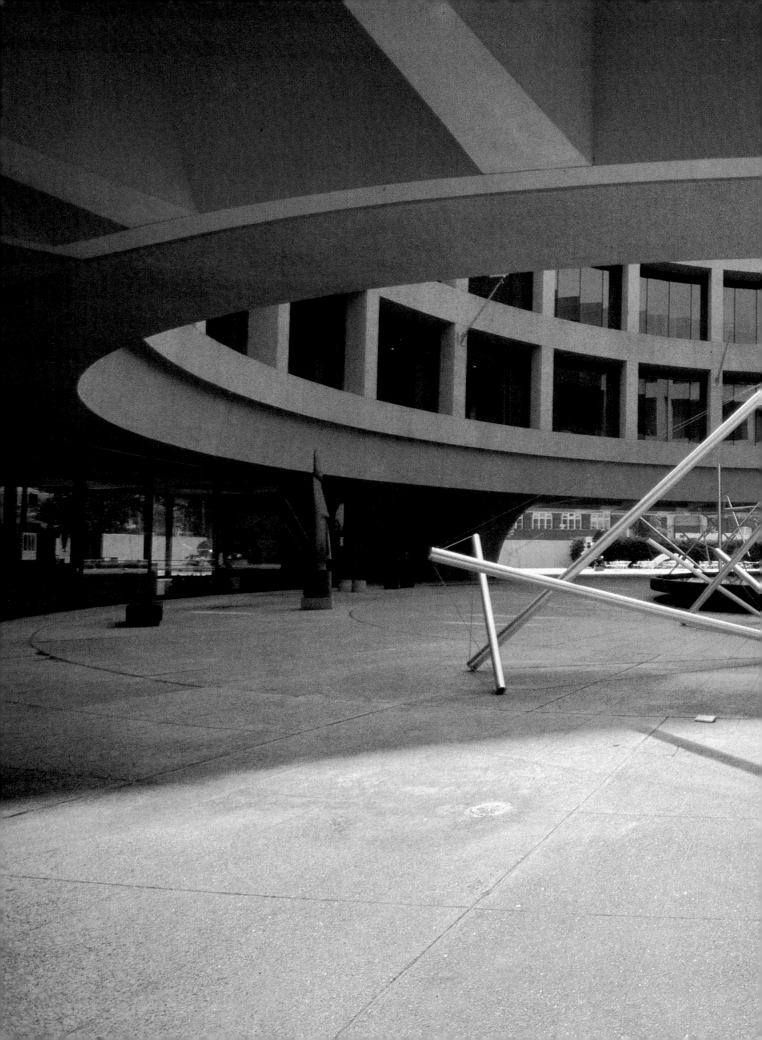

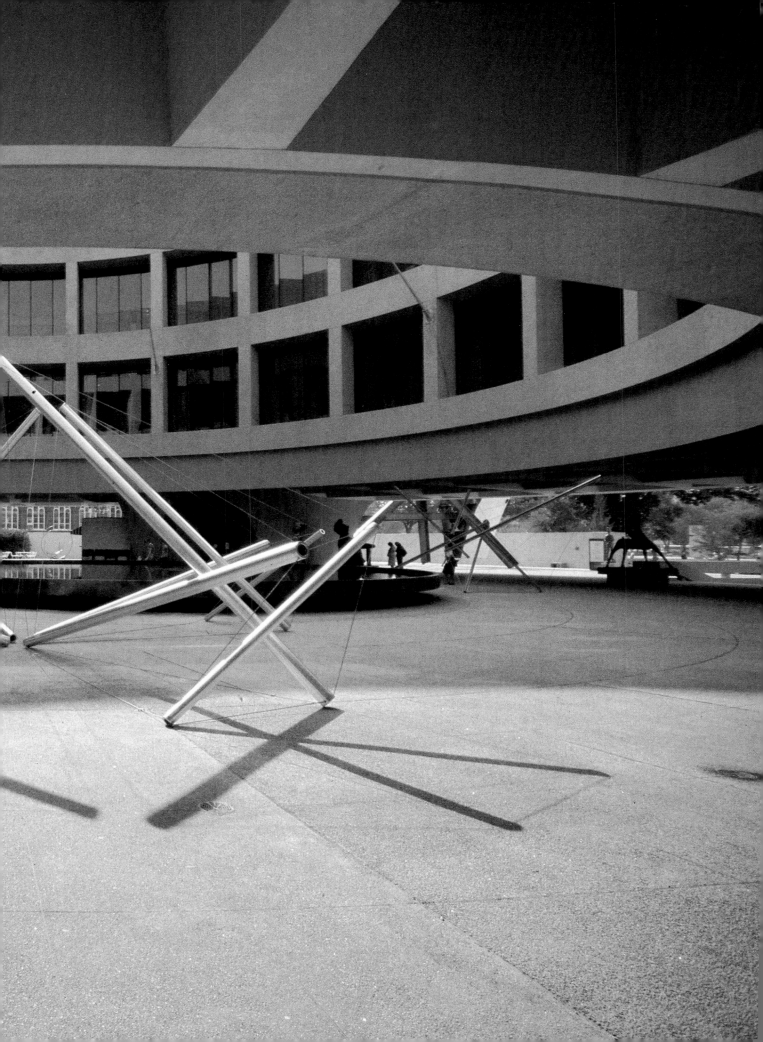

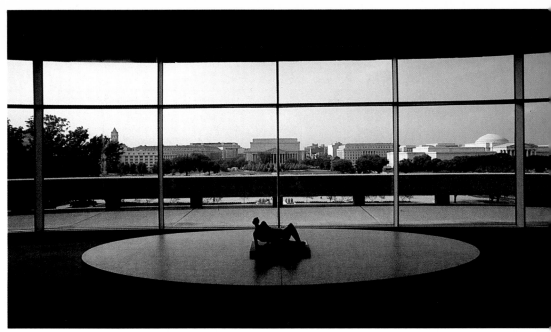

A reclining figure by Henry Moore is situated near a window which faces onto The Mall in Washington, D.C.

*e exterior of the museum de-
:gned by Gordon Bunshaft is
.rtly concealed by a large
.ulpture.*

The statue of The Bishop *in the central court is by the Italian sculptor Giacomo Manzu.*

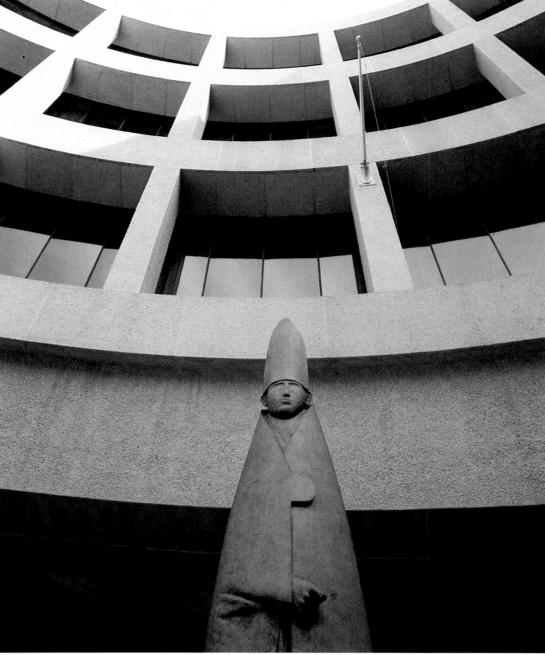

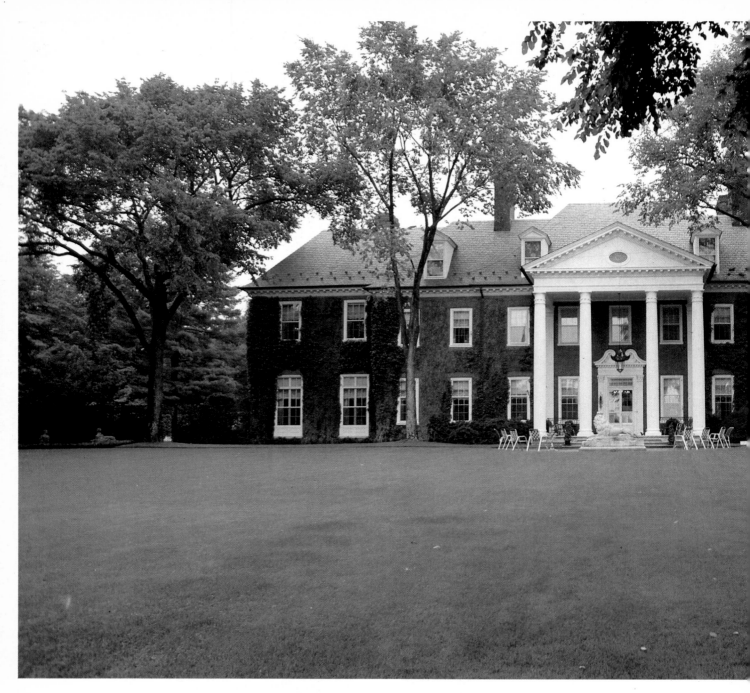

The Japanese garden is one of the many gardens on the 24-acre estate.

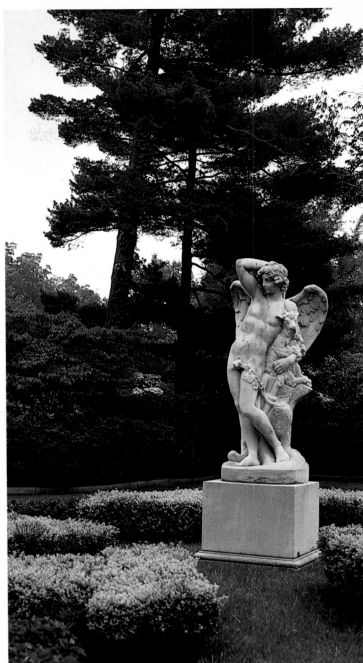

Hillwood was the Washington residence of Marjorie Merriweather Post. Originally built on a smaller scale for an earlier owner, the house was extensively remodeled before she moved there in 1957.

A statue in the garden.

Mrs. Post began collecting Russian pieces when she was ambassadress to the Soviet Union from 1936–1938. Among the pieces she brought to the United States is this chalice of gold and diamonds made in 1791 by I.W. Bich on a commission from Catherine the Great.

81

A marble bust and tapestry, from the important Renaissance collection of the Walters Art Gallery in Baltimore, Maryland.

Detail from a Roman sarcophagus depicting the Asiatic triumph of Bacchus, 180–200 A.D. This is one among seven sarcophagi found in a family tomb on the Via Salaria in Rome in 1884. These were acquired in 1902 by Henry Walters as part of the collection of Don Marcello Massarenti, under-almoner to Pope Leo XIII.

The court forms the nucleus of the first building of the Walters Gallery. It was built between 1902 and 1908, and modeled after Palazzo Balbi in Genoa.

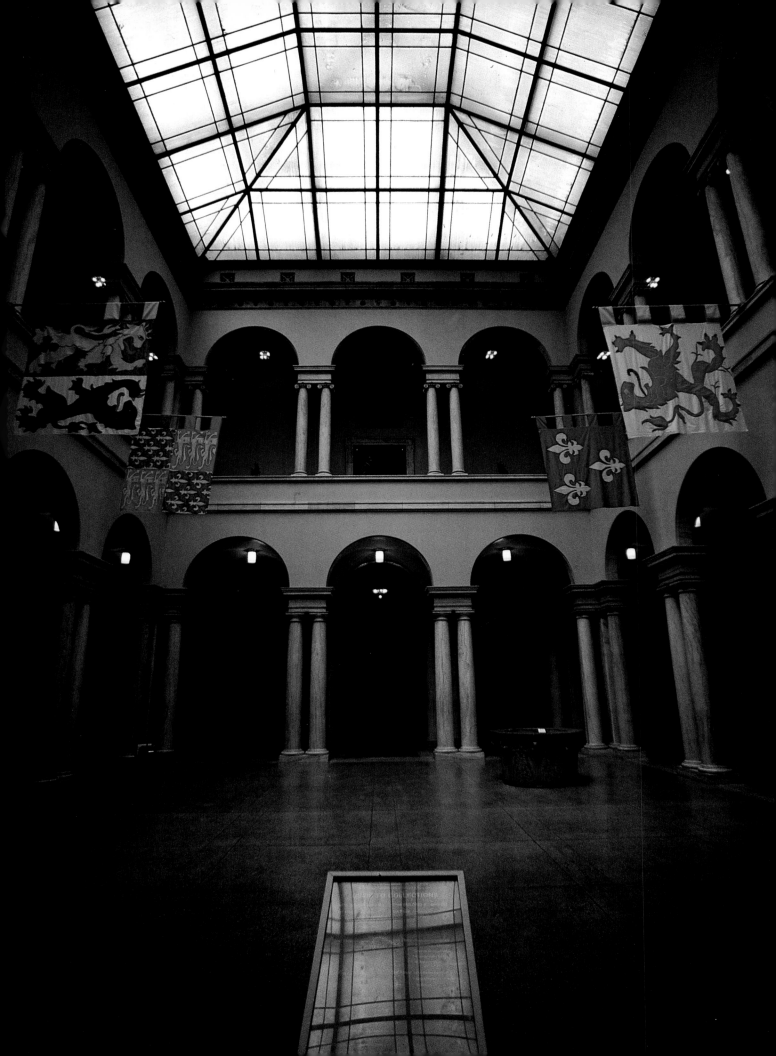

A comb in the shape of an orchid, made by Lalique in 1903–1904. Ivory, gold and diamonds.

An Egyptian Ba-amulet of gold and turquoise, 4th to 1st century B.C.

wo bronze statues frame the
ainting of Countess Lucia de
orto and Daughter by Paolo Ver-
nese. The collection was begun
a 1830 by William Walters and
reatly expanded by his son in the
ears 1899–1931.

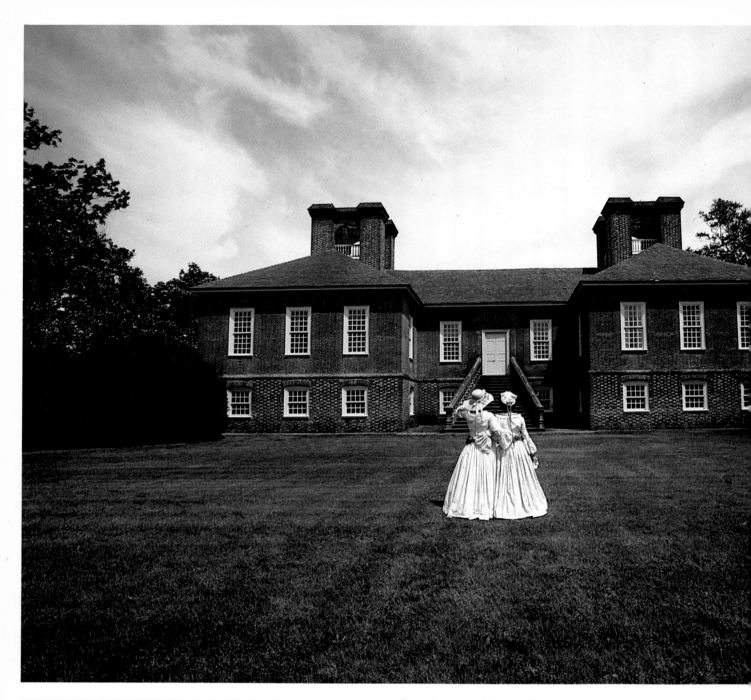

Two clusters of four chimneys atop the great house at the Stratford Hall Plantation form observation towers (from which the residents once watched for incoming ships). Women in Colonial dress stroll across the central portion of the lawn in the Stratford farm and plantation complex, which was built in the 1720's.

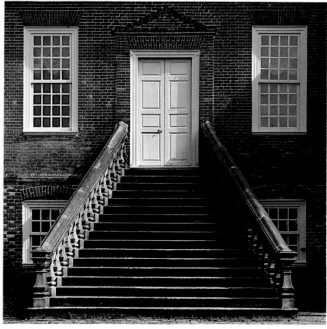

The reconstructed south stairway of the great house, which today contains American art and furniture from the late seventeenth to the early nineteenth century.

The cliffs overlooking the Potomac form a natural barrier to the 400-acre estate that Thomas Lee bought in 1716.

The commander-in-chief of the Confederate forces, Robert Edward Lee (1807–1870), in a portrait by M.S. Nachtrieb.

following page:
Thomas Jefferson's Monticello was completed in 1809 from his own designs. It is situated upon an artificially created plateau in his 658-acre estate in the Blue Ridge Mountains of Virginia.

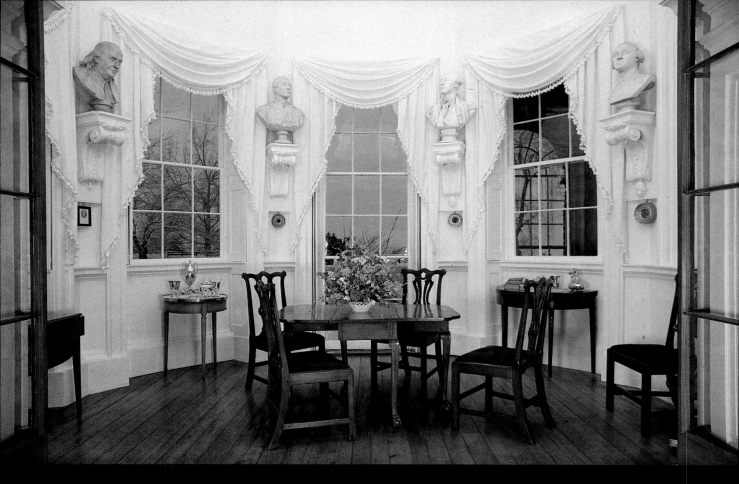

The Tea Room at Monticello.

The parlor at Monticello is furnished with pieces which were donated to the Thomas Jefferson Memorial Foundation; many of them are authentic Jeffersonian

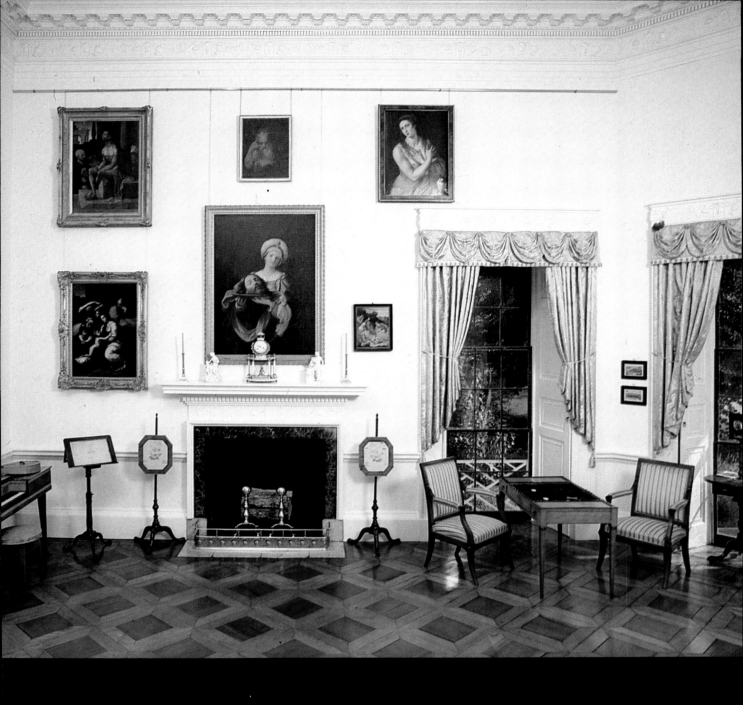

following page:
The candelabrum in the Entrance Hall hangs from a plaster escutcheon shaped like an American eagle.

4

THE VISION OF A NATION

THE PHILLIPS COLLECTION

Henry Clay Frick modeled his collection on the Wallace Collection in London, and Andrew Mellon, in turn, modeled his on Frick's. But Duncan Phillips was his own man. Like Frick and Mellon, Phillips's family came [fro]m Pittsburgh, and like them he loved art. But [Fr]ick and Mellon collected Old Masters, while Phil[lip]s was more interested in nineteenth-century [Fr]ench paintings and works by living American art[ist]s. While they were obsessed with the art of the [pa]st, Phillips always had his eye on the art of his [ti]me. Frick and Mellon crowned their business ca[re]ers with their collections, but Duncan Phillips's [co]llection *was* his career. Art was his greatest passion, [an]d his energy and knowledge created the first mu[se]um in the United States to emphasize the work of liv[in]g artists; the Phillips Collection's subtitle is "Museum [of] Modern Art and Its Sources."

Duncan Phillips was born in Pittsburgh in 1886. [Hi]s grandfather, James Laughlin, was one of the [fo]unders of the giant steel firm of Jones and Laugh[li]n. When Major Phillips, James's son and Duncan's [fa]ther, retired from business, the family moved to [W]ashington and built the house on 21st and Q [st]reets that was the original seat of the collection. [At] Yale, Duncan wrote numerous articles for the [Ya]le Literary Magazine—among them "The Need of Art [at] Yale"—and although his friends were chiefly literary, [it] was here that he became seriously interested in art. [Th]e journals he kept during his postgraduate travels in [Eu]rope are filled with notes on Old Masters, but in 1911 [Ph]illips visited Durand-Ruel, the legendary Parisian [de]aler who specialized in French Impressionist paint[in]gs, and discovered Renoir. He found, in Renoir's can[va]ses "an infectious good humor about his work—a [th]rilling vitality in his vivacious raptures over modern [li]fe. Pretty girls in a box at the opera or dining on a [te]rrace—children playing on an opal beach—a group of [Pa]risians lunching up the river on a hot holiday." This [la]st description, as it happens, fits the most famous [pa]inting in the Phillips Collection, Renoir's *Déjeuner [de]s Canotiers.*

In 1914 Duncan Phillips published a volume of col[lec]ted essays called *The Enchantment of Art,* which was favorably reviewed. At this time he made his home in New York, where his friends included the painters Alden Weir and Gifford Beal. In 1915 Duncan and his brother James, then sharing Duncan's bachelor quarters in New York, launched a campaign to persuade their parents to begin collecting, with James arguing that "the average private collection has not nearly the knowledge, experience and appreciation of art Duncan and I possess." Moreover, he noted, "J. Pierpont Morgan, the greatest financial genius America has produced, had over half his fortune in works of art. Frick, one of the industrial kinds, and Altman, New York's greatest merchant, both have a good percentage of their wealth in such investments." Duncan and James's father must have had faith in his sons' judgment, for he agreed to give his sons $10,000 a year to buy paintings. For this new collection, which was to contain works by Alden Weir and Arthur B. Davies, among others, the architectural firm of McKim, Mead and White designed a gallery over the library of the Phillipses' house.

This scheme for a jointly developed family collection soon fell through, however, for Major Phillips died in 1917—on the day of James's wedding—and James died during the great influenza epidemic of 1918. It was to honor their memory that Duncan Phillips conceived the idea of a memorial gallery that would be opened to the public. In 1921 the Phillips Memorial Art Gallery was inaugurated; three days a week visitors came to see the works of Chardin, Monet, Sisley and Fantin-Latour as well as Weir, Davies, Lawson, Luks, and Hassam.

Duncan Phillips's marriage to Marjorie Acken, a painter herself, was to cement his ambition to create a major collection, for in her he found a critical and impassioned partner in his venture. In the words of their son, Laughlin Phillips, their collecting proceeded "at a wild and wonderful pace in those early years." On a trip to Paris in 1923 they bought *Dejeuner des Canotiers* from Durand-Ruel. Duncan was never to pay more for a painting than he did for this one, and it has been the chief adornment of the collection ever since. In 1924 they bought Daumier's *Uprising;* in 1925, Cezanne's *Mont St. Victoire.* By 1930 there were 600 paintings in the collection. Exchanges, trades, and sales have reordered the scope of the holdings several times. "It has been my policy," Duncan Phillips wrote, "and I recom-

mend it to my successors, to purchase spontaneously and thus to make mistakes, but to correct them as time goes on. All new pictures in the Collection are on trial, and must prove their powers of endurance."

The Phillipses purchased a great many paintings by American contemporaries such as Arthur Dove, who was represented by the remarkable Alfred Stieglitz. Although Stieglitz later claimed that he had turned Phillips's taste in a modern direction, Phillips had actually begun turning in that direction long before. When Duncan Phillips liked a man's work, he tended to buy a lot of it. This was the case with Davies—one of the few people to influence Phillip's taste—and with the French painter Pierre Bonnard. Phillips was one of the first Americans to appreciate Bonnard's work, and also that of Milton Avery.

In time his tastes evolved; he came to favor Picasso, Braque, and the modern Americans. Backed by his wealth and self-assurance, he was convinced of the rightness of his own opinions of modern artists as disparate as Mondrian, Kokoshka, Dove, Marin, and others. In addition, the holdings of "Sources" in the Collection included fine paintings by Giorgione ("the inventor of romantic landscape"), El Greco ("the first expressionist"), Courbet ("the romantic realist"), Renoir ("the lover of life"), Van Gogh ("the most inspired of the great Impressionists"), and Seurat and Gauguin ("the most direct influences").

Like the Blisses, who worked together to create Dumbarton Oaks, Duncan and Marjorie Phillips were full partners in this art enterprise. After her husband's death in 1966, Marjorie directed the collection for a time before ceding the responsibility to Laughlin Phillips. Until recently, when the Phillips Collection made its first public appeal for funds, it had been entirely supported by the family.

DUMBARTON OAKS

Dumbarton Oaks stands in what Carl Feiss, Washington's city-planner, once called "America's most civilized square mile," an area that includes Rock Creek Park and Washington's most fashionable quarter, Georgetown. Originally, the Federal-style house that William Hammond Dorsey built in Georgetown in 1800 was a rather modest structure. The estate of Mr. and Mrs. Robert Woods Bliss is an extravagant engraftment upon Dorsey's original house. The mansion itself is considerably expanded—the Dorsey house today is but the nucleus of a complex of buildings that includes the country's only museum of Byzantine art, the Robert Woods Bliss Collection of pre-Columbian art, and a center for the study of landscape architecture.

The history of Dumbarton Oaks begins with Ninian Beall, the first owner of the Rock of Dumbarton. His descendants sold the land to William Hammond Dorsey. Dorsey built his house at the end of the eighteenth century, a time when speculating in Georgetown property was a popular pastime. Of subsequent occupants, John C. Calhoun was the most famous. Vice President of the United States from 1824 to 1832, he gave a splendid party in the house for Lafayette during the triumphant return visit of the aging French general in 1824. A century would pass before Dumbarton Oaks would know such splendor again, and then it would come from the objects, not the people, assembled beneath its roof.

Robert Wood Bliss, who was in the foreign servic[e] bought the property in 1920 to fulfill a dream "twenty years of professional nomadism," that "having a country house in the city." The Blisses d[id] not move in until 1933, when Bliss retired as Unite[d] States Ambassador to Argentina. They occupied t[he] house until 1940, when they gave it to Harvard. Du[r]ing the Second World War the National Defense R[e]search Council took over a part of the facilities. [In] 1944 the State Department held the first Dumbart[on] Oaks Conference on the estate—which resulted [in] the creation of the United Nations.

The three facilities maintained at the estate [by] Harvard University reflect the Blisses' interests [in] pre-Columbian art, Byzantine art, and landscape a[r]chitecture. They created the remarkable collection[s] that form the core of the holdings of Dumbart[on] Oaks almost a decade before acquiring the house[.]

After Harvard, Robert Woods Bliss served brie[fly] as secretary to the governor of Puerto Rico, lat[er] joining the United States embassy staff at St. P[e]tersburg during the Russo-Japanese War. Seve[n] years in Paris were to follow. "Soon after reachi[ng] Paris in the spring of 1912," Bliss later wrote, "[my] friend Royall Tyler took me to a small shop in t[he] Boulevard Raspail to see a group of pre-Columbi[an] objects from Peru . . . Within a year, the antiqua[ry] of the Boulevard Raspail, Joseph Brummer, showe[d] me an Olmec jadeite figure from Mexico." That d[ay,] Bliss confesses, "the collector's microbe took ro[ot] in . . . very fertile soil."

As Bliss described it later, he only collect[ed] "pieces which appealed to me as objects of a[rt.] What I have amassed is a small collection of jade[ite] and other hard stones, of gold, silver, and bron[ze] objects, with a few examples of ceramics and Pe[ru]vian textiles." He found them in Europe and in t[he] United States, always looking for examples of fi[ne] workmanship. "But not one," he noted "did I ev[er] find in the country of its origin."

Royall Tyler not only introduced Bliss to pre-C[o]lumbian art, he was also to make Mrs. Bliss an e[n]thusiast of Byzantine art. Tyler was an extraordina[ry] man, the son of a Boston Brahmin and a central E[u]ropean mother. He was educated at Harrow, Oxfo[rd,] and the University of Salamanca, where he becam[e] a friend of the rector, the great philosopher Migu[el] de Unamuno, who was also a scholar of Byzanti[ne] art. Tyler and Mrs. Bliss had been friends fro[m] childhood and they were to correspond regularly u[n]til his death. Over the years his artistic passions b[e]came hers. Many fine works in the Bliss Collectio[n,] including a number of pieces of Greek and Rom[an] statuary in bronze and marble, were bought with [his] advice between 1933 and 1940. Dumbarton Oa[ks] was also to get a share of the great mosaics fro[m] Antioch, excavated in the 1930s by Princeton U[ni]versity in cooperation with the Syrian governme[nt.] The collection of books on Byzantine art, some [of] them written by Royall Tyler, was also begun in th[is] decade. Today the Byzantine collection is gather[ed] in one wing of the museum. It includes silver a[nd] metal work, ivories and jewelry, coins and ename[ls,] textiles and lead seals. Among the greatest tre[a]sures is a large sixth-century Coptic tapestry [of] Hestia Polyolbos, the goddess of the hearth.

A second artistic personality involved in the fo[r]mation of Dumbarton Oaks was Beatrice Jones Fa[r-]

The Walters Art Gallery: an early eighteenth-century choir screen from the St. Pierre Cathedral in Troyes, France, framed by two French mid-eighteenth-century limestone statues of Calliope, the muse of epic poetry, and Urania, the muse of astronomy.

nd, a highly respected and successful landscape chitect. The author of a treatise on Italian gardens, she was the niece of Edith Wharton and the fe of Max Farrand, the first director of the Huntngton Gallery and Library in San Marino, California. The creation of Dumbarton Gardens was ntrusted to Mrs. Farrand.

These were planted in part while Mr. Bliss was staoned in Sweden. The Blisses's confidence proved lly justified: the grounds include the Star Garden, e Green Garden, the Beach Terrace, the Urn Terce, and Melisande's Alley. Frederick Rhinelander ng's Garden Library, which contains Mrs. Bliss's ollection of horticultural books, documents the story of landscape architecture.

After Mr. Bliss's death in 1962, Philip Johnson was ommissioned to design a building to house the e-Columbian collection. It is a gemlike structure glass cylinders grouped in a square around an en court, with each cylinder devoted to one area pre-Columbian culture. Here one is never far om the green world of the grounds. Many of the 0 pieces of the collection are displayed on lucite edestals, among them gold jewelry from the Sinu nd Tairona cultures of Colombia, dating from A.D. 00-1500. A favorite piece with visitors is a sculpre of the Aztec goddess Tlazolteotl. Perhaps the ngle most remarkable object is an Inca ceremonial oncho woven of cotton and wool and decorated th heraldic devices whose meanings are lost in the stant past. As a whole, the pre-Columbian collecon is recognized as the leader in its field, and umbarton Oaks is known by scholars all over the orld as a gracious and inspiring center of study.

1E HIRSHHORN MUSEUM AND SCULPTURE GARDEN

The Hirshhorn Museum and Sculpture Garden houses the world's most extensive privately assembled collection of twentieth-century American art. The opening of the museum in ctober of 1974 capped Joseph Hirshhorn's phenomenal career as a collector and marked the fulfillent of a prophecy he had expressed years before typically blunt fashion: "Who was Henry Frick?

The public, they know him for that museum. Someday that's what they'll know me for."

Joseph Hirshhorn was the son of a poor widow who emigrated from Latvia to the United States in the beginning of the century and settled in Brooklyn, where she worked in a hat factory. At the age of twelve Joseph left school and began work as a newsboy to ease his family's financial straits. By the time he was twenty he had founded his own brokerage company and amassed capital of $168,000. His intuitive feel for the stock market served him well. In August 1929, just two months before the crash, Hirshhorn pulled out of the stock market.

He next turned his attention to the mining industry in Canada, opening a branch of his company in Toronto with the advertisement: "My name is opportunity and I am paging Canada." He struck it rich in uranium—two Canadian mines Hirshhorn acquired produced more uranium than all the mines in the United States.

Hirshhorn had been interested in paintings since childhood, but it was not until he became the Uranium King of North America that he began collecting in a conspicuous way. His first acquisitions as a novice collector were two Dürer engravings, but he soon developed a taste for American contemporary painting and modern sculpture as well, which he collected in the same manner he approached business—largely by instinct. He did not buy as a connoisseur or an art historian, nor did he seek their advice. Abram Lerner, for twenty years Hirshhorn's private curator and director of the museum, testifies that Hirshhorn did all the choosing himself and that "expert advice seemed to turn him off." He bought "from the heart," with complete disregard for the investment value of his acquisitions, and indulged in buying sprees in which he sometimes cleared out entire galleries. With equal ardor he bought the works of the known and the unknown. Having begun like so many of his generation by collecting European salon painters of the last century such as Bouguereau and Landseer, he soon discovered works in modernist modes. Among these were paintings by George Bellows, Georgia O'Keeffe, and Roy Lichtenstein, and sculpture by Giacometti,

Russian Imperial Easter Egg made by Karl Fabergé for Tsar Nicholas II in 1914, from the collection of the Hillwood Museum.

Degas, Picasso, Nadelman, and Henry Moore.

Hirshhorn was married four times and had sev[en] children. He was known as much for his ebullie[nt] personaliity as for his business deals and passi[on] for art. He carried his 5'4" frame with the agility o[f a] vaudeville dancer, and his Brooklyn speech retain[ed] its punchiness throughout his years in corpora[te] boardrooms. His singular instinct, together with h[is] personality, made him both a hero and a villain [in] the art world, but his changing reputation never d[e]terred him from his relentless pursuit of art. By t[he] mid-1960s his collection had outgrown two ma[n]sions—one a palatial estate in Connecticut whe[re] statues by Rodin and Moore graced the grounds[—] two apartments, two offices, and a warehouse.

The question of the final disposition of the colle[c]tion was much discussed, and overtures were mad[e] by institutions and governments in, among oth[er] cities, Los Angeles, Jerusalem, Florence, Zurich, O[t]tawa, and London. The contest was won by S. Dill[on] Ripley, head of Washington's Smithsonian Instit[u]tion, who prevailed on President Lyndon Johnson [to] woo Hirshhorn with an invitation to the White Hous[e] in 1965. Hirshhorn later recalled the visit in chara[c]teristically plain language: "Once the President pu[ts] his arm around your shoulders, you're a dea[d] cookie." Hirshhorn donated more than 6,500 work[s] of art worth approximately $50 million and anoth[er] $1 million toward the costs of constructing a m[u]seum on the Mall between the Capitol and the Was[h]ington Monument. A good deal of criticism wa[s] directed at the project—Gordon Bunshaft's desi[gn] for a circular building was dubbed "the concre[te] doughnut"—and Hirshhorn's insistence that t[he] museum bear his name annoyed some people in p[a]trician Washington.

The Hirshhorn Museum and Sculpture Garden is [a] sawed-off cylinder of cement resting on four gre[at] piers. The ground level is open to a circular pla[za] with a pool and the sculpture garden. Among t[he] notable pieces on display are the four relief sculp[p]tures by Matisse depicting a nude female back an[d] the great Rodin bronze *The Burghers of Calais.* Insi[de] there are more Rodins and works by Brancusi, Lipchit[z,] Noguchi, David Smith, and others. Although some cr[it]ics have denounced the painting collection as hapha[z]ard, the museum's sculpture collection is wide[ly] considered the world's best.

After Hirshhorn's death in 1981 the museum receive[d] the remainder of his personal art collection—an es[ti]mated 5,200 pieces—along with a $5 million beque[st] and the rights to some of his Canadian oil royaltie[s.] This legacy is free from any restriction, so that the cura[tors] tors have been able to add new art to balance the c[ol]lection. The imprint of its founder remain[s] nonetheless. Joseph Hirshhorn once answered his u[n]wanted advisers by saying: "Don't tell me how to mak[e] money, I don't collect art to make money. I do it b[e]cause I love art."

HILLWOO[D]

Marjorie Merriweather Post was the only chi[ld] of the man who built an empire known a[s] the Postum Cereal Company in Michigar[n.] Married several times, Mrs. Post's mo[st] noteworthy marriage was to Joseph Davies, who wa[s] ambassador to the Soviet Union and author o[f] *Mission to Moscow.* After her divorce from Davies [in]

1955, Mrs. Post, as she was universally known, bought Hillwood, a Georgian house in suburban Washington. This mansion would serve as a setting for the treasures she had acquired during her extensive travels. When she died in 1973, she left her estate to the Smithsonian. It was returned to the Post Foundation after three years because it was too expensive to maintain.

Hillwood was built in 1926, not far from Dumbarton Oaks in the area of Washington known as "America's most civilized square mile," and was a typical mansion of the period. Mrs. Post conversion of the mansion she had bought in 1955 was worthy of a Russian aristocrat's conception of modest opulence. Hillwood is Mother Russia at her best: it even has a dacha tucked into the garden.

Mrs. Post's interest in art concentrated on eighteenth-century France and Imperial Russia. French art came first—she only began collecting Russian art during her husband's posting to Moscow. Many of Hillwoods rooms are given character by French decorative pieces, wood paneling, and rare tapestries. The furniture, of exquisite design, dates mainly from Louis XVI.

At the front door is a Louis XVI marble table and on it a bust of the Duchess Chateauroux, one of the mistresses of Louis XV. The commode at left is signed by Macret, who worked for the French royal family. The eighteenth-century chairs are covered with tapestries woven with pastoral scenes, and others from the fables of La Fontaine. The French Drawing Room is Louis XVI in style and has wood paneling from a château near Paris. There is also a particularly fine mantel, decorated with ormolu, which was originally in the palace of the Countess Greffulhe, mother of the Duchess de Gramont. Over the mantel is a portrait of Empress Eugenie of France, dated 1857, by Franz Wintherhalter. On either side of the fireplace are pieces of Sèvres porcelain, one in a color known as "Rose de Pompadour," the others in "bleu celeste" (a kind of turquoise blue). Underneath a portrait of Princess Louise-Elizabeth of France is a Roentgen roll-top desk, said to have been made for Marie Antoinette, bearing the cipher M A and a crown.

Because there was a great interchange of influences between Russian and French art—to be sure, much of Russian art had its roots in France—the two groups complement each other. The Russian porcelain room was designed especially to house Mrs. Post's remarkable collection. In particular, it contains four services from the Francis Gardner Factory which were commissioned by Catherine the Great. These were used for yearly dinners given by the empress for the knights of each of four imperial orders: the Order of Saint Vladimir Close to the Apostles, the Order of Saint Grand Martyr George the Victorious, the Order of Saint Andrew First-Called, and the Order of Saint Alexander Nevskii. Each of the plates in the set of porcelain are emblazoned with the crest of that particular order.

The Icon Room is of equal importance, containing some of Mrs. Post's best acquisitions. While the room is named after icons, there are fewer of these and more jewelry to be found in this part of the collection. One icon of particular note is seventeenth-century and represents all the saints of the month of March. It is one from a set for the entire year, which are not in the collection. Also displayed is a wonderful collection of enameled eggs by several important goldsmiths, two of which are the work of Karl Fabergé. One, in blue enamel, was given by Alexander III to his wife and the other, in pink, was given by Nicholas II to his mother in 1914. The Fabergé miniature gold model of the famous equestrian statue of Peter the Great in Saint Petersburg is astonishingly life-like. Also in the collection is the Russian Imperial Nuptial Crown, made in 1840, which consists entirely of diamonds and was worn at the weddings of the last three tsarinas. It is a fitting capstone to a collection that is termed the most representative collection outside the Soviet Union. Although often considered willful and indulgent, Mrs. Post preserved a segment of Russia's artistic patrimony that might otherwise have disappeared into the vacuum of its revolution.

The Pavillion, where Mrs. Post often entertained, houses an important Russian painting: *The Boyar Wedding*, the work of Konstantin Makovsky, which was completed in 1883. It was given to the Smithsonian Institution on the stipulation that it hang at Hillwood.

Today the spirit of Hillwood is much the same as it was when Mrs. Post lived there—a combined tribute to French and Russian art without peer in America.

THE WALTERS ART GALLERY

The Walters Art Gallery in Baltimore is the creation or two extraordinary men, William Thompson Walters and his son, Henry. The older Walters was the only rival of William K. Vanderbilt as a collector of nineteenth-century French paintings. William and Henry Walters were, in addition, the only rivals of Pierpont Morgan as collectors of medieval and Renaissance decorative arts, medieval manuscripts, and early printed books. Today the Morgan collection, except for the Morgan Library, is gone; by contrast, the entire Walters collection is preserved in the magnificent gallery that Henry built at the corner of North Charles Street and Mount Vernon Place. This is not a specialized collection, like the Frick or the Cloisters, but a general museum, with everything from Egyptian art to one of the finest jewelry selections of its kind. The Walters Art Gallery is undoubtedly the most important privately assembled general museum in the United States.

Like the great collectors of the Middle Ages and the Renaissance, the Walters were fascinated with history and genius, with the rich, the minute, the precious, and with man's creative instinct and its documentation. Like the Vanderbilts and the Huntingtons, the Walters were railroad barons; their Atlantic Coast Line dominated the traffic between North and South. Railroads were just as important a century ago as oil is today; competition was fierce, and those rail lines that survived did so through consolidation. It was men like the Vanderbilts, the Huntingtons, and the Walters who did the consolidating.

William Thompson Walters was born in Liverpool, Pennsylvania, in 1820. He began collecting early, and it is sometimes said that the first money he ever earned he spent on pictures. Like many residents of Maryland, Walters had strong Confederate sympathies as well as Southern business interests, and he spent the Civil War years in Paris. There he saw a good deal of fellow Baltimorean George Lucas, who acted as resident picture buyer for William K. Van-

derbilt and, eventually, for Walters, on the formation of whose artistic taste he certainly had a profound effect.

The Walters, father and son, became Lucas's greatest patrons, and over the years he guided the elder Walters in his selection of paintings of Millet, Corot, and the Barbizon School. Lucas got Walters to commission watercolors from Daumier—also a great favorite of Duncan Phillips—and he introduced Walters to the French animal sculptor Antoine-Louis Barye. In time Walters became his greatest patron, and Walter's enormous collection of Barye's work is now in the gallery. Walters interest in animals extended beyond sculpture. He introduced the Percheron, a huge and beautiful breed of work horse, to this country. He also published a book about them—as he did about Barye—being, in addition to all else, a lover of fine printing.

After his father's death, Henry Walters carried on splendidly with all the various family enterprises, including both the Atlantic Coast Line and the collection. Very little is known about his private or personal foibles—except that he liked to carry around a pocketful of jewels, so that he could toy with them. A Southern gentleman of the old school, he waited until the age of seventy-four to wed, then married a lady whom he had known for some time.

Henry Walters was a pioneer in the collecting of Byzantine art, a precursor of Robert Woods Bliss. A trustee of the Metropolitan Museum of New York, he characteristically refused the presidency but nonetheless gave the museum a beautiful Boucher, one that had previously belonged to Sir Richard Wallace. Walters's taste was much broader than that of his father, who had rarely strayed from nineteenth-century French painting. Henry's first collection, of classical art, was begun in 1899; and his early purchases include a statue of the late Etruscan-early Roman period. A small Roman Dionysos found at Le Thuit, France, and an Egyptian cat wearing gold earrings and a pectoral were acquired later. Walter's passion for classical art was confirmed with the extraordinary purchase of the entire Massarenti Collection of antiques, which included objects found in archeological excavations in many parts of Italy: bronzes from a late-Roman house at Bolsena, seven carved marble sarcophagi, bronze portraits of Roman emperors, and a gold-plated horse's head from the province of Ancona. In all, the Massarenti Collection had filled at least ten galleries and rooms in its former home, the Accoramboni Palace in Rome.

In time Henry Walters would assemble an impressive collection of paintings from the fifteenth to the eighteenth centuries, among them Perugino's *Madonna and Child, The Holy Family* by Ghirlandaio, and *The Way to Calvary* by Giovanni di Paolo. Some of his Old Masters came directly from Bernard Berenson's private collection.

In 1934, the Walters Art Gallery opened to the public with a collection that is extraordinary both in quality and diversity. Among its treasures are Renaissance armor, Japanese art, Chinese ceramics, Sèvres porcelain, Asiatic art, and watercolors of the American West. Long a place of pilgrimage for art lovers, this museum not only surveys the history of man's artistic achievement, but also possesses a special flavor given to it by the passions of two daring collectors.

THE STRATFORD HALL PLANTATION

Built in the 1720s, Stratford Hall, the home of the Lees of Virginia, is a truly American museum. Its watch-towers, set in the four blocks of chimneys overlooking the Potomac and its slave quarters, bear witness to violent epochs in the nation's past. The Lees of Stratford Hall were one of the great American families, whom John Adams called: "That band of brothers intrepid and unchangeable, who like the Greeks at Thermopylae, stood in the gap, in defense of their country, from the first glimmering of the Revolution . . . through all its rising light to its perfect day."

The head of the family was Thomas Lee, Justice of Westmoreland, a member of the house of Burgesses, and the builder of Stratford. In its heyday the estate was a wholly self-sufficient community centered on a plantation. At that time Stratford's extended household included family and relatives, house servants and tutors, slaves and indentured workers. An abundance of agricultural activity and trade provided ample revenues to the family as it did for the neighboring members of the landed aristocracy in the Tidewater region.

By 1794, however, the house and outbuildings were in disrepair and "Light Horse Harry" Lee, a prominent member in "the band of brothers" who was far more interested in politics than in farming, was unable to manage the farm productively. In 1822, Stratford was sold by Harry Lee when his youngest son, Robert E. Lee, was only three. Thus the most famous of the Lees did not grow up in his forefathers' home and was forced to seek his fortune elsewhere. During the Civil War Robert E. Lee was made head of the Confederate Armies, fought gallantly against his enemies, and won the admiration of all who fought by his side.

After the defeat of the Southern Armies, the general, by then a revered hero, wrote to his wife on Christmas Day 1863: "In the absence of a home, wish I could purchase Stratford. That is the only other place, accessible to us, that could inspire me with feelings of pleasure and local love." He never succeeded in returning to Stratford. He became president of Washington College in Lexington, Virginia, where he lived until his death in 1870.

The mansion never did return to the Lee family, although their presence is felt everywhere in the woods that surround the plantation. Wendell Garrett, in the magazine *Antiques*, describes the family thus: "The Virginia Lees, characterized by close family alliances and led by dominant figures, constituted a governing class in the commonwealth and in the nation. What Samuel Johnson once said of great eighteenth-century English families might well have been said about the Lees: 'A well-regulated great family may improve a neighborhood in civility and elegance, and give an example of good order, virtue, and piety.'"

Restoration of the Lee mansion was carried out through the willpower and determination of Mrs. Charles Lanier of Greenwich, Connecticut, the daughter of the Southern poet Sidney Lanier, who borrowed money to buy the house in 1929 and succeeded in raising funds to pay back the loan during the Depression. The architect of the restoration was Fiske Kimball, director of the Philadelphia Art Museum and a great admirer of another great Virginian, Thomas Jefferson. In 1936, the house was opened to the public. The struc

ture itself is red brick and H-shaped, with a separate building set at each corner. The house is an unusual variation on the plantation architecture that is found elsewhere with its massive blocks of chimneys at either end and an unadorned outside staircase that narrows as it rises toward the small front door. In contrast with the elegant and comfortable interior, the fortress-like exterior gives the mansion a distinctly forbidding overall aspect. The most unusual and striking room in the house is the Great Hall, which forms the cross-arm of the H-design; it has a seventeen-foot ceiling, unusually high for the time, and no fireplace, being used only in the summer.

The interior of Stratford Hall is now fully restored and furnished with period pieces. Foremost among these is a combination desk and bookcase, made of mahogany in Salem, Massachusetts, that once belonged to General Robert E. Lee himself. The rooms are furnished with eighteenth-century English and American furniture and several paintings of members of the family. The most recent addition to the plantation is the du Pont Memorial Library. Jessie Ball du Pont, "Miss Jessie," a Virginian and the library's donor, was the first director from Delaware and the association's most generous benefactress. The library houses a collection of rare eighteenth-century books. The restoration at Stratford Hall is an unquestionable success and has restored this eighteenth-century plantation in all its detail. Ironically, this most historic of all Tidewater mansions owes its present glory to not one but two Northern ladies.

MONTICELLO

Monticello is both a national landmark and a keystone to American architecture. It was designed by Thomas Jefferson, revolutionist, diplomat, governor of Virginia, Secretary of State, and third President of the United States. Jefferson began construction of Monticello in 1769, when he was twenty-six years old, and continued to work on it for the next forty years.

Considered to be as avant garde for his day as Frank Lloyd Wright was several generations later, Jefferson produced a host of innovations. The dome of Monticello, for instance, inspired the United States Capitol and the Jefferson Memorial in Washington. In addition to Monticello, Jefferson designed the buildings for the University of Virginia, considered to be one of the most beautiful college campuses in America, and the state capitol building in Richmond, Virginia. But it is Monticello which places Jefferson firmly in the ranks of this country's great architects. He began construction of the house on a 640-acre parcel of land south of Charlottesville, completing it in 1809 at the end of his second term as President. Far above the waterways, which plantation houses customarily flanked for the sake of transportation, it commands a spectacular view, of which Jefferson wrote, "And our dear Monticello, where has nature spread so rich a mantle under the eye? Mountains, forests, rivers, rocks . . . With what majesty do we there ride above the storms. How sublime to look down into the workhouse of nature, to see the clouds, hail, snow, rain, thunder, all far beneath our feet!"

While he had no training in architecture, Jefferson assembled a collection of books on the subject. Although Georgian architecture was the style of his day, he rebelled against it, preferring a Palladian

The kitchen of Stratford Hall Plantation displays American utensils, furniture and copperware.

design enlarged to encompass elements of classical revival architecture: Roman domes, Greek columns, red-brick walls, and white trim.

Appointed Minister to France in 1784, Jefferson left Monticello for five years. While there he lost no opportunity to visit the great architectural monuments of Europe. He was especially taken by the Roman ruins in the south of France and, in particular, the Maison Carré at Nimes, which he used as the basis for his design of the Virginia state capitol. On his return to Monticello Jefferson changed many of the plans he had made for the house. He was keen to develop a pecularly American style of architecture, embodying the lessons to be learned from classical building.

When he was first planning his house, Jefferson designed after Palladio, as the main order of the building illustrates. He was one of the first in America to turn to this Renaissance authority on Roman architecture. Palladio's great work, *I quattro libri dell'architettura* (1570) was not well known in this country; Jefferson had one of the few copies.

Although he made many drawings for Monticello, only the south pavillion, begun in 1769, was finished when he and the twenty-three-year-old Martha Wayles Skelton moved in on a winter's night some two weeks after their wedding. Construction was not finished for another ten years. Progress was slow because the brick and the lumber came from the estate, and everything was built or made by hand. In 1773 the work was principally on the brick walls; in the following year the middle portion of the house and the south wing were completed. During the strenuous period of the Revolution, Jefferson still managed to push the work forward, and by 1779 the house was nearly complete.

Monticello is the repository of many of Jefferson's inventions. Among them are the seven-day calendar clock with its cannonball weights and a set of double doors between the front hall and the parlor that opens simultaneously when either is moved. A weather vane, connected to a dial on the ceiling beneath, can be read from several places within the house. Jefferson's bed is placed in an alcove in such a way that it is open to two rooms instead of one, and Monticello is also the first house to feature a dumb waiter, which Jefferson invented to carry wine from the cellar to his kitchen.

Jefferson lived at Monticello for fifty-six years. He died there on July 4, 1826, fifty years to the day after the signing of the Declaration of Independence. Unable to maintain the property thereafter, his daughter sold it, retaining the rights to the family burial ground where her father was buried. It was sold first to James Turner Barclay, who planned a silk-worm farm there. When it failed, he sold Monticello to the naval officer Uriah Phillips Levy, a great admirer of Jefferson who willed Monticello to the "people of the United States." His family successfully contested that will, however, and the estate passed into the hands of Jefferson Monroe Levy, a nephew, who spent the next fifty years restoring the buildings, which had fallen into such disrepair that at one point they had been used to shelter cows. In 1923 it was taken over by the Thomas Jefferson Foundation.

Through research, repair, and restoration, the Monticello of today is much as Jefferson left it. It stands as a fitting tribute to the only real polymath among the nation's presidents. John Kennedy, presiding over a White House dinner for Nobel laureates, acknowledged this when he told the assembled guests that they represented the most learned group ever to dine under the White House roof—"with the possible exception," he added, "of when Thomas Jefferson dined here alone."

A pond in the ten-acre formal gardens at Vizcaya, designed by the landscape architect Diego Suarez.

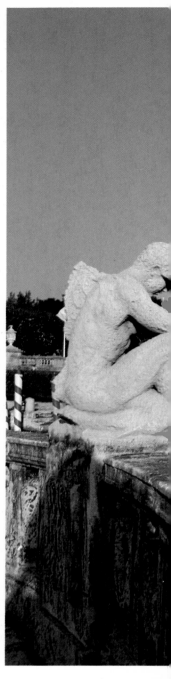

Boat mooring on the estate, which James Deering purchased in 1912.

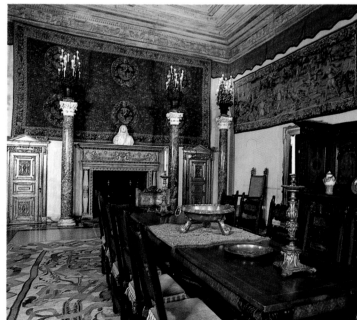

The Banquet Hall, decorated with several tapestries dating from the sixteenth century, also includes furniture from that period and two Deering family portraits.

102

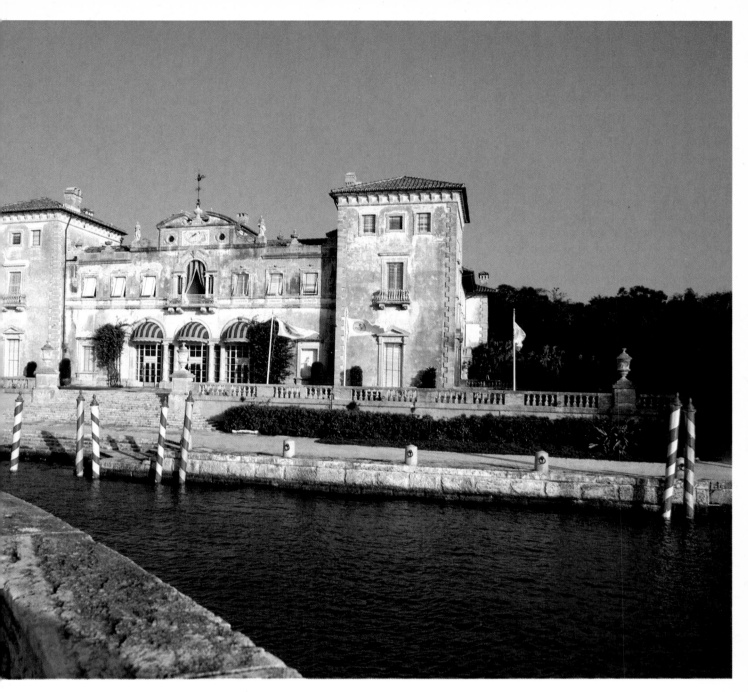

Vizcaya, which fronts the Atlantic Ocean, was designed in 1914 by the architects F. Burrall Hoffman Jr. and Paul Chalfin to incorporate the best architectural features of the Italian, French, and Spanish palace-fortresses of the seventeenth century.

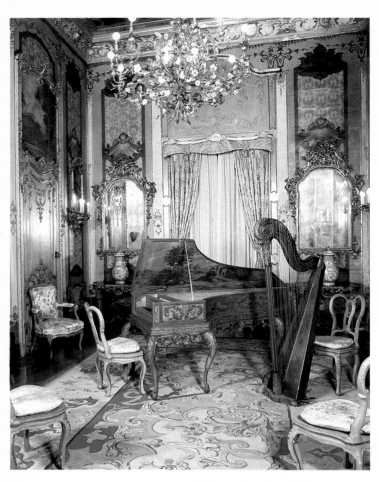

The music room at Vizcaya.

Vizcaya's large stone barge was designed by A. Stirling Calder (1870–1945) as a breakwater. It was here that Deering arrived on his yacht Nepenthe to open the mansion on Christmas Day, 1916.

The Venetian museum was built
by John Ringling to house his
collection of European paintings
by Rubens, Tintoretto, Rem-
brandt, El Greco and Velazquez.
The bronze statue at the center
of the museum's cloister is a
copy of Michelangelo's marble
David. At Ringling's behest, this
version is twice the size of the
original.

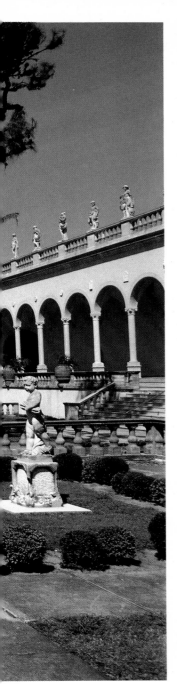

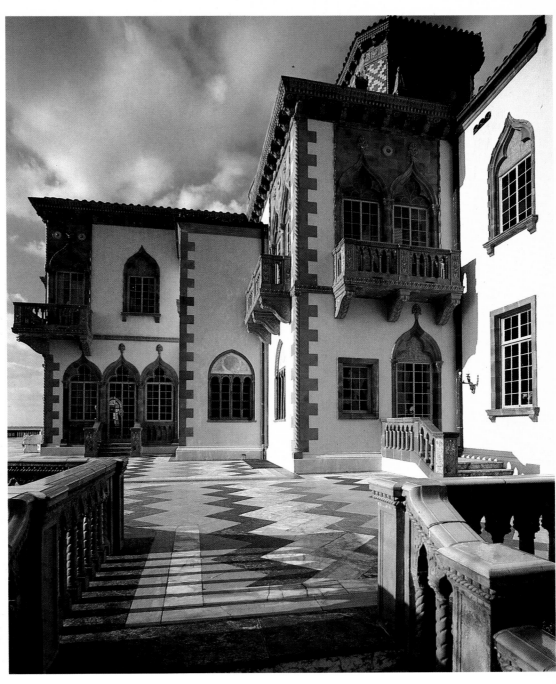

Cast stone, lavender marble, and masonry of many tints were used to decorate the exterior of Ca' d' Zan, Venetian for "John's House," built in 1926.

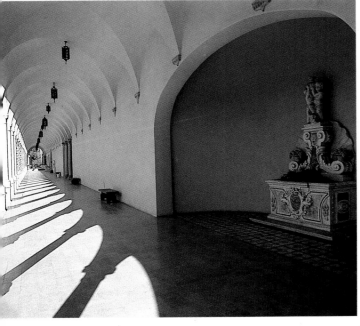

A vaulted gallery at Ca' d' Zan.

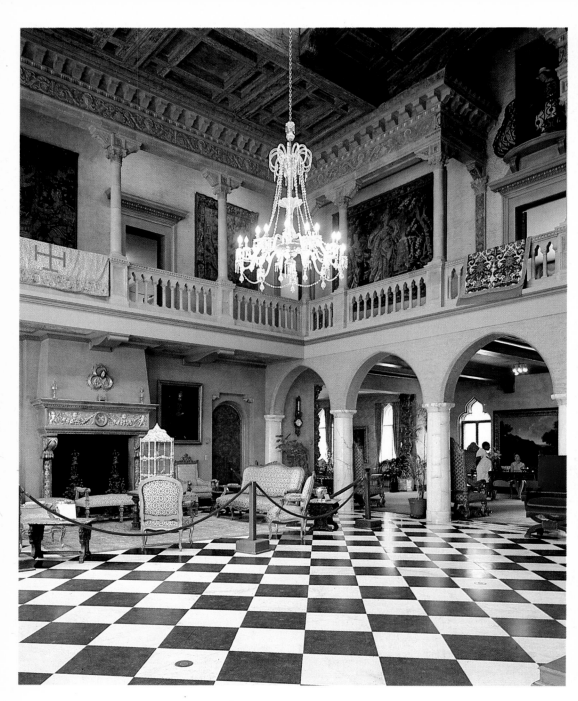

Mexican onyx pillars support a balcony that surrounds the great hall on three sides. Flemish tapestries of the seventeenth-century are hung on the walls of the court which was used as the main living room of the mansion.

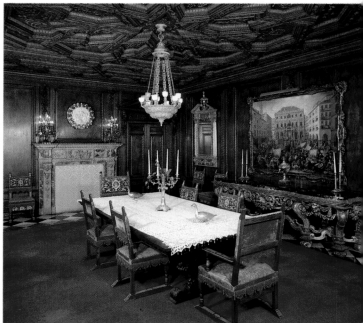

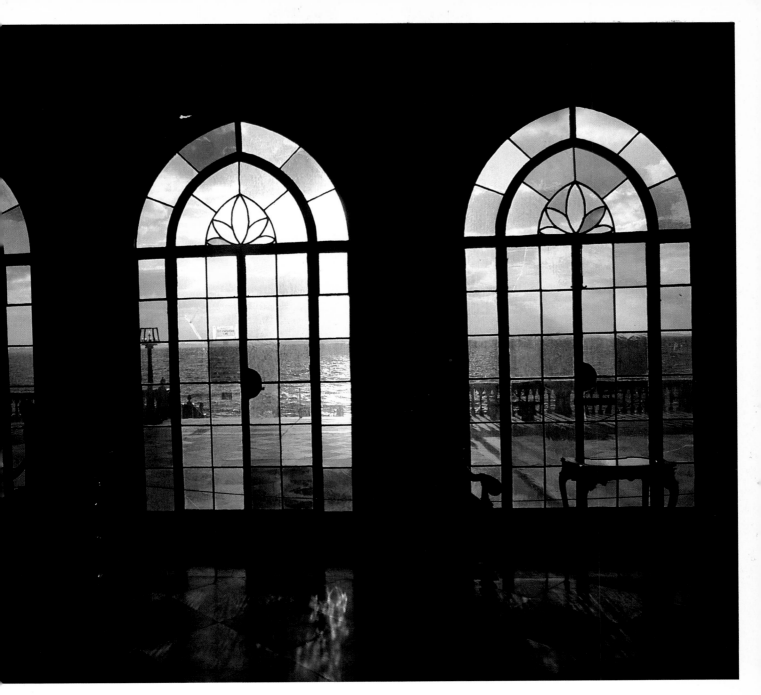

Many windows in the mansion have panes of hand-blown Venetian glass, tinted in rose, violet, green and blue. Some of the arched bronze frames were bought in Venice by John Ringling.

Much of the furniture for this house was acquired from the Vincent Astor and Jay Gould collections. The State Dining Room has a tondo over the fireplace in the style of Della Robbia and a painting by Granieri on the right wall entitled Crowded Market Place.

following page:
Mable Ringling had much to do with designing the mansion, whose final planning was the work of Dwight James Baum of New York. The roof of red barrel tile, imported from Barcelona, is topped by a tower that rises to 61 feet.

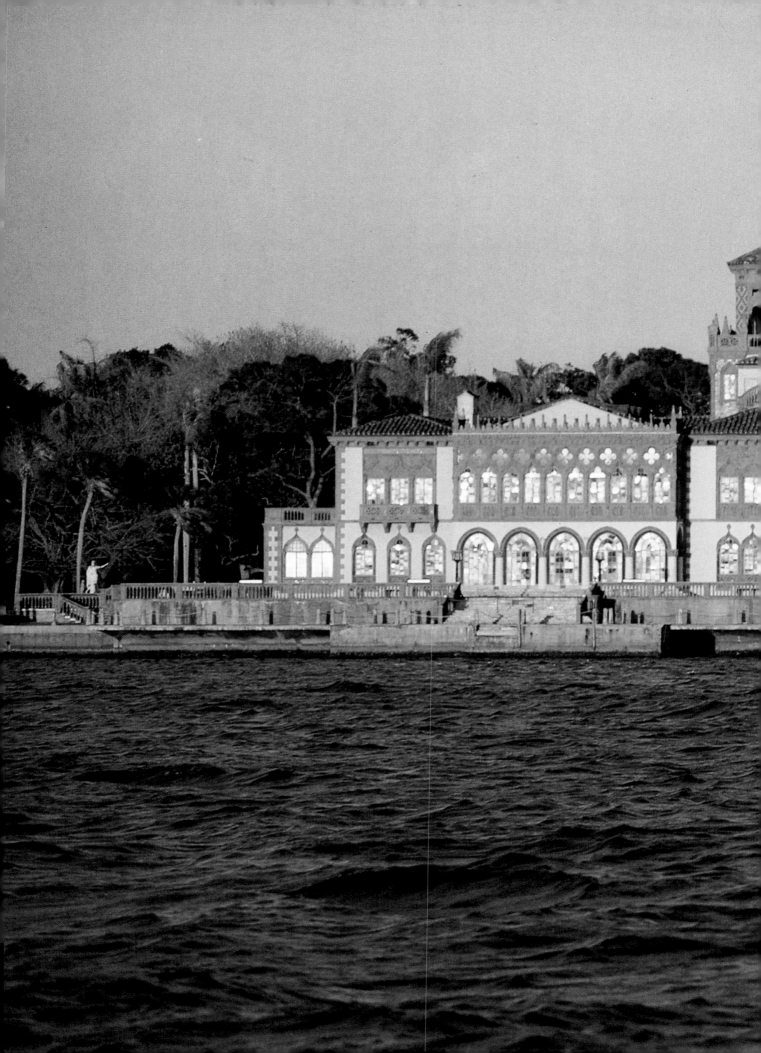

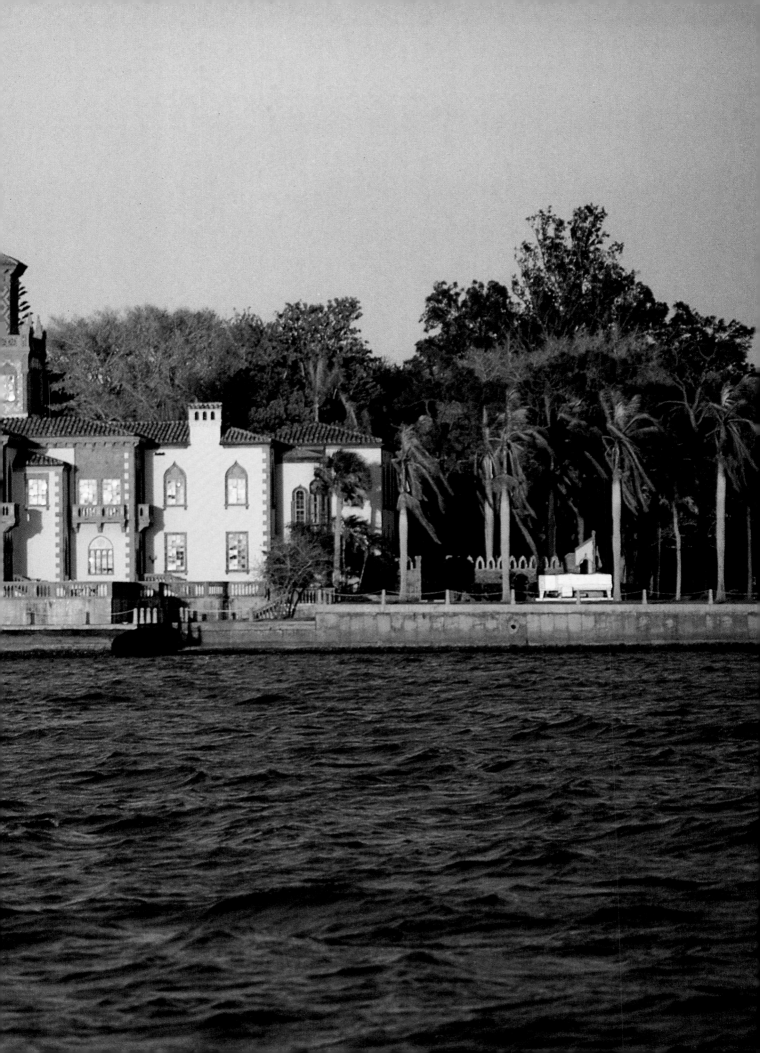

Men rebuilding St. Bernard's Monastery on its present site in Miami, Florida. It was William Randolph Hearst's death in 1951 that cleared the way for the dismantled monastery's sale in 10,761 crates to Mr. Moss and Mr. Edgerton.

St. Bernard's, purchased in the 1920's by W.R. Hearst to fit around his swimming pool, was transported from Segovia in Spain, where it had stood since 1141. When it finally arrived in New York harbor, customs officers quarantined the stones because the hay in the crates was thought to harbor an infectious disease.

Originally the home of Cistercian monks, St. Bernard's Monastery has unusually few details of Moorish design.

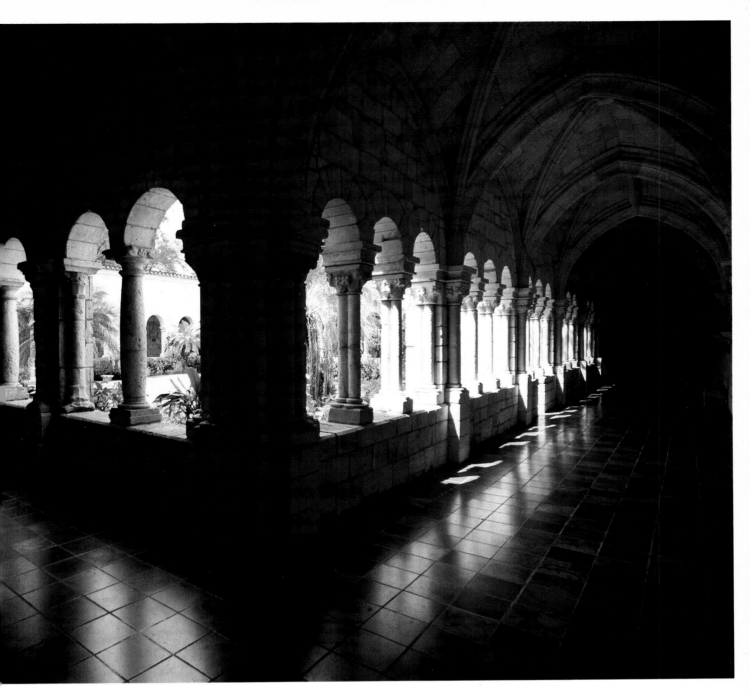

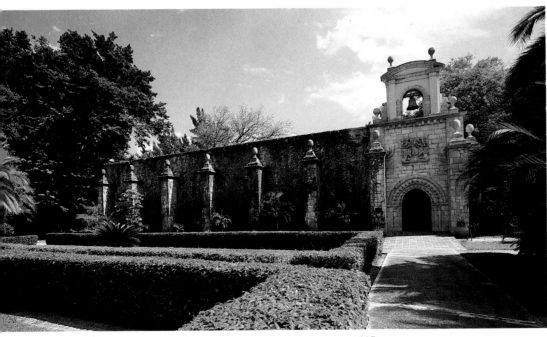

*The monastery was later pur-
chased by the St. Bernard's
Foundation and opened to the
public in 1965.*

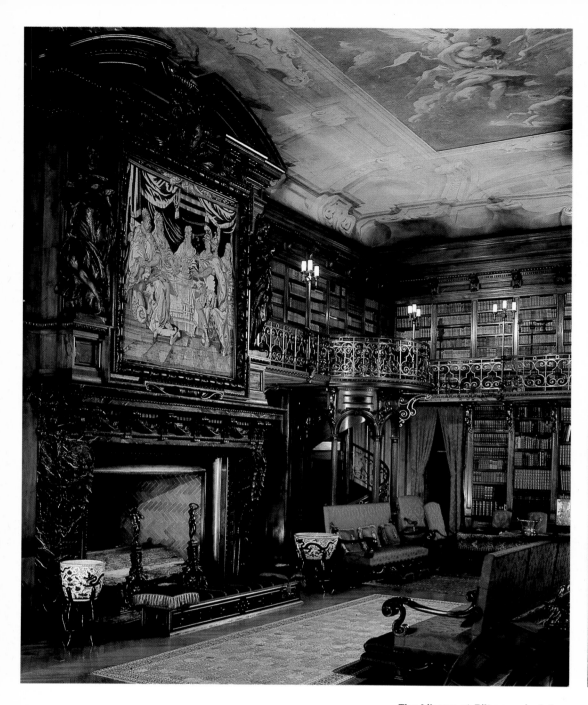

The Library at Biltmore, in Asheville, North Carolina, contains 20,000 volumes. The ceiling of the library, acquired from an Italian palace, is attributed to Giovanni Antonio Pellegrini (1675–1741).

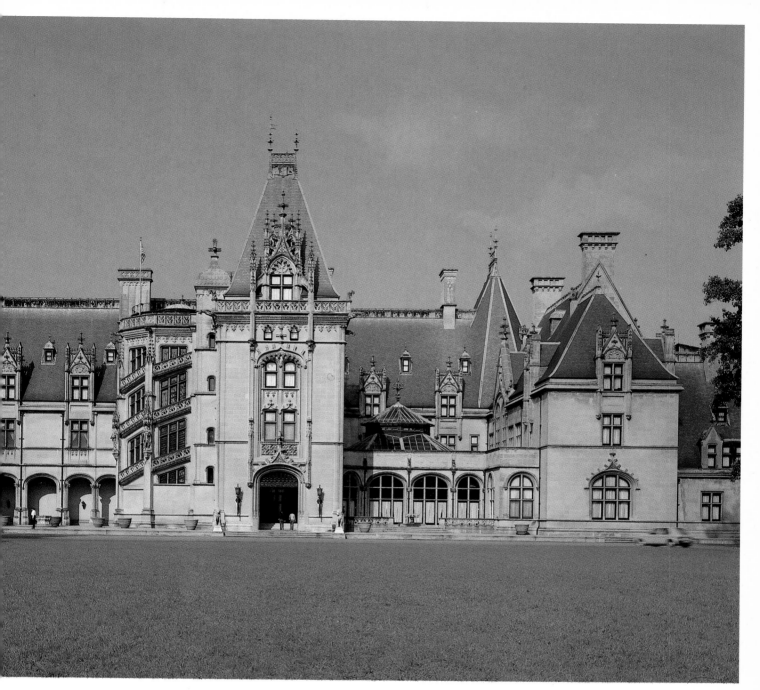

Biltmore House was built in five years by a crew of five thousand workers. The house itself, an amalgam of French Château architecture, was designed by William Morris Hunt; the extensive grounds were laid out by America's foremost landscape architect, Frederic Law Olmstead, and was completed in 1895, when George W. Vanderbilt was twenty-six years old.

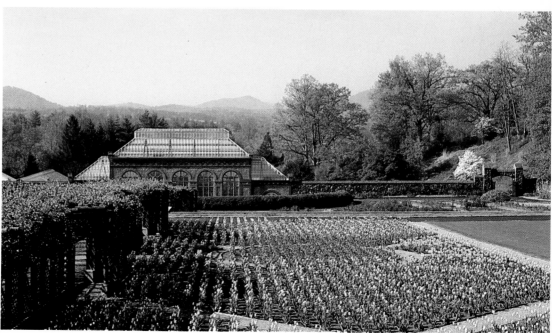

Walled garden and conservatory during the tulip season.

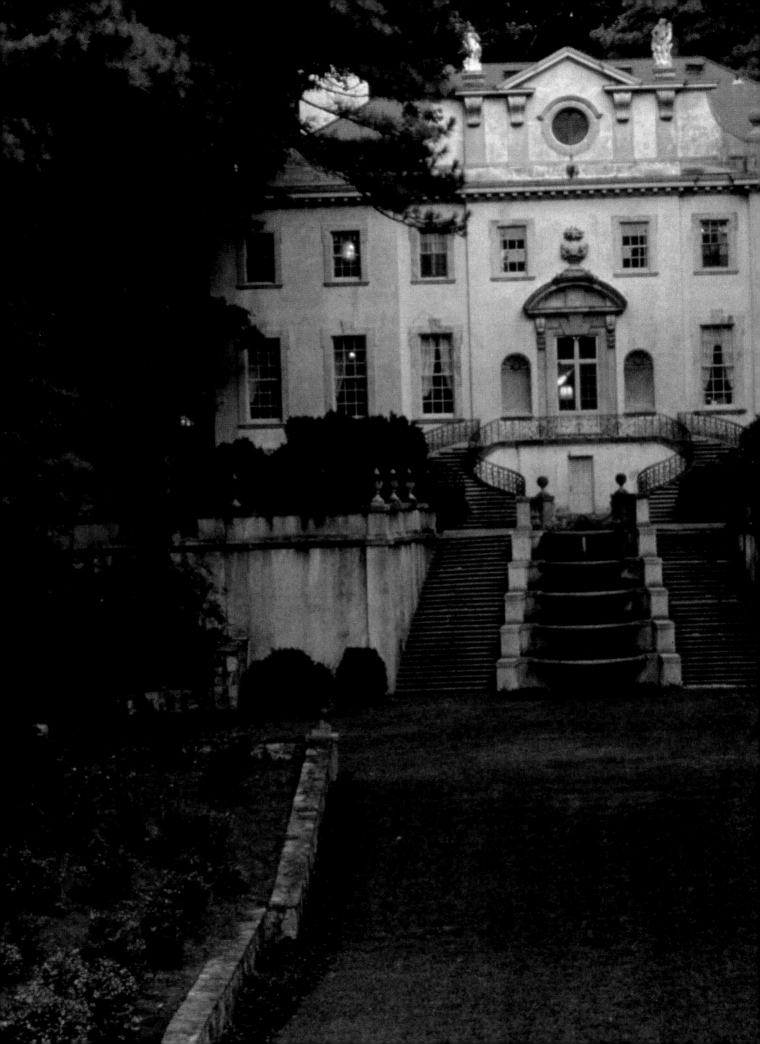

A pair of intricately carved eigh-teenth-century English console tables by Thomas Johnson; the bases depict swans among reeds and water plants.

Swan House was completed in 1928 for Mr. and Mrs. Edward H. Inman; its architect was Philip T. Schutze. A classical façade on a rising slope, it has a double stair descending on either side of a cascade.

following page:
The Rothko Chapel in Houston, Texas, was formally consecrated by representatives of several religions and dedicated by its founders, John and Dominique de Menil, to world spiritual com-munion. The 14 panels which now hang in the octagonal chapel were commissioned in 1964 from Mark Rothko.

page 120:
Barnett Newman's Broken Obe-lisk, executed in 1967, is situ-ated in front of the chapel. The plans for the building were drawn by Philip Johnson in col-laboration with Mark Rothko and the structure was completed in 1971 by Howard Barnstone and Eugene Ashby.

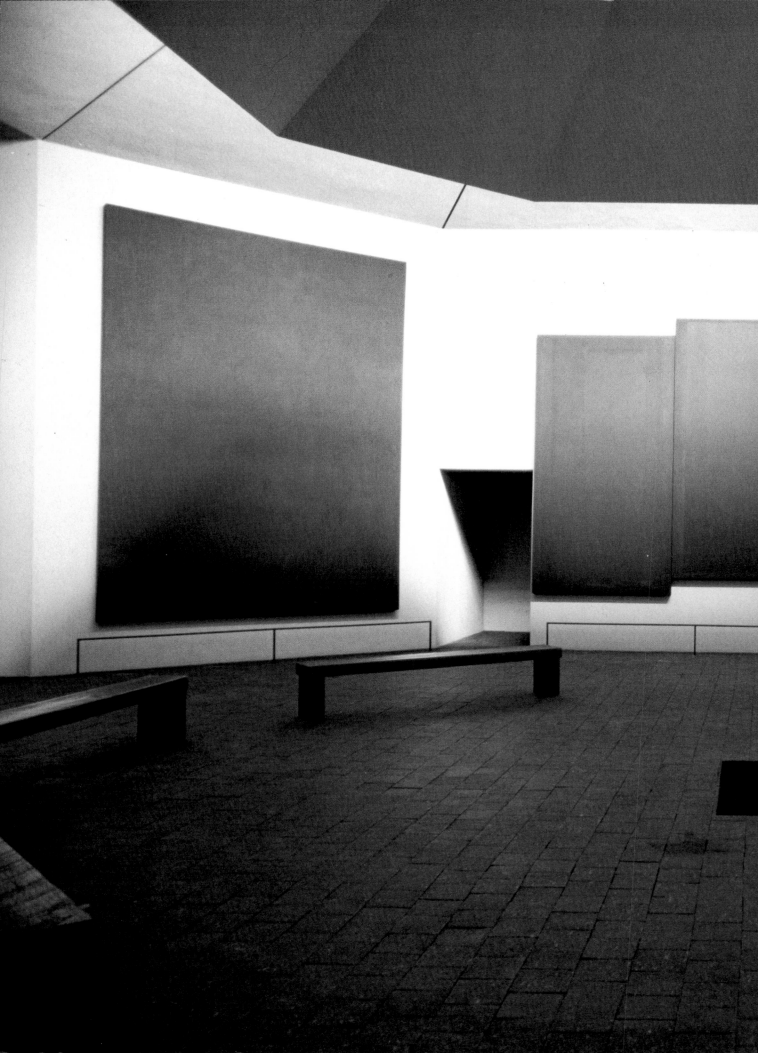

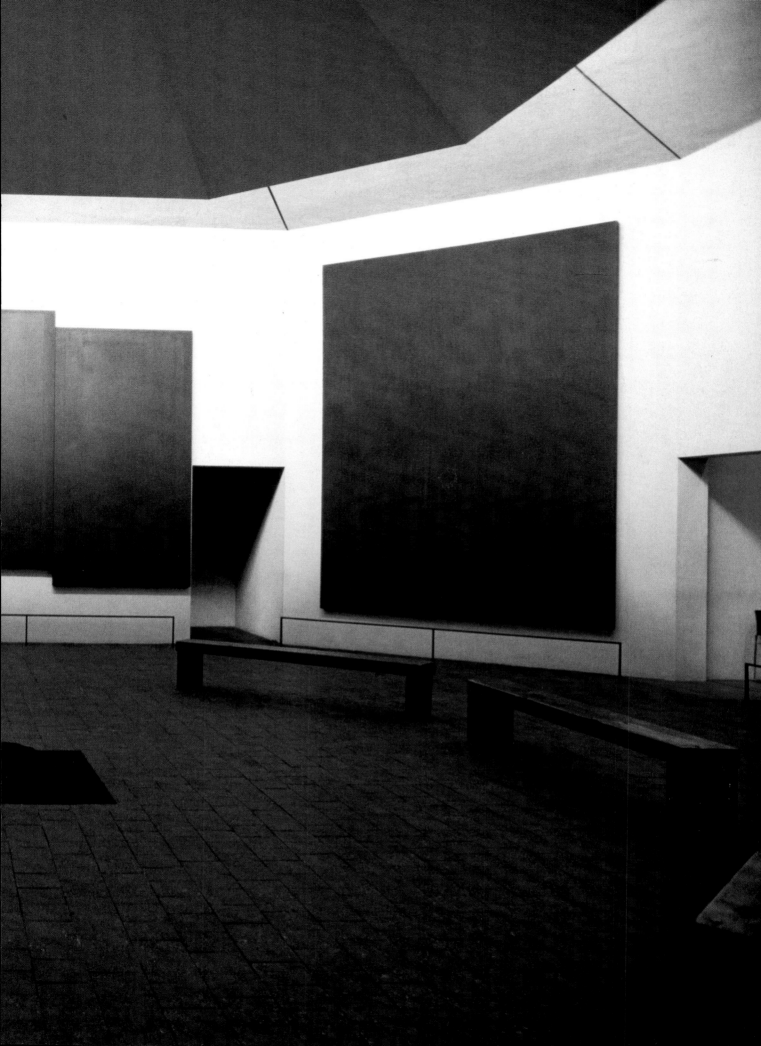

ECHOES OF THE SOUTHERN STATES

Florida was a sparsely populated state composed of low-lying savannah land, mangrove swamps, and empty white beaches when Henry Flagler, oil man and partner to John D. Rockefeller, arrived there in 1883. Taken by its natural beauty, Flagler, with the backing of several northern businessmen, set out to create an American Riviera along Florida's Atlantic coast.

He began by building a railroad line five hundred miles down the peninsula. It was later extended to join the mainland with Key West, at the state's most southern point. This segment however, was destroyed by a powerful hurricane in 1926. Its foundations, when the rubble was cleared, became the roadbed for the last miles of U.S. Route 1. Flagler also built churches and schools. In Palm Beach, hoping to attract northern investors to do the same, he built himself a marble palace called Whitehall.

VIZCAYA

When James Deering, scion of the International Harvester Company, was told to slow down by his doctors, he began to look for a place to build the castle of his dreams. He followed Henry Flagler to Florida, choosing Miami as the place to build.

After attending M.I.T., Deering began working for the family business as a machinery salesman. He travelled throughout the midwest until 1902, when the Deering Company merged with McCormick Harvester Company to form International Harvester, of which James Deering eventually became the vice president.

At the time his younger brother, Charles, was studying art in Paris, where he befriended the American portrait painter John Singer Sargent; James also moved to Paris, and managed the company's European office.

When he quit his job, James began to travel around Europe collecting art. It was to become his full-time occupation. A variety of objects caught his eye, some of them not necessariliy constituting "art": a Roman bath among the ruins of Pompeii, the interiors of several Italian palazzi, and the tiles from a Cuban village—to roof the house he had yet to build.

While Ca'd'Zan was Ringling's sideshow, Vizcaya (Spanish for Biscayne) was Deering's entire existence: everything was to evolve around its construction and embellishment. When Deering arrived in Miami in 1910, it was a black-mud swamp. Within its confines he created, among other things, the best Renaissance garden to be found in the United States and the largest stone barge in the country.

The man on whom Deering most depended for the creation of his house was the painter Paul Chalfin. When the two men spent a year in Italy studying Italian architecture, they discovered the Villa Rezzonico, a severely elegant seventeenth-century mansion, which became the basis for the design of Deering's house. With the help of New York architect Burell Hoffman, Chalfin incorporated details from all manner of Palladian buildings and the result was a mansion of seventy rooms as unique in its design as the Doge's Palace and Madison Square Garden.

In 1912, when the drawings for the house were complete, Hoffman was asked to incorporate all the architectural fragments and decorative pieces Chalfin and Deering had accumulated. Hoffman was aghast when he was taken to a New York warehouse and shown such objects as a twenty-five-foot-high Renaissance fireplace taken from the château of Chenonceaux.

According to James Maher, author of *Twilight of Splendor*, Deering interfered far less than most palace builders with the men who worked for him. He did not think of himself as the architect or inventor of his house; instead, he hired men who knew how to build and let them get on with it.

In Florence, Deering and Chalfin encountered a Colombian landscape architect, Diego Suarez, whose specialty was formal Renaissance gardens. Chalfin, who had convinced Deering that his Miami palace should be Italianate in design rather than Spanish, also persuaded him to carry the theme into the gardens. Suarez was hired to create a Renaissance garden for Vizcaya, which he built on several levels, including a secret one, completely enclosed in sculptured walls, with stairs leading to hidden grottoes. Vizcaya also features a theatre garden with a raised stage, a circular tea garden,

In the gardens of Vizcaya, a marble bust being prepared for restoration.

and a garden with a seventeenth-century fountain from Bassano di Sutri, near Rome.

Vizcaya was formally opened Christmas Day, 1916. Deering, in the company of a few friends, arrived by boat. Christmas lunch was eaten off china, while later dinners would be served off gold platters.

The tall entrance doors are taken from the Hotel Beauharnais in Paris, once the palace of Napoleon's stepson. Two urns near the door are of Egyptian granite, made during the craze for Egyptian art that followed Napoleon's campaign in North Africa.

The Adam-style library is typical of the best work of the Adams brothers, held in great repute in the history of English architectural design. Among the library's contents is an eighteenth-century rug from a loom set up in Madrid by Bourbon kings, trying to emulate those of La Savonnerie in Paris.

A reception room has a plaster ceiling from Palazzo Rossi, built in Venice in 1750. An adjoining telephone room has Venetian furniture, a Spanish chest, and carved walnut sixteenth-century Umbrian columns.

The great hall of Vizcaya recalls the high Italian Renaissance. The lofty wooden ceiling is in the style of Sansovino, whose two buildings flank the Piazza San Marco in Venice. The chandeliers are from a Spanish cathedral.

The east loggia has doors and ornaments from the Palazzo Torlonia in Rome. A dolphin table is from the Sciarra Palace in the same city and the large blue-and-white fish bowls are seventeenth-century Chinese.

Deering enjoyed all this splendor for ten years. He died in 1925, while returning home from Europe aboard the liner *Paris*.

The hurricane of 1926 flooded Vizcaya's cellars, wrecking its heating plant. For years the mansion was dank in stormy weather until money was raised by volunteers to repair the damage; today Vizcaya is administered by Dade County.

Lillian Gish, who had visited Vizcaya as a young actress, told Deering's biographer, James Maher, "I had the impression that Mr. Deering was not interested in women. But then, he certainly wasn't interested in men either. He was tied up in things that interested him—whatever they may have been." Foremost among those things was Vizcaya, his opulent palazzo on Miami's Biscayne Bay.

THE RINGLING MUSEUM

The Ringling Museum and Ca'd'Zan, a Sarasota on Florida's west coast, were bui by John Ringling, the circus king. In Vene tian dialect Ca'd'Zan means John's house and indeed this sprawling compound was once Joh Ringling's house. It contains the best Baroque mu seum in America, Medici-style gardens, a circus mu seum, and an eighteenth-century Italian theatre.

Ringling was one of the first of the nineteenth-cer tury's self-made millionaires to discover the Gu Coast of Florida. Still remote when Ringling arrivec it provided him with all the space in the world to re alize his ambitions. He constructed the first cause way connecting mainland Florida with the keys o Florida's west coast. Envisioning a major lan boom, he built his own house, vaguely inspired b the Doge's Palace in Venice, on the grandest c those keys.

Ringling was a circus man first and foremost. An Ca'd'Zan is a showman's house. Only a part of hi passion lay in creating Ca'd'Zan, but it certainly se the stage for John Ringling's grandly theatrical wa of life. He was a gambler and the combination c home and museum proved to be one of his bes bets. His brother, Charles, who was very much hi partner, also built a mansion nearby, which is th centerpiece of the University of South Florida.

John Ringling's career in show business began a sixteen when he became a singer and dancer i "The Ringling Brothers Classic and Comic Concer Company." In 1884 he and his brothers launche their first circus, which took place in a tent seatin an audience of a few hundred people. Later the transformed their wagon caravans into railroad cir cuses and changed the name of the performances t "The United Monster Shows." Their popularity grev fast. By 1907 John Ringling was able to buy out hi principal rival, The Barnum and Bailey Circus, an audiences for the combined acts were more thai fourteen thousand at each performance. John Ring ling married a performer in one of his shows, Mabl Burton, who later proved to be as interested as he i artistic matters. She played a major role in the plan ning of the Sarasota complex.

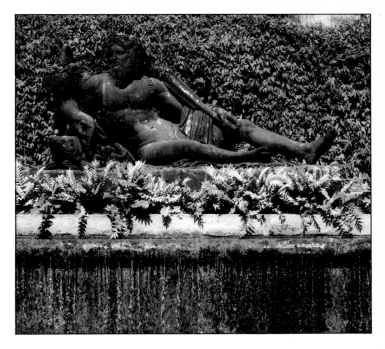

A sculpted fountain in the formal garden of the Ringling Museum.

John Ringling made regular tours to Europe to find new acts for his circus. In 1925 he met Julius Böhler, one of the major art dealers of the day and consulted him about his idea to erect a museum. Under Böhler's guidance Ringling made his first acquisitions, a noble Veronese, *The Rest on the Flight into Egypt,* and Luini's *The Madonna and Child with SS. Sebastian and Roche.* The Veronese had been in the Electoral Galley at Dusseldorf and the Luini in the Ducal Palace at Weimar.

Various successful enterprises, including speculation in oil, enabled Ringling to begin work on his museum. In 1927 he commissioned a New York architect, John Hyde Phillips, to design and erect a building to house his collection. As Ringling conceived it, the museum would have fifty galleries. It would take him four years to buy the bulk of his collection. Aside from buying traheze artists and trained bears, his collecting up to now had been confined to buying furniture and entire rooms from demolished New York mansions. He had bought whole rooms from Vincent Astor's and Jay Gould's mansions before they were torn down. Their contents furnished Ringling's Florida palazzo.

Ringling built his collection by amalgamating other established collections. His detractors said his criterion for picture quality was based on where they had hung before; more objectively Ringling was said to be a good judge of painting, perhaps because he had spent so much of his life staging shows. Certainly he was a clever and outrageous buyer, and he didn't flinch at a high price if a work caught his fancy. He began to tour the great houses of Europe and the auction rooms of New York and London and, when possible, negotiated for an entire collection rather than one or two works, as Frick or Mellon might have done.

One of his major coups, the critic Denys Sutton says, came when he heard that Rubens' four large cartoons for *The Triumph of the Eucharist* had gone unsold at the Duke of Westminster's sale at Christie's in 1924 and were to be seen in the old ballroom at Grosvenor House, which was then still standing." Ringling realized that this acquisition would make him the only owner of large scale works by Rubens in the United States. His detractors said that Ringling was more taken with its provenance then its substance. It had gone from the palace of the Infanta Isabella in Brussels to the Church of the Discalced Carmelite Nuns at Loches. In 1808 they were moved from there by George Wallis, acting on behalf of William Buchanan, a noted dealer of the day, and, in turn they were bought by Bourke, the Danish ambassador at Madrid. He sold them to the first Marquess of Westminster.

John Ringling also bought pictures from such dealers as Duveen, A.L. Nicholson, who had a New York gallery, and Robert Langton Douglas. These acquisitions included Gainsborough's immense equestrian portrait of General Philip Honeywood. In 1929 he bought from Duveen the entire collection of Mrs. Oliver Belmont, which included a Madonna and Child from the school of Roger Campin, *St. Jerome* by Jacopo Sellaio, and Piero di Cosimo's *Building of a Palace,* which expresses the complex imagery of the Florentine Renaissance. Later he acquired another fabulous Rubens. This time it was *The Departure of Lot and his Family from Sodom,* which was presented by the City of Antwerp to the Duke of Marlborough after his victories after the French. Like the other Rubens, this too came from the Duke of Westminster's collection. From that source he also bought Salvator Rosa's *Allegory of Study.*

When it was completed, the Ringling Museum of Art incorporated shiploads of columns, doorways, and scuptures that Ringling had bought in Naples, Venice, Rome, and Genoa. It was laid out on three sides of a garden court and connected on the fourth by a bridge dominated by a statue of *David* by Michelangelo, cast at the Chiurazzi firm in Naples. An elevated loggia extends along three sides, capped with a balustrade surmounted by seventy two roof sculptures. In the terraced courtyard and throughout the gardens John Ringling placed reproductions of classical and Renaissance sculptures and fountains. The building was begun in July 1927, and although there were financial problems, it was opened to the public in January 1930. It remained sporadically open until Ringling's death in 1936—and opened permanently in 1948 with 'Chick' Austin as its first director.

Adjacent to the museum, added by the state of Florida in 1957, is a wing built to house the Asolo Theater, the only original eighteenth-century Italian theatre in America. It once occupied the great hall of the castle of Queen Catherine Cornaro in the hill town of Asolo, northwest of Venice. Like its Venetian prototypes, the

theatre has a horseshoe plan, rising tiers of boxes, and pastel and gold decorations. Built in 1798, it had a panoply of great actors and actresses who played there, before the theatre interior was purchased by the state of Florida in 1949 and shipped to Sarasota.

Also added after Ringling's death was the Museum of the Circus, which, as Denys Sutton says, would have delighted the likes of Degas, Edmond de Goncourt, Sickert, or Toulouse-Lautrec. It contains many unusual prints and posters, and such extremely decorative works as the *Cage Wagon* of the early 1900s, the *Lion and Gladiator Bandwagon* (c. 1910) and the *Two Jesters' Calliope Wagon* of 1920.

The last year's of Ringling's life were plagued by troubles. Mabel Ringling died in 1929; the Florida land boom came to an end with Depression and because of it he lost control of the family circus. He refused to sell any of his collection when hard-pressed for cash—he believed that good times were just around the corner.

His financial troubles led to the loss of a lease he held on Madison Square Garden to another show, the American Circus Corporation. He turned the tables by buying it, but then could not meet the note of $1,700,000. Ousted from his throne, Ringling's circus was taken over by a group headed by Sam Gumpertz. Years later a nephew, John Ringling North, regained family control.

In his comparative poverty, Ringling retired to spend the last years of his life in seclusion at Ca'd'Zan with a skeleton staff of servants. Shortly before his death he was driven to Pensacola to see the first big circus parade he had witnessed in fifteen years. He stared at it with a faraway look, and with tears in his eyes he asked to be driven home. When he died in 1936 he only had $311.00 in his local bank account.

Denys Sutton best completes the Ringling story: "The elephants have left Sarasota, but a sense of fun still radiates the Ringling Museum. That the Baroque and Rococo are honoured there is as it should be; they were styles of illusionism and fantasy; they contribute embellishment of life, and so does John Ringling's vision of life."

William Randolph Hearst was a supreme example of the omnivorous collector. A driving and restless man, he had an obsessive need for possessions, particularly works of art. His accumulation of medieval and Renaissance objects was so vast that he ceased to know what he owned, let alone what he intended to do with them. He spent millions of dollars on art—and like Morgan, the total was more than he could afford.

Hearst was not a selective collector. He did not have time to consider individual objects carefully, for he was busy running more newspapers than any other man in the United States—and running them personally, scribbling "MUST ! WRH" atop each piece he wanted printed. Hearst said that he detested tranquillity, and buying art helped him avoid it, particularly during the Depression. According to his biographer W.A. Swanberg, Hearst simply could not stop buying: "It was understood everywhere that he could not take a normal view toward art, could not appraise a piece according to cold market value, set a top price and stick to it. When he bid for something, it was seldom with a hard-headed take-it-or-leave-it attitude, but with the idea that he *must* have it." The thought of losing a coveted work to another collector was sheer anguish to Hearst, who was aware of his own weakness, but powerless to correct it. "Even when he entrusted the bidding to an agent," Swanberg notes, "he would be bitterly disappointed and often reproachful if he lost an item or two to another bidder. Thus, the agents came to understand that, with Hearst, price was secondary, the primary object was to make the purchase. The result was that most of what he bought was at highly inflated prices. Experts later estimated that he had paid somewhat over twice the value of his holdings."

Hearst maintained two warehouses to house his purchases. By 1937, however, he had stopped buying because the Depression had had a devastating impact on his fortunes. His spending had left his enterprises with scanty reserves, and Hearst's newspapers in Rochester, New York, Omaha and Pittsburgh were forced to close.

Curtain call in the Asolo Theater. Built in 1769, on a hill near Venice, it was dismantled in 1949 and brought to the Ringling Museum in Florida.

Construction was temporarily halted on Hearst's castle at San Simeon in California, and many of the art objects he had stored were put on sale at Gimbel's in New York City. Gimbel's turned over the entire fifth floor to this unprecedented sale, which went on for a year. Some objects did not do well—a Van Dyck portrait for which Hearst had paid Duveen $375,000 went for $89,000—but despite considerable critical sneering, the sale was considered a commercial success. Many people bought an object or two just to own something that had once belonged to Hearst.

Among the items for sale at Gimbel's—through photographs—was the monastery of Sacramenia, in central Spain, which Hearst had bought in 1925 with the idea of reconstructing it at San Simeon, perhaps around a swimming pool. The monastery consisted of a twelfth-century romanesque chapter house and cloister first named in honor of St. Mary Queen of the Angels. But after the canonization of St. Bernard of Clairvaux it was renamed in his honor, and it remained a Cistercian monastery, as his order was called, until the 1830s, when the building was confiscated by the government and used as a barn.

At the time of its purchase by Hearst, the round arches of the cloister were blocked up with limestone and rubble. One of them was opened so that photographs could be made of the interior and sent to him. He promptly payed $500,000 for the ancient building and had it dismantled. A record was made of the exact location of every stone in the structure.

When the shipment arrived in the United States it was seized by U.S. Customs because of a recent outbreak of hoof-and-mouth disease in Spain. All 11,000 crates were opened, the stones removed, and the hay that had been used for packing was burned. The stones were then put back in the crates, but not in the original order, and the crates were stored in New York. Photographs of the monastery, exhibited at Gimbel's sale, produced no buyer, and the crates remained in one of the Hearst warehouses for twenty-six years. In 1952 the building was bought by an entrepreneur who erected it as a tourist attraction in North Miami Beach. Putting the stones together took nineteen months and cost $1,500,000. In 1964 the Episcopal Diocese of Southern Florida bought the ancient monastery and today it is used as a parish church. The dirt floor has been re-placed with one of tile and stone, and the ninety arches of the cloister are pristine. Sculpted coats of arms of the noble families who helped build the monastery—also from the inexhaustible Hearst collection—hang from the walls, and suits of armor from the Royal Museum in Madrid as well as a confessional from Madrid's Royal Chapel, have been added. The monastery has come to its own, and Hearst would doubtless be pleased with the appearance of his purchase.

BILTMORE HOUSE

The Vanderbilts were the greatest builders of great American houses, and the greatest Vanderbilt house of all is George Vanderbilt's Biltmore, outside Ashville, North Carolina. The drive from the front gate of Biltmore to the house is three miles long and passes through an estate that originally contained 130,000 acres, most of which was later ceded to the government. A railroad spur connects Biltmore to the main line nearby—an extravagance that made perfect sense to George Vanderbilt, grandson of the master builder of railways, Commodore Cornelius Vanderbilt. George's interests ran more to intellectual and artistic matters than to railways, and so did those of his half-sister Gertrude Vanderbilt Whitney, the founder of the Whitney Museum of American Art in New York. Biltmore, a 250-room vacation retreat, was George's pride and joy. It was also the crowning achievement of the Vanderbilt family's principal architect, Richard Morris Hunt.

The houses Hunt built for the Vanderbilts made him famous and immensely wealthy. He designed their "cottages" in Newport, Rhode Island, and also the family's red-brick château across from Saint Patrick's Cathedral on Fifth Avenue, in New York. (The latter has been demolished, however, leaving the façade of the Metropolitan Museum as Hunt's only remaining monument in New York.) Hunt was the first American student to attend the Ecole des Beaux Arts in Paris. After graduation, he worked on an addition to the Louvre, and when he returned to the United States, he brought back with him traditional French architecture, particularly that of the château. Bilt-

St. Bernard's Monastery, re-erected in Miami, Florida. Inexplicably, several hundred stones, constituting a substantial mass in themselves, could not be fitted into the reconstructed building.

more is the supreme example of this transplanted style. In preparation for building Biltmore, George Vanderbilt had studied architecture himself, and he and Hunt got along very well. Vanderbilt also studied forestry and landscape architecture, and to design the grounds at Biltmore he hired Frederick Law Olmsted, the famous landscape architect who laid out Central Park in New York, Prospect Park in Brooklyn, the Boston park system, and the grounds of the Capitol in Washington. Vanderbilt worked closely with Hunt and Olmsted, but he never interfered with their work. He even put in time in the quarries with the stonecutters and in the woods with the loggers.

Hunt used three sixteenth-century French châteaux as models—Chambord, Blois, and Chenonceaux—but Biltmore is his own creation. It is a triumph of the unexpected. An exterior stairtower is copied from the famous octagonal stairwell built for Francis I at Blois. The banqueting room, avowedly a replica of a Norman hall, has a groined wood ceiling seventy-five feet above the stone floor. A triple fireplace dominates this room. Its design is likewise taken from Loire Valley châteaux, but it is surmounted by a long rectangular relief by the American sculptor Karl Bitter, a protégé of Hunt's. The elk and moose heads below the cathedral windows are very American, and so are the state flags hanging above them. The walls of the banqueting room were built to accommodate five enormous sixteenth-century Flemish tapestries that may have belonged to Henry VIII. The massive banqueting table is of recent origin, but the red damask chairs that flank it are eighteenth-century Italian. Bearskins are scattered among the Oriental carpets. Opposite the fireplace, where a musician's gallery might be, is an organ loft.

Splendid tapestries also hang in the ninety-foot-long Tapestry Gallery. It also contains family portraits and twelve white porcelain figures by Johann Kändler, the great eighteenth-century modeler of Dresden china. Like the banqueting hall, the Tapestry Gallery has an elaborately carved wooden ceiling and massive fireplaces. All those fireplaces did not stop Henry James from complaining of the chill when he visited Biltmore, however.

In the library, on ornately carved walnut shelves, are thousands of books that George Vanderbilt collected. Most of the ceiling, which is seventy-three feet long, is covered by a superb painting by the eighteenth-century Italian painter Giovanni Antonio Pellegrini, whose work was greatly admired in England. This room is a scholar's domain, its shelves filled with 20,000 volumes, for George Vanderbilt was a studious man who is said to have spoken eight languages.

The dining room is as elegant as the rest, with a delicate Wedgwood fireplace, walls of Spanish leather, and an elaborated ceiling and frieze. The private apartments at Biltmore are equally magnificent. The rear of the house, with its surprising façade, opens on a half-mile of gardens worthy of Versailles. The estate surrounding Biltmore was forty miles wide and included scattered hamlets for the farmers, craftsmen, and artisans working for the "Vanderbilt principality." When George Vanderbilt was planning schools, churches and a railroad station to serve his community, it took him and his overseers a week to ride the whole property. Unlike most of his contemporaries, he disliked the automobile and went instead by horse.

Vanderbilt did not use his house until after his mother's death in 1896; by then it had been standing empty for eight years. Two years later, he married Edith Stuyvesant Dresser of Newport. Tucked away in the Tapestry Gallery today hangs his portrait by John Singer Sargent. It depicts a slim, sensitive aesthete with large eyes and a drooping mustache who looks rather lost in the monumental solidity of Biltmore. he bears a haunting resemblance to the French novelist Marcel Proust, with whom, it is probably fair to say, he had more in common than with such captains of industry as his grandfather Cornelius.

SWAN HOUSE

Swan House, which is now the headquarters of the Atlanta Historical Society, was built in 1928 yet seems decades older. The former home of Mr. and Mrs. Edward Hamilton Inman, its twenty-two acres of beautifully landscaped grounds are situated on the northern outskirts of the city. Henry Hope Reed, in the magazine Classical America, called the architect of Swan House, Philip Trammel Shutze, "America's greatest living Classical architect." In present-day architectural jargon, classicism has very little to do with Athens' Parthenon or Rome's Pantheon, and Shutze's design for Swan House owes much more to Thomas Jefferson and the English Palladian architects of the eighteenth century than to antique sources. Classicism, as the term is now used, gives the architect considerable latitude. According to Shutze himself, "You don't copy the past, you adapt the past to your current needs, and in the process you make each design uniquely your own." This is precisely what he did for the Inmans, and in the process he created what Architectural Digest has called "a monument to the golden age of America."

Philip Schutze was to design many beautiful houses in Atlanta, but the façade of Swan House is particularly striking. With its cascades falling from basin to basin and its monumental stone staircase, the front of the building is of an almost Portuguese ornateness. As Elsie de Wolfe wrote in her book The House in Good Taste, "The whole thing should be a matter of taste and suitability . . . The effect is the thing you're after, isn't it?" Taste and suitability were what Philip Shutze was after—and what he abundantly attained. This is the house that beauty built, inside and out. The bold but graceful Palladian doorways, with their broken pediments, are continued inside the house, and so is the grand staircase, though much lighter in mood.

The house is exceptionally livable and cheerful. Elsie de Wolfe, the interior decorator of Swan House, believed that a dining room should be "a place where the family meet in gaiety of spirit for a pause in the vexatious happenings of the day," and in accordance with her precepts, the dining room is the color of sunlight, with a bold decoration of birds and flowers. Two console tables display the intertwined swan motif that recalls Mrs. Inman's fondness for the stately birds; the swan motif is repeated many times, but never obtrusively—and, not incidentally, gives the Inman house its name.

Philip Shutze, also noted, "People need to stroll outdoors, turn a corner and come upon an interesting

"Visual silence."
The Rothko Chapel.

plaza, an interesting view". This need is amply provided at Swan House. The terraced lawns, the retaining walls with recessed arches, the massive stairs, and the water cascades remain essentially as they were when the Inman's occupied the house—an enduring monument to beauty, and a vestige of a past golden age.

THE ROTHKO CHAPEL

The Houston interfaith chapel, commissioned by John and Dominique de Menil, was initially planned by Philip Johnson, an architect known primarily for his skyscrapers. He designed this plainest and least conspicuous of buildings working in conjunction with the late American painter Mark Rothko. Johnson's architectural concept was to subordinate the design to the spirit of the project. The exterior is shaped like a cross, the space inside is octagonal. The chapel, carried to completion by Harold Barnstone and Eugene Aubry, was consecrated in 1971.

The de Menils, long connected with the oil drilling company Schlumberger, undertook the project in 1964. It was their intention to establish "a sacred place where art and religion intermingle, where art leads the mind from the visible to the invisible." Rothko's commission from the de Menils was to create an environment for a chapel; it took him two years to complete the fourteen paintings now on view. The huge brown painting that hangs on the south wall is flanked by identical triptychs to the east and west, with another on the north. These triptychs are separated by four enormous black panels. The canvas on the north wall has a touch of pink to give it a predawn atmosphere. The overall impression of shadow and painting seems to weld the shapes into a continuous expression of light and dark forms.

Rothko was the ideal painter for what the de Menils wished to create. His late work—large, blurred rectangles of dark warm colors, without a point of focus—encourages meditation. It could be said that his work was suffused with a religious light. Certainly his work evokes harmony and tranquillity.

The only other work of art on the site is a sculpture on the lawn outside the chapel—*The Broken Obelisk* by Barnett Newman. Newman, who was, with Rothko, one of the leading painters of the New York School of Abstract Expressionism in the 1960s, had begun work in 1963 on this striking design—the lethal-looking tip of a broken obelisk balanced on the apex of a pyramidal base. The monument was finished in 1967 and bought by the de Menils in 1968, the year of the assassination of Martin Luther King, Jr., to whose memory it is dedicated. Its harsh angular form stands out sharply against the slanting walls of the chapel.

Rothko's work takes up most of the wall space in the otherwise plain interior, where there is just enough light from the ceiling to make the vast paintings visible. Rothko, a deeply unhappy man, was almost overpowered by this ambitious project, and the commission led him to reassess his belief in his own powers. He wrote to the de Menils that "the magnitude, on every level of experience and meaning, of the task in which you have involved me exceeds all my preconceptions. And it is teaching me to extend myself beyond what I thought was capable for me. For this I thank you."

Accoording to Dominique de Menil, the guiding spirit behind the project, "the Rothko Chapel is like a big tree it has a mysterious beauty and offers hospitable shade to everyone." The chapel has been a great public and critical success, and Mrs. de Menil is fond of quoting the comments of visitors, one of whom wrote, "Never has the void seemed so vast and warm." Another added: "At first unsettling because of the unusual darkness of the paintinigs, the spaces become slowly appealing by the very darkness of the colors, by their monotony, by their subtle harmony." The daunting blackness of the paintings "repels the gaze at first, then gradually absorbs it, creating a sense of void, or nothingness, a plunge into the night."

The Rothko Chapel, an oasis of quiet in downtown Houston, is no purveyor of easy solace; it admits of our desolation. In his search for poignancy, in his acceptance of risk, and in his intimate orientation toward infinity, Rothko created a genuinely religious space, his legacy to mankind. The influence of his work and his chapel extends far beyond Houston, for it has close connections with religious centers all over the world—"a humble relay," Mrs. de Menil called it, "in man's everlasting adventure in communion."

6

REFLECTIONS OF
THE GOLD COAST

Situated atop a hill in California's Santa Lucia Mountains overlooking the Pacific Ocean, Hearst's La Cuesta Encantada at San Simeon ranges over 245,000 acres of mountains and valleys.

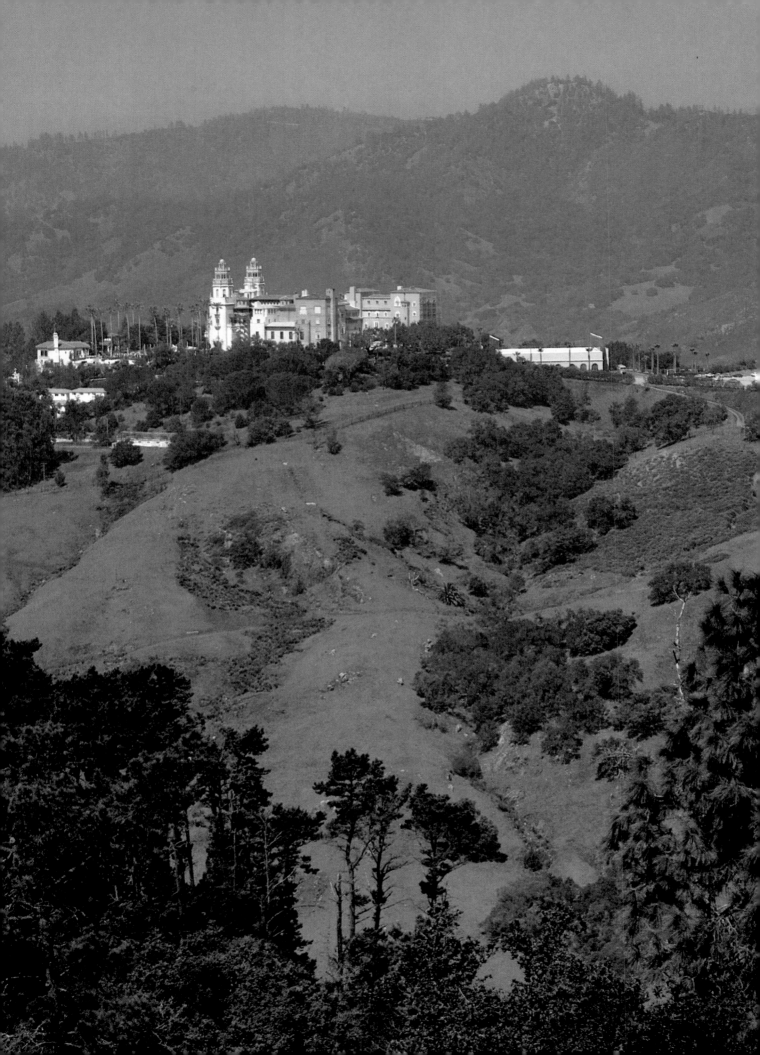

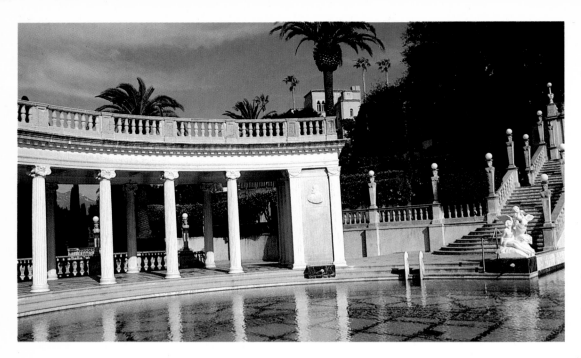

The guiding force behind the architecture of the castle was William Randolph Hearst, who hired a young architect, Miss Julia Morgan, to interpret his inspirations. The greco-roman balcony looks onto the ocean and surrounds the Neptune pool.

The Library at La Cuesta Encantada.

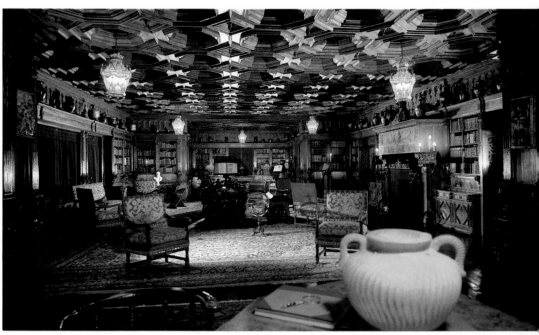

This is one of the three guest houses and other buildings, including a private zoo, which top the hill.

following page:
The indoor pool is ten feet deep and the mosaic is lapis lazuli and gold leaf covered in glass. The marble statues are by Carlo Freter.

13✳

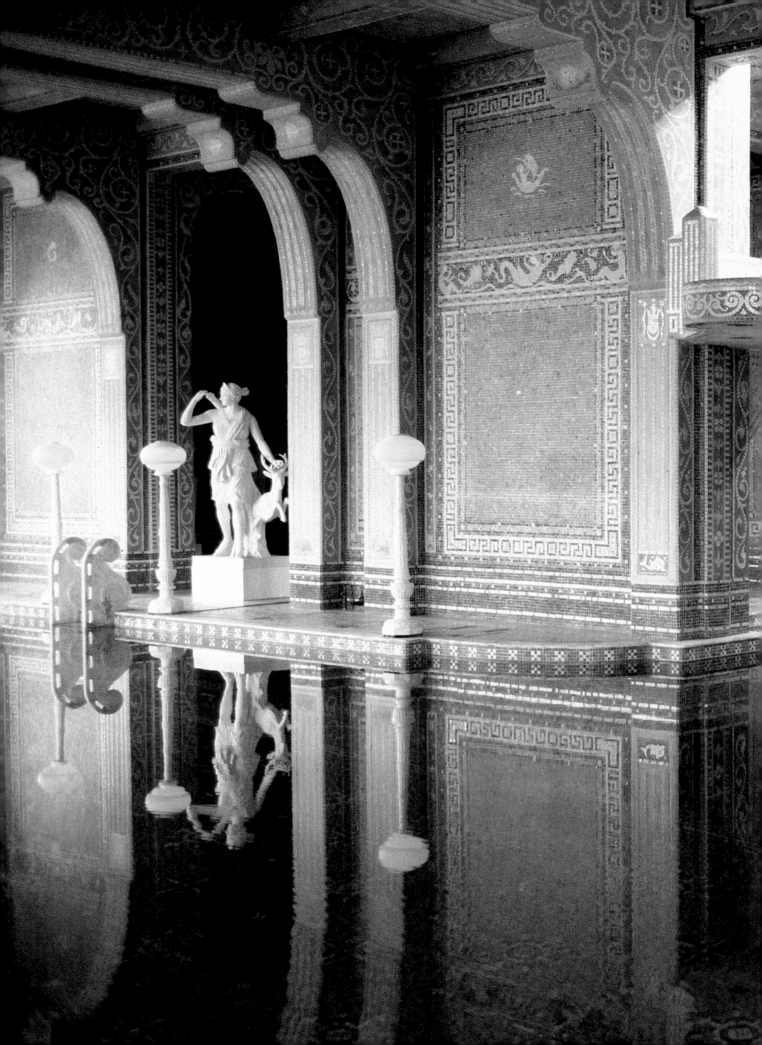

View of the clock tower from the sunken garden. This clock is atop the carriage house, designed by Arthur Brown Jr., who also designed several of San Francisco's civic buildings. It presently houses a collection of carriages.

Main entrance to Filoli, which was built between 1915 and 1919 for William Bowers Bourn II by the architect Willis Polk. Its name, selected by Bourn, stands for the first two letters of the words FIGHT, LOVE, LIVE, which come from a credo he admired: "Fight for a just cause, love your fellow man, live a just life."

A stone decorative motif in the garden of Filoli, in Woodside, California.

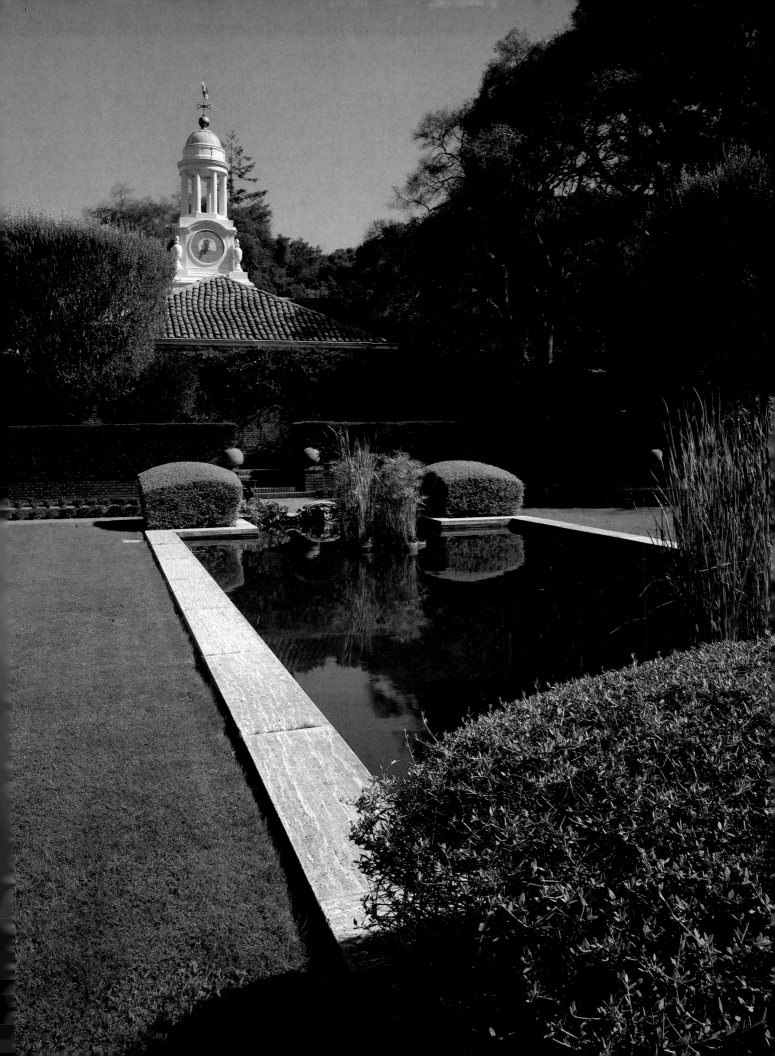

Bronze bust of Hercules in the main peristyle garden of the J. Paul Getty Museum in Malibu, California. This is a copy of a Roman bronze, found at the site of excavation of the Villa dei Papiri at Herculaneum, near Naples. The pupils of the statue are made of coloured glass, as they were in antiquity.

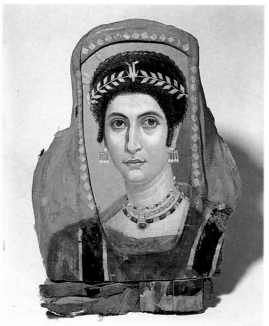

The Fayum portrait of Isidora is one of the recent acquisitions of the Getty Collection of Greek and Roman antiquities.

Entrance to the vestibule of the museum based on Villa dei Papiri which was discovered by monks digging a well in 1750. The excavation of this Roman seaside villa of the first century B.C. took place in the 18th century under the supervision of Karl Weber whose plans were used in building this recreation to house the art works of J. Paul Getty.

View of the Arch of Constantine, by Canaletto, was painted c. 1740, and is part of the extensive collection of Renaissance and Baroque paintings.

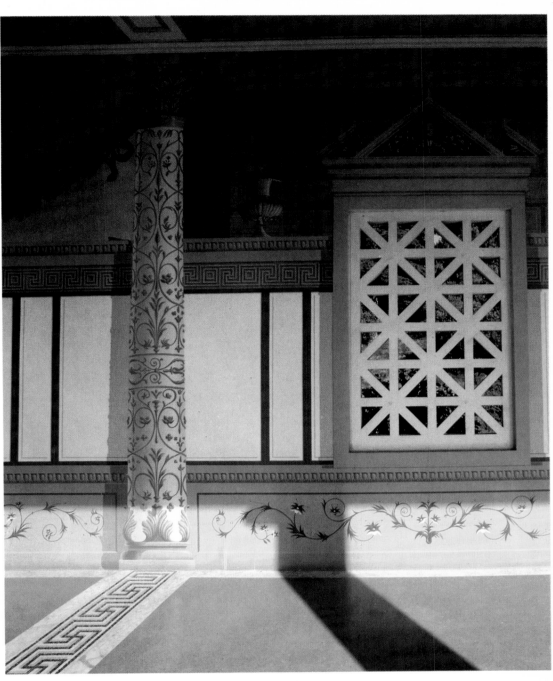

A trompe l'oeil, in the fashion of the latter half of the first century B.C., adorns the walls of the portico that surrounds the main peristyle garden. It was executed by the American artist Garth Benton.

following page:
View of the Moon Bridge in the Japanese garden at Huntington, in San Marino, California. Its landscaping was the work of William Hertrich and Henry Huntington. Together they planned and executed the development of half the present acreage of the ranch.

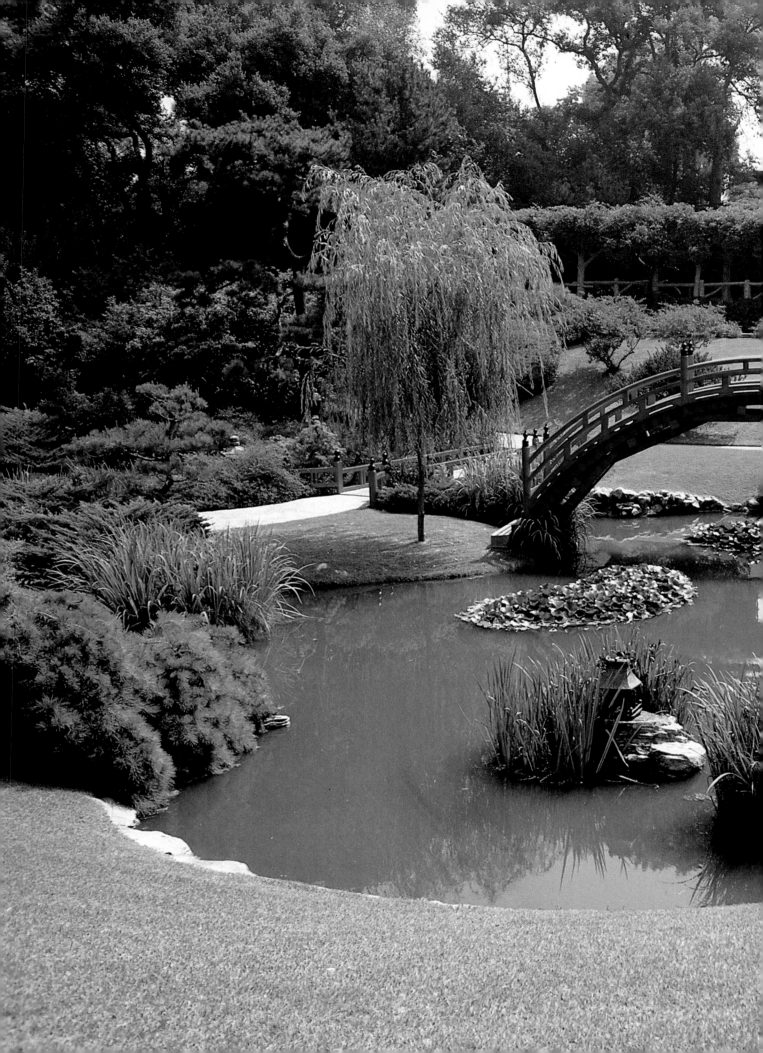

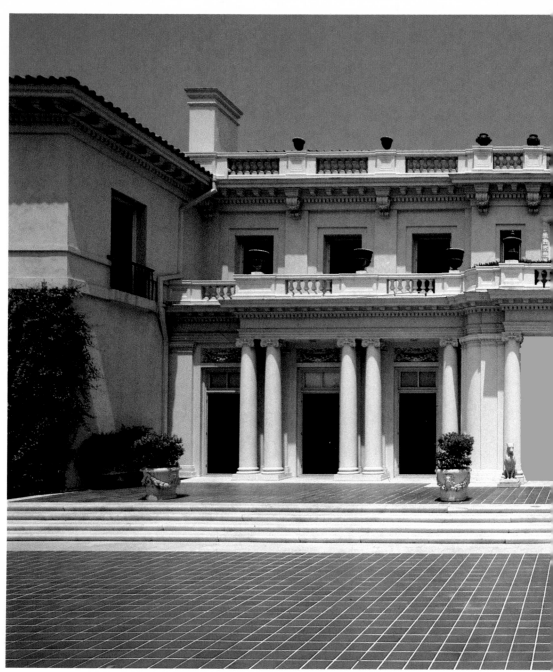

The art gallery, formerly the residence of H.T. Huntington, was designed by the Los Angeles architects Myron Hunt and Elmer Grey and built during the years 1909–1911.

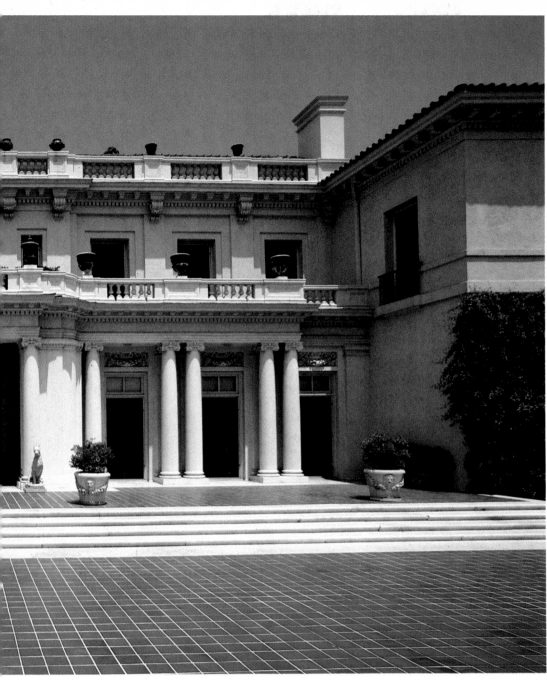

Plants and cacti from the Huntington Botanical Garden.

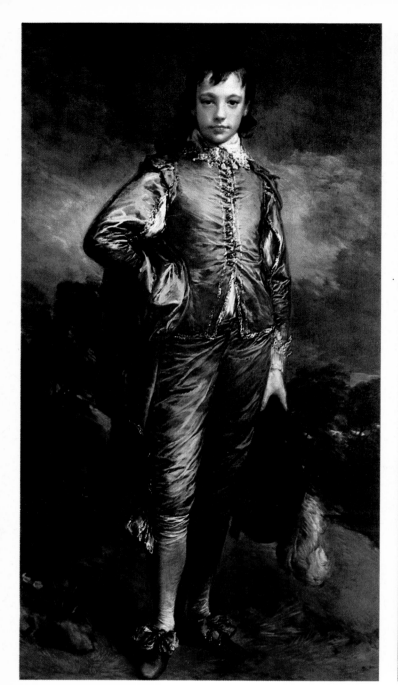

Thomas Gainsborough's Blue Boy *is a portrait of Jonathan Buttall, the son of a close friend of the artist. His costume dates from approximately 140 years prior to the painting of the portrait, and is deliberately in the manner of the Flemish artist Sir Anthony Van Dyck, whom Gainsborough admired above all others.*

An illuminated page from the Gutenberg Bible, from the Huntington Library, which has today some 600,000 volumes and rare manuscripts covering the full range of American and English history and literature, in which the library specializes.

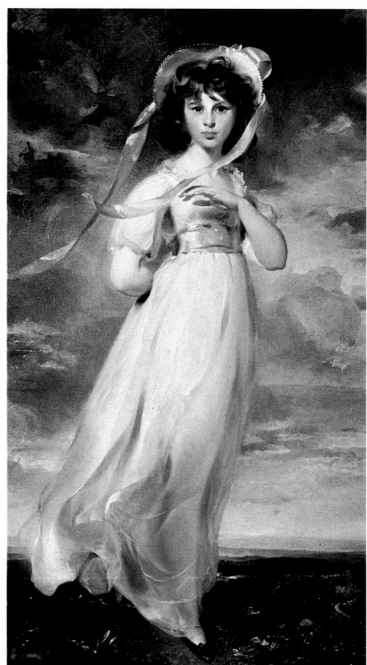

The Quinn Room has English paneling from the mid-eighteenth century. The furniture, also English, is from the first half of the eighteenth century.

Pinkie, by Sir Thomas Lawrence, was acquired in the 1920's, shortly before the death of Henry Huntington. It is one of the best known pieces of the Huntington Art Gallery Collection of English art of the eighteenth and early nineteenth centuries.

The Queen Marie of Romania Room at the Maryhill Museum in Goldendale, Washington. This gallery is devoted to furniture and art objects of Queen Marie, a talented craftswoman who worked on some of the ornate furniture.

The large corner throne was made in 1908 by craftsmen at Castle Pelesh, Sinaia.

This vase was designed by Emile Gallé and purchased directly from his son by Alma de Bretteville Spreckels, the benefactress of the Maryhill Museum.

The architects Hornblower & Marshall designed Samuel Hill's mansion so that a car could ascend the ramps at either side of the residence and pass through the main floor of the building.

following page:
Massive Corinthian pillars upholding the pediment and a dome skylight are among the architectural details that highlight this Colonial Revival mansion, built by Alexander Dunsmuir in 1899.

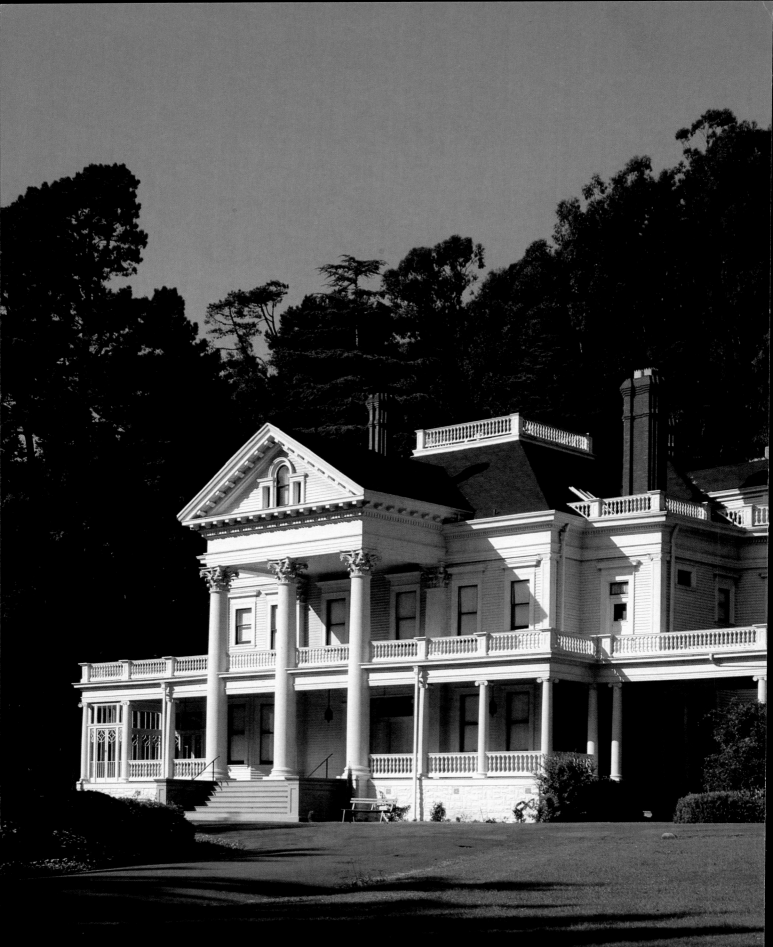

The Hirshhorn Museum and Sculpture Garden. Washington, D.C., 1974.

Huntington, Davic C., *The Landscapes of Frederick Edwin Church.* New York, 1966.

The Founding of the Henry E. Huntington Library and Art Gallery. San Marino, California, 1969.

Jewelry: Ancient to Modern: The Walters Art Gallery. Baltimore, Maryland, 1981.

Johnston, Alva, *The Legendary Mizners.* New York, 1953.

Karp, Walter, "Electra Webb and Her American Past." *American Heritage*, April/May, 1982.

Larkin, Oliver, *Art and Life in America.* New York, 1949.

Lewis, Oscar, *The Big Four: The Story of Huntington, Stanford, Hopkins and Crocker.* New York, 1938.

Lewis, R.W.B., *Edith Wharton: A Biography.* New York, 1975.

Lundberg, Ferdinand, *Imperial Hearst.* New York, 1936.

Lynes, Russell, *The Tastemakers.* New York, 1954.

Maher, James T., *The Twilight of Splendor: Chronicles of the Age of American Palaces.* Boston, 1975.

Marble House: The William K. Vanderbilt Marble Mansion. Newport, Rhode Island, no date.

Mariano, Nicky, *Forty Years with Berenson.* New York, 1966.

Masson, Georgina, *Italian Gardens.* New York, 1961.

Master Paintings from the Phillips Collection. Washington, D.C., 1981.

Masterworks on Paper: Prints and Drawings from the Ringling Museum, 1400–1900. Sarasota, Florida, no date.

Moore, Charles, *The Life and Times of Charles Follen McKim.* Boston, 1929.

Newman, Sasha M., *Arthur Dove and Duncan Phillips: Artist and Patron.* Washington, D.C., 1981.

Odessa: The Spirit of Times Past. Winterthur, Delaware, 1981.

The Phillips Collection in the Making: 1920–1930. Washington, D.C., 1979.

Phillips, Duncan, *The Enchantment of Art.* New York, 1914.

Phillips, Marjorie, *Duncan Phillips and His Collection.* New York, 1970.

Post, Marjorie Merriweather, *Notes on Hillwood.* Washington, D.C., 1979.

Rheims, Maurice, *The Strange Life of Objects: Thirty-five Centuries of Art Collecting and Collectors.* New York, 1961.

Richardson, Edgar P., *Painting in America, The Story of 450 Years.* New York, 1956.

Rigsby, Douglas and Elizabeth, *Lock, Stock and Barrel: the Story of Collecting.* New York, 1944.

Rorimer, James, *The Cloisters: The Building and the Collection of Medieval Art in Fort Tryon Park.* New York, various editions.

Spaeth, Eloise, *American Art Museums: An Introduction to Looking.* Revised and enlarged edition, New York, 1975.

Sprigge, Sylvia, *Berenson.* London, 1960.

Steffens, Lincoln, *Autobiography.* New York, 1931.

Sutton, Denys, *John and Mabel Ringling Museum of Art,* New York, 1981.

Sutton, Denys (editor), *Letters of Roger Fry,* 2 volumes. New York, 1972.

Swanberg, W.A., *Citizen Hearst, A Biography of William Randolph Hearst.* New York, 1961.

Taylor, Francis Henry. *Fifty Years of Art.* New York, 1960.

Taylor, Francis Henry. *Pierpont Morgan as Collector and Patron.* New York, 1970.

Tharp, Louise Hall, *Mrs. Jack.* Boston, 1965.

Tompkins, Calvin, *Merchants and Masterpieces: The History of the Metropolitan Museum of Art.* New York, 1970.

Watson, George L., "Isabella Stewart Gardner." *Notable American Women.* Cambridge, Massachusetts, 1971.

Wecter, Dixon, *The Saga of American Society: A Record of Social Aspiration, 1607–1937.* New York, 1937.

Whitehill, Walter Muir, *Dumbarton Oaks: The History of a Georgetown House and Garden, 1800–1966.* Cambridge, Massachusetts, 1967.

Wilmerding, John., *American Light: The Luminist Movement, 1850–1875.* Washington, D.C., 1980.

Wright, William, *Heiress: The Rich Life of Marjorie Merriweather Post.* New York, 1978.